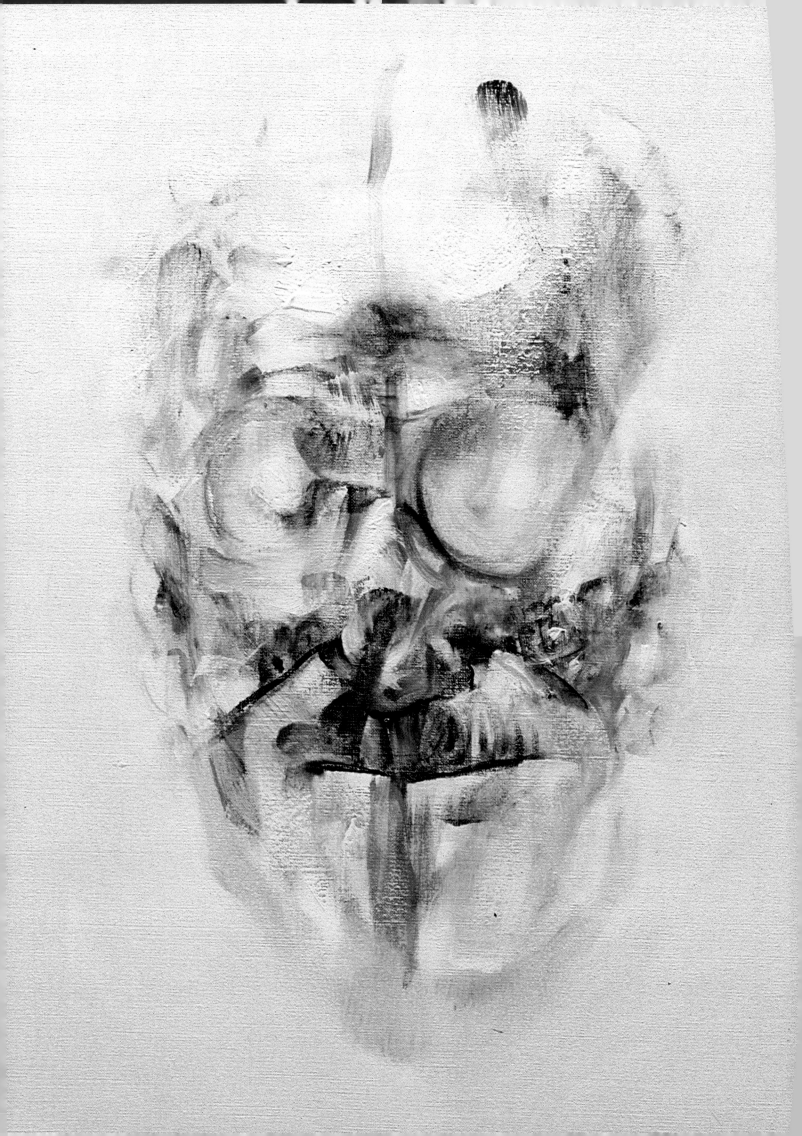

LOUIS LE BROCQUY
THE HEAD IMAGE

INTERVIEWS WITH THE ARTIST

GANDON EDITIONS KINSALE

Contents

TABLE DES MATIERES / INHALT

LOUIS LE BROCQUY
– THE HEAD IMAGE

© Gandon Editions, Louis le Brocquy, 1996
All rights reserved.

ISBN 0946641 587

Editor Pierre le Brocquy

Design John O'Regan (© Gandon 1996)
Production Nicola Dearey, Gandon
Photography Claude Gaspari, Paris
 Claude Germain, Antibes
 Kenneth M Haye, New York
 (The New York State Museum)
 Lee Stalsworth, Washington DC
 (Hirshhorn Museum & Sculpture
 Garden, Smithsonian Institution)
 Lucien Clergue
Translation French:
 Eurotranslations, Cork (Morgan)
 Alice Bellony-Rewald (Peppiatt)
 German:
 Eurotranslations, Cork
Repro Masterphoto, Dublin
Binding Kenny's Bindery, Galway
Printing Betaprint, Dublin

front cover 'Ancestral Head', 1964
back cover 'Human Image', 1996
frontispiece 'Image of James Joyce', 1977

JAMESON
IRISH WHISKEY

The publishers gratefully acknowledge the
assistance of
JAMESON IRISH WHISKEY
TAYLOR GALLERIES, Dublin
GIMPEL FILS, London
in the production of this book.

The publishers also wish to thank the
collectors of the works illustrated and all
those who have collaborated in this
publication.

This is one of four books on the artist
available from Gandon:
Louis le Brocquy – The Irish Landscape
 (Gandon Editions, 1992)
Louis le Brocquy – Procession
 (Gandon Editions, 1994)
Louis le Brocquy – Paintings 1939-1996
 (Irish Museum of Modern Art, 1996)

GANDON EDITIONS
Oysterhaven, Kinsale, Co Cork, Ireland
tel 021-770830 / fax 021-770755

Foreword

The ancient Celtic image of the head – that 'magic box' of consciousness – is central within the wide span of le Brocquy's preoccupations as an artist. For over thirty years, he has been painting an unending series of head images that have become emblematic of his work.

This book explores the origins and development of the theme, from the *Ancestral Heads* to the successive images of individuals, including WB Yeats, James Joyce and Samuel Beckett. The book concludes with a return to the anonymous in his minimalist portrayal of the human image.

The Head Image is the third publication by Gandon Editions in a series based on interviews with le Brocquy. Together with George Morgan's exploratory discussion, an interview by the author and critic, Michael Peppiatt, provides an earlier insight into the artist's mind.

The book is published on the occasion of the artist's eightieth birthday and the celebration of his life's work in a retrospective exhibition at the Irish Museum of Modern Art.

PIERRE LE BROCQUY

The Head Image

AN INTERVIEW WITH LOUIS LE BROCQUY BY GEORGE MORGAN

The following interview was recorded during four separate meetings in 1995 and 1996. The sessions took place in Louis le Brocquy's studio in the South of France. The text has been edited for publication but the contents and tone reflect accurately Louis' thoughts and mood on those occasions.

———

George Morgan — It seems to me that the outstanding characteristic of your head images is their unrelenting repetition. Why this obsessive repeating of the image? How did it come about?

Louis le Brocquy — Well, you see, in order to produce a human image which has some kind of contemporary relevance, you have to recognise that certain factors which have arisen in the last hundred years have revolutionised the way we look at things. Because of photography and the cinema on the one hand, and psychology on the other, we can no longer regard a human being as a static entity, subject to merely biological change. No longer can we perceive the nineteenth-century images of Dominique Ingres as reflecting the faceted, kinetic, ever-changing nature of human reality today. Replacing the single definitive image by a series of inconclusive images has, therefore, perhaps something to do with contemporary vision, perceiving the image as a variable conception rather than a definitive manifestation in the Renaissance sense. Today we tend more to question, to deconstruct and analyse perhaps. Repetition/variation is an aspect of that process. The Renaissance had no need of repetition. On the contrary, it would seem that it tended to follow a *linear* mode of thought, implying a beginning, a middle and an end, thus achieving completion, wholeness. Repetition, on the other hand, implies not linear but *circular* thought, a merry-go-round interpretation of reality, another form of completion, another whole, which can be entered or left at any point. This latter counter-Renaissance tendency is, curiously enough, already evident here and there within our Irish tradition, from the Books of Kells and Lindisfarne to *Finnegans Wake*.

What was the origin of your interest in heads? What were the factual or emotional factors which triggered their discovery and which made them so meaningful to you?

The origin of this long series of head images was the Musée de l'Homme in Paris. It was there in 1964 I discovered the Polynesian decorated heads — skulls over-modelled in clay and painted ritualistically to contain the spirit. I was very excited by the idea.

Was your later discovery in Provence of the Celtic dimension of this head cult also a revelation?

Coming across those rude stone sculptures, systematically smashed by the Romans – as were the Celts themselves – in the year 123 BC, that *was* a revelation. But, you know, revelation is essentially the showing forth of an idea already latent in the mind. In Ireland, I had known isolated examples of the same culture, such as the tri-faced Corlech Head. Now all this became integrated within the concept of human consciousness. Much as I was excited by the Polynesian head image, it remained intensely foreign to me. I could grasp it anthropologically, so to speak, rather than emotionally. The Celtic concept mirrored feelings of my own.

Is this cult of the head something that you assimilated into your way of being? Did it affect you existentially? Or was it merely a tool and a technique which allowed you to take your artistic quest further?

It certainly didn't affect me existentially. This macabre Gaulish practice seemed as unpleasant to me as it did to the Greek and Roman individuals who were proudly shown the sacred spoils. No, it was a way of finding a path or inroad into an invisible area of reality, an intangible site underlying the outward appearance of the human being.

S-I-T-E or S-I-G-H-T?

S-I-T-E.

And at the same time it gave you a kind of 'sight'.

And, hopefully, insight.

Following your discovery of those two very different cults of the head in 1964, you painted a series of head images, many of which were titled Ancestral Head. *What had you in mind at the time?*

What I tried to evoke in these paintings was, I suppose, the conception of earlier human lives. I made a play to rediscover in the imagination visual traces of beings like ourselves, beings who had preceded us historically and even prehistorically.

Do you see this painterly activity as a kind of evocation, as in a spiritualistic séance?

No. That would be to evoke *actuality*. The painter evokes a reality of the mind. I am aware, of course, that the spirit is implied not only by the painter's material means – by the paint itself – but by the form of the object painted. I vividly remember my emotion when, some thirty years ago, I came across the skull of René Descartes in a glass case in the anthropological section of the Musée de l'Homme – an ivory-tinted dome, smooth as a woman's breast. Merely a bit of bone perhaps, but, by implication, a tabernacle to this great instance of human consciousness.

The anthropologist Joseph Campbell, in The Hero with a Thousand Faces,

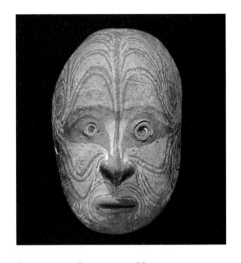

DECORATED POLYNESIAN HEAD
East Sepik Province, New Guinea
(Musée de l'Homme, Paris)

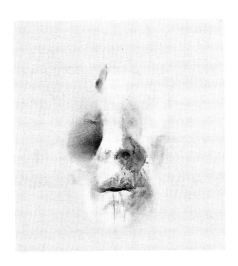

ANCESTRAL HEAD, 1971
oil on canvas, 70 x 70 cm (detail) (296)

describes the heroic quest in terms of different masks worn by the hero as he pushes out on his journey to the perimeter of consciousness. There seems to be a similarity with the way your own painting works with its ongoing quest and changing faces.

I haven't read Joseph Campbell, but I like the idea of those differing masks worn by the individual hero. WB Yeats might have liked it too, reflecting upon his Mask, his alter ego, enabling him to extend yet further his identity and the vast perimeter of his mind. It brings to mind Samuel Beckett's poignant words in face of the navigation of his art and what he called his failure:

> For if I see myself putting to sea in the long hours without landfall.
> I do not see the return ...
> I do not hear the frail keel grating on the shore.

The artists I've painted repeatedly, such as Yeats, Joyce, and Beckett himself, are envisaged in this way, essentially within the isolation of their art, outside circumstance.

Then you are concerned above all with their being, with their conscious existence?

Yes, and in wonder at such instances of human experience.

I'm interested to hear you use the word 'wonder'. It encompasses a lot of what I feel about your painting – a sense of indefinable awe. Is this what you are looking for?

Wonder is, I imagine, the deepest thing in us – too often left behind in childhood. It implies not knowing, but it also suggests an awareness of meaning and of mystery. By not imposing conscious ideas, by letting the painting speak, the painter can sometimes induce wonder. If he fails in this, then the painting has failed.

You ask whether I was pushing my painting out to the periphery of consciousness. I would not claim that at all, but I do feel that consciousness is *in itself* on the outside rim of what we know. It is at once the most familiar and the most distant of all problems – the one that confuses science the most because the nature of consciousness is the very last thing that science can discern. The eye cannot see itself. Science can comment on the behaviour of consciousness – as did Freud or Jung – but to define its identity as you might analyse the chemistry of water is not possible and scarcely envisageable, as far as I am aware.

Does this discourage you?

No, on the contrary. If anything it provokes me to paint towards this hidden reality that I can never reach.

Are you, as an artist, trying to push out to the perimeter? Do you see yourself as an explorer of new territory? Or is your work irrelevant to today's art movements in any of their varied forms?

In Dublin or in London or elsewhere I have never belonged to any group or movement in art. I've no great interest whether my work be judged *avant garde* or otherwise. At one time or another it has been attacked or ignored from

both sides. At my age, I'd be disappointed, if not worried, had the visual arts not moved further afield. They certainly have, and I'm excited to witness the imaginative experiment of recent years. But, you know, what I wish for myself is to go not far, but deep. If my work has any originality, it is – like that of a well-known Irish poet – won through *digging*. A sort of archaeology, you could say.

An archaeology of the mind?

Yes, in the sense that the image is not a careful representation, but a discovery that is allowed to some extent to form itself, an image that can surprise the painter.

Surprising as the image may be, external appearances and figurations continue to play an important role in your work.

Appearance is very important to me as a painter. In the head images it signals identity. In reaching out towards an underlying reality, I constantly refer to external appearance – not in the solid Renaissance sense, but simply to identify the *whatness* of, say, an apple, a forehead or a lower lip.

In your head images, do you feel you're attempting mentally to enter beneath appearances, beyond what you have referred to as 'the billowing curtain of the face'?

Well, when you see photographs of someone strewn around the easel, around an image as it emerges, inevitably you feel drawn into that image to some extent. Stéphane Mallarmé called such a process 'immersion'. But immersion can cause problems. Some people have remarked that several of the images I've painted of others have a look of the painter. I can't see this myself. It certainly wasn't my intention, but I suppose you have to accept this ambivalence since the image is reflected within the painter's head. Even Picasso's goats have a look of Picasso!

So does this mirror effect explain why you like to paint the head full-face? Is it important for you to see the face full on?

Looking your question full in the face, I would think that a head image of an individual – implying something of his inner reality – must be attempted frontally, head on. If the head is viewed sideways – in profile – the individual is seen more objectively, devoid of that sense of entry induced by face-to-face encounter. In full-face, we all know the significance of the eyes as 'windows' into an invisible reality. Their expressive significance is overwhelming by implication, even when they are closed. Clearly, the head regarded full-face is more penetrable, more transparent.

———

You have talked in the past about your painting being a form of exploration. At what stage do you recognise that the exploration is complete, that the head is realised, that this is it?

You have just asked a very, very old question constantly asked of painters and which they recurrently ask themselves: when is the painting finished? There can be no meaningful reply. A painting is finished when it is finished, when it

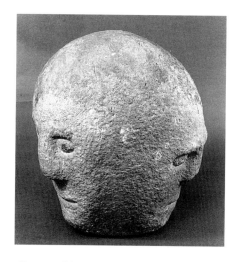

CORLECH HEAD
c.100BC-100AD
(National Museum of Ireland)

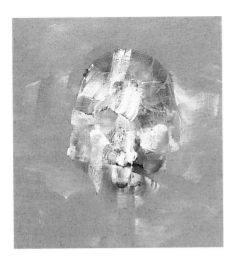

HEAD OF A MAN, 1968
oil on canvas, 73 x 73 cm (detail) (214)

can be taken no further. Something has come through and no more can emerge in the context of a particular work.

And if the painting finished badly?

It must be destroyed; it *has* been destroyed. In 1963, I destroyed virtually the entire year's work. I was in despair at the time, but I don't regret what I did. The work had veered off course. My friend, the painter Joan Mitchell, would have ascribed those paintings to 'Henry'. Henry, for Joan, was the monkey which lurks in us all and must be firmly rejected.

Have you ever regretted the destruction of a canvas?

Often. You see, apart from Henry, there are two distinct people involved in painting a picture. First, there's the painter himself, working, linked to his canvas. Then there's the observer, who objectively judges not only the painter as he works, but the finished painting. The latter perceives the painterly structure more acutely perhaps, but may fail to divine the unconscious thrust of the work. Now and again, he destroys the wrong work.

Are you suggesting that the artist is not the best judge of his work?

Generally speaking, the artist has a deeper understanding of his own work than any other person. But his fallibility, where it occurs, has ruinous consequences. In years gone by, René Gimpel, the Paris art dealer who supported Haïm Soutine, supplied him *inter alia* with a housekeeper free of charge. *She*, however, was charged to remove half-length portraits 'before the artist got to the hands'. You see, it was at that point Soutine judged the work finished and almost invariably destroyed it. Thanks to an unknown housekeeper, those intensely urgent paintings with their unfinished hands are with us today.

How do you place your work in relation to the contemporary scene?

It will be for others to answer that, but naturally I have my own ideas about what I've been trying to discover through painting over the years and where my work points today.

It could be said, however, that over the years painting has become less relevant. Has there not been a progressive shift in visual art forms? It seems to me that contemporary art based on conceptual, environmental and photographic techniques has largely replaced painting.

Yes. Many of the vital concerns of our time, both social and aesthetic, are now expressed by means other than painting, by conceptual arrangement, by environmental re-arrangement, by behavioural forms, by photographic process. I think this widening of means in visual art is to be welcomed as leading to further modes of questioning and insight on a wide social basis.

But are these new forms going to replace the act of painting? After some six centuries, have you artists painted yourselves into a corner?

Not in the very least. Recognised or not, painting today remains essential.

The art of painting is as limited as the human imagination.

You have devoted the greater part of your lifetime to painting. Do you think of painting as having any essential quality peculiar to itself?

In the hands of an artist, whether his work be abstract or figurative, paint can become *music* – a vibrant thing in itself. But painting has yet another magic ambivalence, a transformation within itself in which the paint, while maintaining its material identity, *becomes* the image, while the image – be it a rectilinear surface or a bunch of asparagus – is transformed into paint.

It was Malraux who said that 'the 21st century will be mystical or it will not be'. Do you think that art or human consciousness generally will tend to develop towards the kind of exploration you are involved in, an exploration of wonder, an exploration of an inward spiritual kind?

In studying painting, I've naturally wondered what kind of age has begun with this century. I even wrote a bit about it when I was a visiting tutor at the Royal College of Art in the early fifties.[1] It seemed to me then that, from its origins, western culture tended to traverse a series of prolonged epochs, long periods of alternate inward-looking and outward-looking visions. Over-simplification is notoriously misleading, but it did seem to me then that our cultural origins in Egypt, Mesapotamia and primitive Greece represented an inward-looking reality, a conceptual reality. Somewhere around the fifth century BC, this view of things appears to have given way dramatically to our first outward-looking, scientific, perceptual age – the era of Greece and Rome. Apparently this reversed in the succeeding Byzantine, Romanesque, Gothic styles, when we once more turned, in one form or another, to the hieratic spirituality of a Ravenna mosaic. You will agree that we then re-entered the visible and tangible world through the gateway of the Renaissance, when a blue sky rose above us, so to speak, replacing the Byzantine gold background of infinity. After a thousand years, the old classical world was reborn to endure for a further six hundred years.

And now?

And now? Well, at the turn of the present century, have we not perhaps re-entered a new in-looking, immaterial age? Hasn't Cézanne, proclaiming that 'reflection modifies vision', reinstated the conceptual 'gold' background, the *reduction à la surface picturale*? Didn't Cézanne's anti-Renaissance 'boxed' space reveal matter in crystalline planes, to be further deconstructed by Picasso and his peers?

And what of time to come?

As André Malraux remarked, no-one can tell how the epoch we've entered upon will develop, but in the mid-fifties, it did seem to me that the wind had turned, that every sensitive sign pointed pennant-like the other way, that with the advent of the twentieth century a new age had begun.

You seem to be boring towards some kind of essential core, what the critic Michael Gibson called quidditas *or 'whatness'. How does this essence emerge out of a head?*

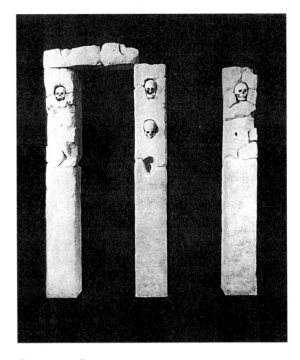

PORTICO AT ROQUEPERTUSE
4th century BC

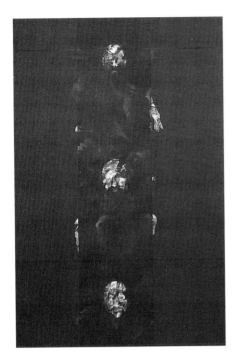

ENTREMONT, 1968
oil on canvas, 195 x 130 cm (219)

What insight do you draw from it?

Clearly, it is not possible to paint the spirit. You cannot paint consciousness. You start with the knowledge we all have that the most significant human reality lies beneath material appearance. So, in order to recognise this, to touch this as a painter, I try to paint the head image from the inside out, as it were, working in layers or planes, implying a certain flickering transparency. What one is left with at the end – if I am in any way excited by the image that emerges – is the suggestion of some turbulence going on beneath the picture surface, beneath the external appearance of the image. That's all I can say.

You've been working on the heads for thirty years. There is a continuity in the way you approach your work. Do you feel it has evolved?

My fear would be that they might be seen as monotonously repetitive. You see, my search demands an intensely narrow focus, an almost minimalist approach, precluding a widely animated surface or a free use of colour. I am held to a very narrow boring hole, so to speak.

Do you sometimes yearn to break out into some kind of painterly expansion?

At times, I do indeed break away into images of nature – doves, flowers, fruit, deconstruction of landscape in watercolour, or those group paintings, the *Processions*. Existence, if you like, at another level. Yet, I seem always to return to what is central – that indivisible social unit, the individual human being in its 'matrix' of isolation.

What do you understand by the word 'matrix'?

I remember you once referred to the thoughts of Lao Tsu in this context, in respect of his vision of a primordial matrix where all reality lay unborn, a pregnant universal presence destined to produce all matter and all life. As for my paintings, I claim no such profundity! But in them the image may be seen to arise from a comparable matrix or limitless background, which the critic Pierre Schneider has named *un fond perdu* – a lost depth.

Do you see this phenomenon as being purely physical, or does it have, to use a tricky word, spiritual manifestations?

I think you have to say it does have a spiritual side. The 'trickiness' of the word is, I suppose, due to its often being interpreted as esoteric. For a painter, I think, it should simply signify those values which are realised beyond his material means, in the world of the mind.

Your heads – at least as I read them – are paradoxes. An English critic, Matthew Arnold, once wrote that the Celtic mind is fundamentally paradoxical: emergence/immergence, appearance/what lies beyond appearance. How do you yourself regard these paradoxes?

I think I've always recognised the ambivalence of painting generally. That is the ambivalence of the reality of what a painting is or implies; its identity with and its difference from the reality of the actual world; its otherness. And

then, in respect of these deconstructed head images I paint, I do see a peculiar ambivalence in which certain factors of the actual world – space, time, circumstance – are unstated, stilled, or absent.

You constantly use words such as 'groping', 'searching', 'discovery' in respect of your painting. Does this mean that when you are painting you don't have a clear idea of where you are going?

When you're painting, you don't always fully realise what the painting signifies. Meaning creeps in gradually. In a very early work, like *A Picnic* in 1941 for instance, I was simply intent on exploring the art of painting – the world of Degas and the picture-making of Japanese Ukyo-e. Many years passed before I perceived the surreal nature of the image I had painted: three individuals gathered together for a picnic, yet isolated one from another around a bare tablecloth... Without my knowledge at the time, the painting would seem to imply that the individual is essentially alone – each one of us alone in his individual walled garden of consciousness. Certainly we can look over our wall at the other, but not even lovers can enter the mind of the other. Perhaps the most wonderful function of art, in all its varied forms, is that each one of us can share, to some extent, in an individual consciousness. What interests me though is that this insight, both banal and profound, came to me from painting, from the act of painting.

Are you still expressing this aloneness in the heads?

Certainly every one of them is isolated. But here there's something of a paradox. In each painting, a particular head image takes its place alone on the canvas, but this solitary presence is also every one of us, our potential, our *reach*.

Turning to yourself, is painting a way of exorcising your own aloneness, a means of creating a relationship, perhaps, with the solitude of another?

I don't think it can be that. In my long life, I've often been alone, but I have never consciously suffered in consequence. Of course, the infant may have another story, but he hasn't let me know! No, I cannot claim to have looked to painting for ways to compensate for my aloneness at any time.

So you feel your interest is not so much personal as related to the human condition?

Yes. I imagine aloneness is possibly the deepest reality of the individual, but remember, such knowledge of the human condition is gained as a painter, derived mostly through or along with the peculiar logic of painting. In making a hundred images of Joyce in different media, I came to understand not only his singularity, but his proud isolation, his aloneness. I felt to some small extent I had entered that aloneness. No, not entered – *touched* it. On the other hand – *outside* the world of painting – I remember, in 1944, the great physicist Erwin Schrödinger assuring us in Dublin that 'consciousness is a singular of which the plural is unknown' and 'what seems to be a plurality is merely a series of different aspects of the same thing'.[2] I remain deeply impressed by that thought.

How does this view of consciousness as a single indivisible thing affect you as an artist?

If consciousness really is a single thing recurring in each one of us, quite clearly it is developed more adventurously in some than in others. Perhaps that's why I've been drawn to paint great artists. Art has its own way of thought, and maybe as a painter I can grasp the image of the artist better than that of other thinkers.

And presumably your plurality of heads are different aspects of the same one thing. What might that be?

Yes, I suppose I am inclined to see these heads of utterly different people as being fundamentally related – each one an aspect of a whole. But would you not say that each one of us was a part of the same one thing, whether you call that thing humanity or consciousness or the 'formless, all-pervading something' of Lao Tsu or one of the various religious interpretations of that thing?

And your view of consciousness in regard to yourself?

Well, for long time, I've felt that my own awareness is not *entirely* me, that it is somehow wider and deeper than that. After all, like the rest of us, I'm descended from pre-history. My legs are not wholly *my* legs. They are, so to speak, palaeolithic legs on loan for a lifetime.

———

In 1975, you started with WB Yeats in this series of images. How did you move into Yeats? What was the stimulus?

What set me off painting these multiple images of Yeats was the Galerie Börjeson in Malmö, which was intent on making a portfolio of prints in homage to Nobel prizewinners. As I remember, there were some thirty nations which had gained one or more prizes. Representative artists were accordingly selected to make a print paying tribute to their national prizewinners. Karel Appel represented The Netherlands, Miró, I remember, Spain, and so forth. I happened to represent Ireland. From among the several Irish Nobel prizewinners at that date – Beckett had not yet received his award – I chose Yeats as my subject because I thought him to be the most meaningful, and because I had known him when I was a boy. I made a number of studies for my final aquatint, and was struck by their diversity. It was then I realised that a portrait can no longer be the stable, pillared entity of Renaissance vision – that the portrait in our time can have no visual finality. I went on with these images, making over a hundred studies of Yeats in charcoal, watercolour and oil. They were shown in the Musée de l'Art Moderne de la Ville de Paris in 1976, and I remember the critic from *Le Monde* came to the show and said, 'How can you say all these are Yeats? They all of them appear to be very different, one from the other, and some of them barely resemble him.'

And how did you respond?

I replied that I had asked myself the same question, recognising as I did Theodore Roosevelt in one study and Marlon Brando in another. All I could say to him was that I had invariably *aimed* at Yeats; that the only constant thing in all this was the aim. On the other hand, Anne Yeats wrote in the *Quotidien de Paris* that these images vividly recalled her father as she remem-

bered him. I would like to think that, beyond photographic likeness, Anne had perhaps perceived a deeper Yeatsness with which she had been familiar.

In painting Yeats, were you at all influenced by the poet's own theory of the Mask as an expression of anti-self, of the other?

Inevitably. Yeats' concept of the Mask, as it occurs in A *Vision* and recurrently in the poetry, has a lot to do with his image. Yeats' Mask, his alter ego, was certainly in my own head in making these ambivalent studies of him.

Talking of masks, you have a bronze death mask of James Joyce in your studio. Does Joyce have any particular relevance to you? I sense that he was a seminal influence.

I have no expert insight into Joyce any more than I do in regard to Yeats, but his works, his life, his being, have become progressively important to me. Possibly more so because of that aspect of him which is peculiarly Celtic, not in any nationalist interpretation, but in a profound sense, implying a circular rather than linear way of thought.

The image of Samuel Beckett also seems to have meant much to you in your work.

Yes, even more perhaps than the images of Yeats or Joyce, to which I return again and again. Maybe the courage and the tenacity, the rigour and irony and the humanity in his work were brought home to me more acutely because of knowing him as I did.

You've also painted Shakespeare. There is no reliable likeness to Shakespeare. Did this hinder you at all?

At my first exhibition at the Galerie Jeanne Bucher in 1979, Jean-François Jaeger suggested Shakespeare to me. Initially I resisted, and then, on reflection, entered upon a series of oils and watercolours out of sheer curiosity to see what might emerge. Was this presumptuous? I don't know. I do remember John Russell in the *New York Times* using the word 'hubris' in an otherwise favourable review of the work. To me, these *Studies towards an Image of William Shakespeare* were essentially a game of the imagination. In point of fact, little could be derived from the only two authentic images of Shakespeare. The first is an extremely bad etching of him by some contemporary whose name I forget. The other, a posthumous wood carving, was originally painted, then whitewashed, repainted and superpainted as the years went by. Neither one has the slightest resemblance to the other, nor holds within it nor hints at the presence of this greatest of English writers who belongs to the world.

You paint very few heads of women, apart from a number of studies of your wife Anne. Why is this?

I do find I have difficulty in painting a woman's head. A woman is perhaps more vulnerable to distortion. True, I have often painted Anne, but my mental image of her beauty does tend to interfere with formal discovery in painting.

Do you prefer to avoid the more emotional or sensual associations connected with the female face?

I'd say my own emotional and sensual feelings towards a woman's image remain pretty much as they were when I was painting the earlier 'presences' – mostly female bodies – in which the sensual aspect is evident enough. It certainly seemed so to Herbert Read. I remember in his *Letter to a Young Painter*, he felt that 'the eroticism is intense' but that 'the full force of the erotic imagery is only revealed to quiet contemplation'. The heads, though, are another story. Whether they're female or male, their erotic associations are perhaps less direct, being isolated outside the context of their bodies.

Is art exclusively about 'formal discovery' then? What place do you attribute in your view of things to the traditional notion of 'beauty', that 'joy for ever'?

Formal discovery is certainly central to the art of painting. It is necessarily derived from a sense of meaning. Meaning – like wonder – is not easy to formulate. But without the thrust of meaning, pictorial form remains flaccid or decorative. Beauty in painting is similarly linked, I would say. Without meaning, beauty risks becoming insignificant prettiness. Beauty is also meaning.

In many of the earlier 'presences' and in some of the recent heads, there is what appears to be the depiction of centres of energy, something resembling chakras. Is this part of your intent?

I think that they can be regarded a bit like that. They could be interpreted as chakras conveniently because they are not manifestations of material entities. To my mind, they represent feeling – half physiologic, half sensory.

Your painting has been referred to as a form of discovery or recovery... the recovery of something lost. You seem to have a fascination for things lost, or at least absent, rather like Heaney's obsession with the Bog People, the Tollund Man. In the poem 'Strange Fruit', he refers to a girl's head. These are the opening and closing lines:

> Here is the girl's head like an exhumed gourd.
> Oval-faced, prune-skinned, prune-stones for teeth.
> They unswaddled the wet fern of her hair...
> ...nameless, terrible,
> Beheaded girl, outstaring axe
> And beatification, outstaring
> What had begun to look like reverence.

In this view of the head, there is an element of terror, of 'terrible beauty'. It is also very present in your work as I see it. Would you like to comment?

A good many years ago, in the mid-seventies, I think, I attended an exhibition in Belfast. Coming back on the train, I went along the carriages to find myself a glass of beer and who should I stumble across but Seamus Heaney. I hardly knew him at the time, but we spent the rest of the journey together. Curiously enough, we had, both of us, just read PV Glob's *Bog People*. Each of us was haunted by the Tollund Man, the Windeby Girl, and others sacrificed in an Iron Age bog that had preserved them perfectly to the inclination of an eyelid. Yes, I'm afraid that 'terrible' aspect may well be reflected in my work.

So you see an affinity between this cult of the Bog People and your own uncovering or rediscovery of the heads?

One of the reasons I was so interested in these Bog People was that they, like the Polynesian heads, incorporated and appeared to preserve human presence. Their faces, twisted by the slap of bog-weight, seemed to imply further unlooked-for emotion, a quiet timeless emotion, freeing them even from the terrible circumstances of their death.

You speak somewhere of your work not being a form of self-expression. And, indeed, your work is in many ways extremely impersonal. The faces contain a singular lack of emotion. The eyes, when present, are often stark and staring.

I am conscious that some of these head images may appear impersonal in their isolation. They may even be distressing. But, you know, when I painted Federico García Lorca, I feared his fate, just as he did. My aim was to lift the image out of the context of humour and ordinary social intercourse, to place it outside time and circumstance.

In a sense, these are intimations of immortality.

They might be described as instances of the *idea* of immortality. The idea is contained in a metaphysical attitude of mind. It is perfectly reasonable to say that, since our reality takes place in time, we may take it that what has happened is not real; it *was* real. Yet are we to believe that all that is real now, at this moment, will become unreal? That is a metaphysical question. As I try to paint an image of a person – be he alive or dead – he remains part of a continuum, and that continuum is something that forms a whole, as I see it. It forms a kind of reality which I cannot believe is ever wholly wiped out. In any case, the area in which I'm trying to paint is to do with conditions beyond that consideration of wiping out. It's an area in which the sponge of time is no longer operative.

Very recently, you've been experimenting with a new series of paintings you have entitled Human Images, *evoking more or less explicitly various orifices or apertures in the human body – the mouth, the ear, the navel, and so on. What led you to launch into this new theme?*

I remember the Polish painter Jankel Adler telling me that 'Inspiration, when it comes, comes to the easel, not to the bed-side.' That's how it was with him, and, for that matter, that's how it was with me. Yet, curiously enough, this idea did come to me at night, literally out of the dark. What I saw, what I became aware of, was a pictorial surface, holed or slit, implying an entrance from what is physical and exterior into the intangible human reality within.

This new series is clearly related to your earlier pieces. Yet the treatment in some of the less explicitly 'human' apertures verges on abstraction, embracing a kind of minimalist concern. Do you see these pieces as a new departure or as a further experiment in your lifelong navigatio into spirit?

All significant images, I imagine, emerge from past experience, even those with future meaning for us. Yes, I do recognise the recurrence of those 'presences' of the fifties, *and* the open mouths of the *Ancestral Heads* series. Indeed, in those earlier works, the open mouth might already be seen as an opening within a surface. You are right too to suggest that, in these very recent works,

such a mouth isolated on the canvas and freed from the context of the face, is apt to appear abstract, an abstract hole within the surface of a minimalist painting. But this is not my purpose.

You have entitled these paintings Human Images, *and yet many bear only the remotest connection to the human form as such. The very spareness of their treatment suggests you are moving away from the human into a more quintessential metaphysical dimension. I know how firmly you have always asserted your concern with the 'human', at least in the more immediate sense. So have I got it wrong?*

For some forty years now, I've been trying in one way or another to evoke some kind of sign to illuminate that invisible reality we call consciousness. Human appearance is clearly relevant to all this, but it is not central. And as you move further towards this intangible centre, both familiar and mysterious, perhaps you do tend to lean inevitably towards the metaphysical, as you suggest. But the quest remains the same.

These paintings are intensely concerned with the painterly quality of the pigment itself, with what happens on the canvas. It has been said of them that the surface has now become the presence. Is this relevant to the way you have been working here?

Yes, it is. For a long time I've been working my way towards this very thing. In 1961, Robert Melville quoted me as saying that I was 'striving to produce a substantial identity of surface and image'. Maybe this is at last occurring.

These pieces are remarkable as ambivalent events. They create that sense of awe and excitement I mentioned earlier, the terror of something beyond, and yet they are also moments of beginning, almost the first ripple or flow in the cosmic soup, at it were, as the primordial chaos forms the first mouth, the first word.

It's rather extraordinary that you should refer here to 'cosmic soup' and such-like primordial things. In order to activate, to *energise* the surface of these paintings, I found myself applying successive coloured layers of very diluted paint on prepared canvas. It so happened that the resultant texturing produces a surface of grains or particle – 'primordial' particles, if you like – which might be seen to coagulate into a scant human image, to emerge and to open.

There seems to be an element of violence in these pieces. Many of them suggest a gash or puncture in the canvas.

I suppose there is violence in all of us, and all of us are outraged by violence every day of our lives. You could well interpret my image of an open mouth, isolated at the centre of a canvas, as a cry, or a scream, or an expression of outrage. Look about you. It *is* all that! But it may be seen, too, as a way within.

Those paintings also conjure up a haunting depth, what Heaney called a 'door into the dark'. Already the heads seemed to hover back and forth between the world of appearances and the reality behind the canvas. Here you have opened up the canvas directly to the space beyond it, a space of mystery and awe beckoning through and yet already seeping out. I'm tempted to ask you rather naïvely, 'What is there on the other side?'

Yes, for me, the open mouth, the slit of a closed mouth, the deep dent of the navel, the eye, the ear are seen primarily as selective openings within the body's opacity – entrances into darkness or into that which is not visible, the reality of the interior being, the 'other side', as you call it. You ask me what is on the 'other side'. Do you remember a famous photograph by my old friend Henri Cartier-Bresson? In it a man is seen peeping through a hole in the canvas barrier surrounding a seemingly provincial bull ring. Here I find myself in the same position as the photographer (who, incidentally, is also a painter). Unlike the man looking *through* the hole, consciously witnessing the life-drama on the other side, Cartier-Bresson perceives only the hole in the canvas, beyond which he believes a dramatic experience to exist in the consciousness of the peeping man. I presume it was this exciting belief which caused the photographer to take the photograph, motivated by the *meaning* of a hole in a canvas barrier in relation to the conscious experience hidden on the other side. I'm inclined to regard the 'holes' in my canvasses in much the same way.

Louis, we are coming to the end. Do you have any last word?

That is something I'd have to think about. Nothing specific...

How would you like to be remembered?

I once said to myself – a very long time ago when I was starting to paint, when I was trying to develop the ability to paint – that I would be very happy if I could reach the status of or be considered to be a good painter. Well, now and again along the way, I have been moved while painting and *by* painting to believe that I may have been granted something more, making it possible for me to reach a little into the meaning of life.

Notes

1 'Thoughts on our Time and Jean Lurçat', Louis le Brocquy, *Ark 17* (Royal College of Art, London, 1956)
2 *What is Life?*, a series of lectures on genetics given by Professor Erwin Schrödinger at Trinity College, Dublin

George Morgan is Senior Lecturer in English Literature at the University of Nice, France, specialising in Celtic literature in English and is the author of numerous studies on Irish and Welsh poetry. He is also a poet and translator of poetry.

Interview with Louis le Brocquy

MICHAEL PEPPIATT, 1979

The 'interview' below is a distillation from notes and memory of several hours' conversation that took place at various times in the studio where both le Brocquy and Anne Madden paint. On one occasion, six new but not fully finished heads of Beckett stared down in a semi-circle from their easels; on another, six new heads of Bacon. During the talks, their aura of grimness and terribilità faded, and something more vulnerable, more human, emerged. Further off, on the wall, James Joyce's death mask, its expression entirely inward-turned under the bronze's faint smile, presided over everything. Under this scrutiny, and in the shifting, probing talk, there came the uneasy sensation that all was appearance, all surface alone – with the painted heads and the living, talking heads two layers of the illusion to be stripped away.

———

Michael Peppiatt – Over the past five years you have painted literally hundreds of heads of Yeats, Joyce and Lorca. You're beginning now on Beckett and Bacon. Where does this fascination with heads, heads alone, come from?

Louis le Brocquy – Well, you know, it came after I'd gone through a very bad year, a blind year, as it were, when no image emerged and I got completely bogged down. That was in 1963, and for the previous six or seven years I had been working on a series of figures, or what I think of as 'presences', on a white ground. Suddenly nothing of any value seemed to come any more, and at the end of that year I destroyed forty-three bad paintings. By then I was in a bad way myself, of course, and my wife suggested we should go up to Paris as if we were going somewhere quite new where there'd be things to discover. And in fact I made what, for me, was a vital discovery, by coming into contact with those Melanesian Polynesian images they have at the Musée de l'Homme. They're skulls, you know, partly remodelled with clay, then painted in a typical, decorative way – often with cowrie shells for eyes. They impressed me deeply, and shortly afterwards I started painting heads, disembodied heads, if you like, or rather heads in complete isolation. Then a bit later, in 1965, I came across another head cult. – near Aix-en-Provence, at Entremont and Roquepertuse – this time of Celtic, or what they call Celto-Ligurian origin. And it acted

as a confirmatory revelation for me of the image of the head as a kind of magic box that holds the spirit prisoner.

We're talking now of sculptured heads, I imagine.

Oh yes. You can see what's left of them in the museums in Aix and Marseilles. Very little remains of the Celtic culture there, you know. The Romans systematically obliterated it, destroying both the principal oppidum and the holy place: Entremont and Roquepertuse. Of course, the Celts had some very unpleasant practices themselves, such as cutting off the heads of enemies conquered in battle and wearing them on their belts.

Like the Scyths…

Yes. You know, it's struck me that the Celts must in fact be derived in some way from the Scyths. Their arts are distinctly related. The Celtic culture, as I was saying, was destroyed by the Romans: the Druids were driven into the woods and hunted down. But in Ireland this culture – this Celtic way of seeing things – survived. Christianity merely modified it. When Edmund Spenser, the Elizabethan poet, was posted there, he was touched by the poverty – people collapsing from hunger in front of his eyes, and so on – but he didn't understand them; in fact he hardly thought of them as human beings at all. He was a Renaissance man and they were Celts, the ancestors of the mind of Joyce. And this sensitive poet recommended that the Irish be wiped out – quite literally – as they would never become what he called 'civil'. Of course they probably did strike other people as barbarous, just as their Gallic cousins had struck the Romans. The Gauls used to preserve the heads of notable persons in their sanctuaries, you see. Well, you can imagine what Greek and Roman travellers must have felt when the Celto-Ligurians did them the honours, including a good look at one of their precious pickled heads!

I was wondering whether you'd thought of your painting as related to them in any way.

I don't exactly feel I'm participating in an Irish head cult! But I do derive from it in a sense. Like the Celts, I tend to

regard the head as this magic box containing the spirit. Enter that box, enter behind the billowing curtain of the face, and you have the whole landscape of the spirit. And the face itself, this undeniable outer husk of reality, does express the spirit to a certain extent. That is what fascinates me, because I'm fascinated by appearances and what they reveal, the way expressions change from instant to instant in some people because of the vitality rising within them and transforming them the whole time. So that the head, for me at least, is a paradox, both hiding or masking the spirit and revealing or incarnating it.

But what lead you to Yeats and Joyce and the others, specifically? Was it admiration for their work?

I'm drawn to their work, yes, certainly, and in each case, before beginning to paint, I have tried to steep myself as deeply as possible in it. On the other hand, I don't think of them so much as famous or brilliant men but as vulnerable, especially poignant human beings who have gone further than the rest of us and for that reason are more isolated and moving. Above all, I was drawn to the journey they had made through life and the wide world of their vision.

I believe you knew Yeats.

Only in the way a child 'knows' a schoolmaster or some other lofty figure. My mother knew his family, so I was quite familiar with him – and with his very impressive manner! Yeats is a wonderful example of how appearance changes, and in those images – you see, I think of them as traces, images rather than portraits – I allowed very differing aspects of his appearance full rein. I would say than, now photography has shown us how multi-faceted human appearance is, it would be futile and pretentious to try to capture a great man in a single 'portrait'. Anyhow, in those series of flickering images I did of Yeats,[1] I hoped to catch something of the many-sidedness of that extraordinary Irishman, and so, perhaps, touch the landscape behind 'those ancient glittering eyes'. Occasionally I even played a game of conjuring him up, as one might do in a seance of spiritualism!

Did a similar sensation ever come when you were working on Joyce?

I often felt it was impertinent on my part to play with appearances of these men. With Joyce, I confess I felt over-awed, even quite literally afraid. His is the most evocative and painful head I have ever attempted. I was extremely conscious of all he must have suffered – the humiliations and neglect, the physical suffering and poverty. And, of course, I was also thinking constantly of the extraordinary adventure that had taken place in that head. Because he really did push the boat out, didn't he, sailing into realms that very few people dare to enter. I mean, I think these men, Joyce and Yeats, were real heroes, heroes of courage,

Promethean. And the tensions became so acute while I was working on Joyce that on one occasion I felt I couldn't go on, I simply couldn't go back and face that head – rather like the Douanier Rousseau who didn't dare go back to his studio to face the fearful lion he had painted!

You did something like one hundred and twenty studies of Joyce.[2]

Yes, if you count all the watercolours and charcoal drawing well as the oils. And in a sense I could have kept on indefinitely, because I never felt there was anything definite or conclusive about them. I think Joyce's own work was rather like that, cyclic rather than linear, ending as it began, a circle to be entered at any time, at any point. It was the product of a remarkable mind, a counter-Renaissance mind, in a sense, and perhaps comparable in its minute patience, in its constant circularity, to the interlacings of the Book of Kells. And then you have the extra ordinary plasticity of the head itself, with the great balanced sculptural gestures of the forehead and the chin thrusting forward and the nose taking place in the sweeping hollow between the two. A head like a sickle moon.

You steep yourself in the works and lives of the people you paint, but you also collect photographs of them. What importance do the photos have?

They provide, as it were, objective evidence, even when they're considered 'bad' photographs because they don't correspond the conventional image of whoever it is. I'm interested in making images that are as objective as possible. Naturally, I realise whatever one does has to be to some degree subjective because it is necessarily reflected from some part of one's mind. In this sense, the surface of the canvas becomes a kind of mirror, and in painting others, one is, at least partly, painting oneself. Nevertheless, I am interested above all in the *other*, in the other being. I often think how utterly fascinating it would be to get into somebody else's head, even a cat's head, for a few minutes. I mean, I'm sure we all see each other quite differently. If I were able to get into your head when you were looking at Anne, for instance, I'm certain I'd think, 'No, no, that's not Anne, Anne's not like that at all!'

How do you actually use the photos when you're painting?

Often I don't refer to them at all, but if I do, I tend to have two or more of them beside me at the same time. These photos tend to give a very differing impression of the person in question, and I make no attempt to relate them. In this way I hope to uncover, as it were, different sides and layers of the person in the image I am trying to form. And then photos are also useful reminders of how completely changing a face can be, and they help me avoid, or at least be more conscious of, the trap of verisimilitude. I tend to work in series, too, you know – with three images going at the same time, and that also helps to break the merely personal

or conventional visual idea one carries around of the other person.

You could have gone on doing images of Joyce indefinitely. What made you change to another subject, in fact?

I could have gone on with Joyce alone, you're quite right. But I also welcome the challenge of a new personality, so to speak. I like to think that I might get a leg into another, quite new country, and the change also makes one more aware of the sterile formulas one tends to fall into after a while. You know the way Yeats' nose is broad at the bridge, then suddenly tapers in such a remarkable fashion? Well, once you latch on to such formulas you begin to have a recognisable image of Yeats at your finger-tips – and it turns into a trap, an invitation to mere dexterity. The same thing happens with Francis Bacon if you fix on the unusual width of his jawline. Dexterity is not, as you can imagine, what I'm looking for. I've been reproached for having too much of it, too much technical skill. Well, by a curious mishap, this has now been disproved. About two years ago I injured my right hand; after a bone graft, it had to stay put, in plaster, for several months. For the first time in my life, I began to paint with my left hand, and the images which formed beneath it were indistinguishable from the others: neither better nor worse. And now, although my right hand functions as before, I sometimes still paint with the left to encourage the unexpected or accidental means by which an image may emerge.

How would you explain an 'accident' in that context?

Accident is extremely important to me. I believe that my role as an artist, in so far as it exists, lies in the recognition of significant marks as they occur. And these are what I retain and expand, and from which I hope an image will emerge. To me painting is not a means of communication or even self-expression, but rather a process of discovering, or uncovering. I think of the painter as a kind of archaeologist, an archaeologist of the spirit, patiently disturbing the surface of things until he makes a discovery which will enable him to take his search further.

How do these significant marks tend to occur? How do you actually begin a new image?

With an oil, I usually make a very rough sketch in charcoal first. Then I take the brush, tip it with a little blue, say, on one side and a little Indian red on the other and I make these free gestures round the area of the eyebrow or the chin or wherever. And sometimes the suggestion of an image – a kind of objet trouvé, if you like – begins to emerge. Sometimes not. But those gestures almost always turn out to be significant if one is attentive to their possibilities. They seem to have a queer logic of their own. In my case, all I can say is that there has to be an element of accident, or discovery, or surprise all the way along, so that the emergent

image is not so much made by me as imposing itself on me, accident by accident, with its own autonomous life. Otherwise, I don't think it has any value.

Can you be more specific about how this process tends to evolve?

Well, what occurs, I think, is this. Successive marks made by a brush dipped in this and that pigment, almost at random, build up a kind of scribbled structure of colour in and out of the features of the image which is gradually forming. Then this free structure usually suggests the areas where white pigment may be heavily brushed on to form the outer planes of the image. but each plane and each coloured mark, whether sharp in contour or melting, has to have its autonomy, its independence, if you like, of any merely descriptive role. And these marks have to coexist independently within the various depths of the landscape of the head-image. They have to be allowed, as it were, to float within it.

But with this emphasis on free gesture and accident, don't you ever find yourself in a hopeless mess, having to scrape everything off and start again?

Certainly. But that happens less now than it used to. A great deal of the technical difficulty in these paintings comes from the fact that they are heads in utter isolation – without any particular circumstances, such as a collar and tie, or a recognisable background. Now the difficult thing in my view is to make this isolated head so that it doesn't look like a mere sketch, which it isn't, nor like some kind of decapitation. The image has to emerge from some plausible matrix, beyond habitual circumstance or environment, as if outside time. You may have noticed that there are no circumstantial details in the images – barely even any hair, which I consider circumstantial, since it can be long or short, or indicative of a young or old man, and these are comments which I wish to avoid.

I was going to ask you about the origin of the white background. It seems to be almost a traditional feature of you painting.

Yes, well, I first used a white background in 1956 when I was doing a series of torsos or what I called 'presences'. I'd been in Spain that year and was tremendously struck by the way shadow there looked more real than the substance it was cast by. All substance seemed penetrated and eaten up by this brilliance, so I came to see everything as existing in a matrix of pure white light. Then, later, I has the idea of conjuring up images out of nothing, out of light, out of depths of the blank canvas, as it were.

Do your reactions change at all when you paint images of living people?

I think the big difference is that with the dead you have the whole life laid out on a plane: youth and age become con-

temporaneous. The living, on the other hand, are still in time, moving and changing. And then, of course, with the living there's always the potential embarrassment that they"ll turn up again and confound all the images one has evolved of them!

Has the fact of knowing Beckett and Bacon, of having watched their flesh-and-blood appearance, made any difference?

It's an advantage, but it's also an inhibiting thing. I mean, you may feel it to be an impertinence to be playing with their appearance in this way – and also a distortion to place them outside time, as it were, in the matrix I referred to. Particularly since people believe – it's a reaction I've often come across during exhibitions – that in some way you're making a 'statement' about the person you've painted. I'm not making a statement at all, you know. I'm simply trying to discover, to uncover, aspects of the Beckettness of Beckett, the Baconness of Bacon. But it's also true that once you know people a little in the flesh, those memories of them stay with you. That curiously piercing look that Beckett has comes back to me even from photos where he doesn't have it.

Do you ever think of painting people who are constantly close to you, members of the family or old friends?

Oh but I do. At one point I painted a number of portraits of my mother and father. I've painted my children, and I have made more studies of Anne than of any other human being. But essentially all studies of people pose the same problems.

What fascinates me is their otherness, and this is what I hope to realise in a painting. With Anne especially, I suppose, it's a kind of fetishism: I attempt to realise her being in paint. I don't want to sound esoteric, but you might say I try to enact a magic process within the limitations of my art and so, hopefully, come up with an image that has a life of its own. Nothing more.

You have referred in the past to certain mystical attitudes and also to spiritualism. Does this imply any particular beliefs on your part?

I have no defined religious views. I'm what you might call a good agnostic, who tries to keep his window on to reality as widely open as possible. I was tremendously struck, you know, by something Schrödinger, the physicist, said to me as a student almost forty years ago in Dublin. It was to the effect that matter could not be destroyed – modified beyond all recognition, perhaps, transformed into energy, for example – but never destroyed. Schrödinger also believed that the spirit, or consciousness, was indestructible, too. I must say I remain impressed by that thought... And then, when you think of the universe with its countless galaxies, each with its countless stars, when you think of the infinite possibilities and compare them to our limited perception, it seems impossible to hold any dogmatic belief. I think of us as inhabiting a tiny corner of reality, perceiving what we can, rather like lobsters in a pool, you know, with their sensitive antennae waving this way and that. But what can they really tell, down there in the water, about land or cities or the everlasting night of the stars?

Notes

This interview was first published by *Art International* (Lugano) in 1979.

1 Exhibited at the Musée d'Art Moderne de la Ville, Paris, under the title *A la recherche de WB Yeats – Cent portraits imaginaires*, in October-November 1976.

2 *Studies towards an Image of James Joyce.* Travelling exhibition (1977-78) shown in Genoa (S Marco dei Giustiniani), Zurich (Gimpel & Hanover), London (Gimpel Fils), Belfast (Arts Council Gallery), Dublin (Hugh Lane Municipal Gallery), New York (Gimpel & Weitzenhoffer), Montreal (Waddington), Toronto (Waddington).

List of Illustrations

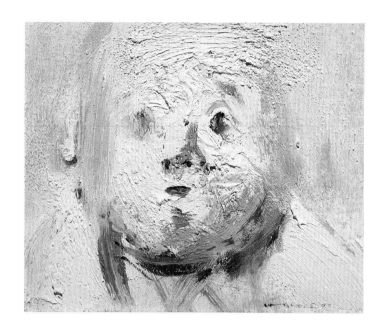

CAROLINE, 1956
oil on canvas, 13 x 15 cm

This portrait of a Downes Syndrome child
is one of a number of works which anticipate the series of Head Images
which dates from 1964 onwards

ANCESTRAL HEAD, 1964
oil on canvas, 41 x 33 cm (140)

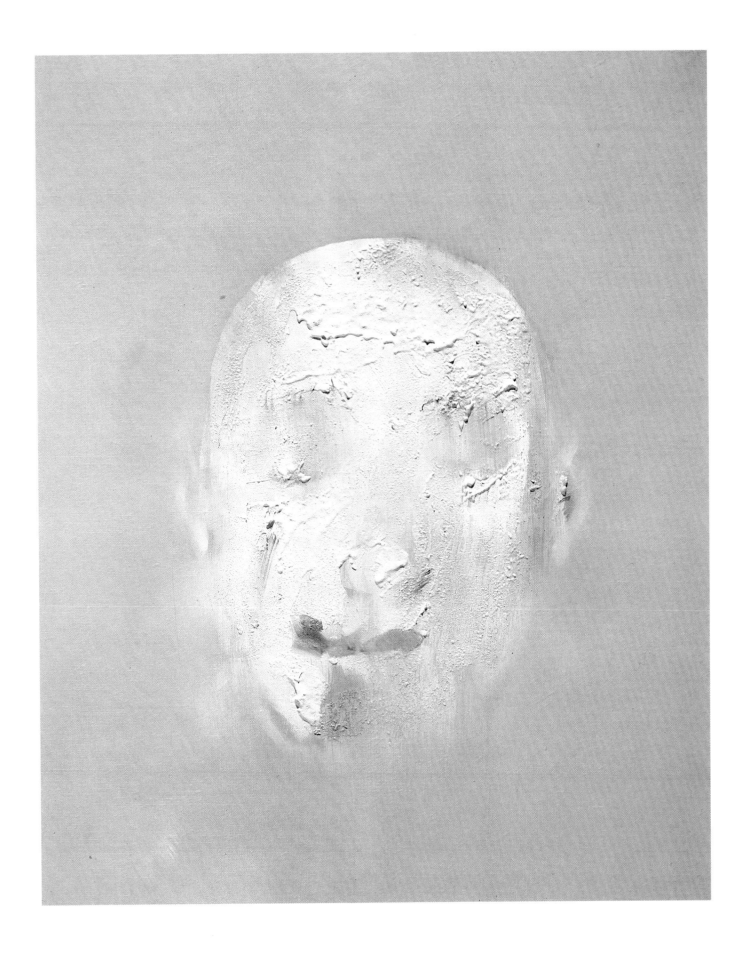

RECONSTRUCTED HEAD OF WOLFE TONE, 1964
oil on canvas, 65 x 54 cm (151)

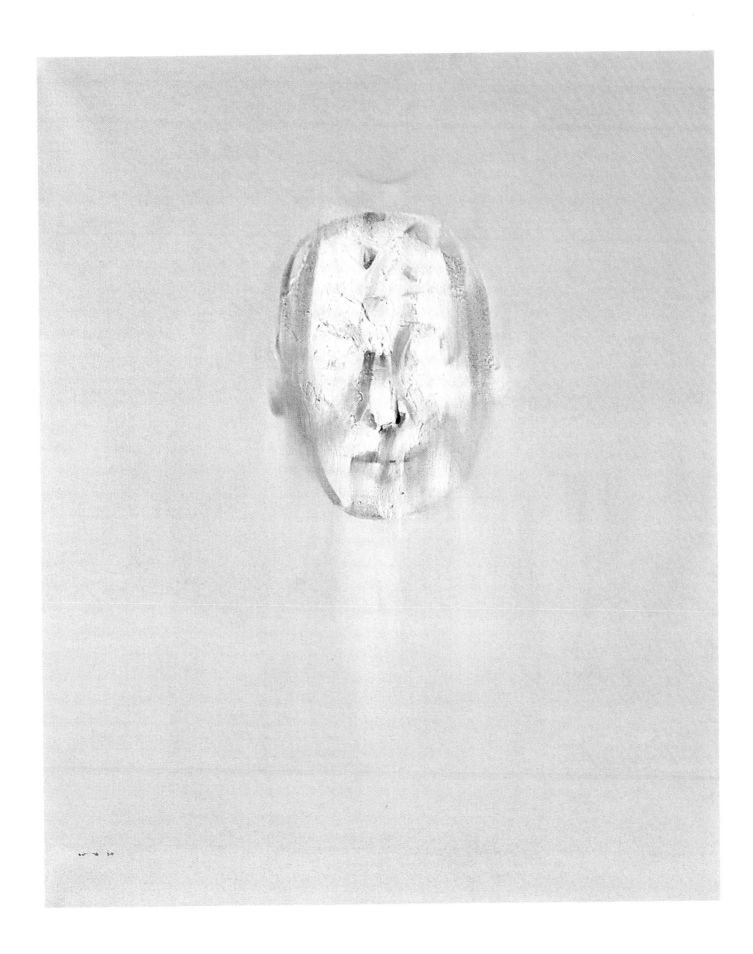

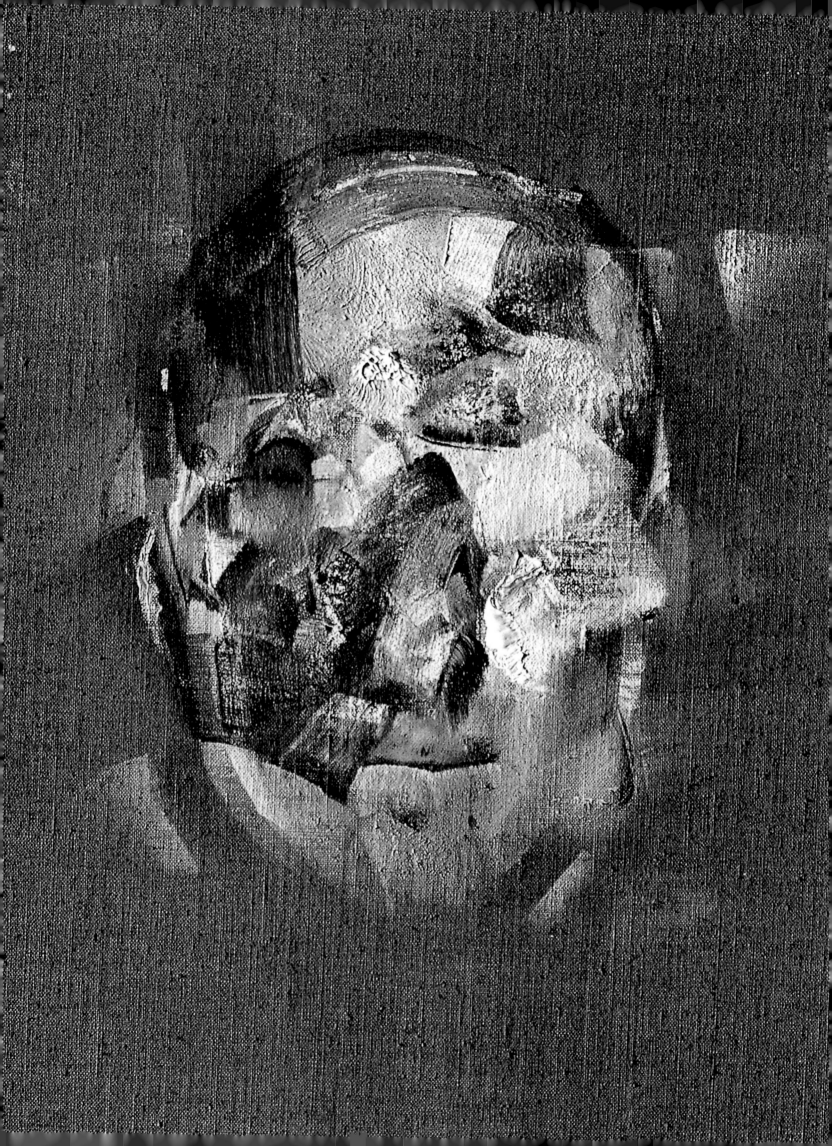

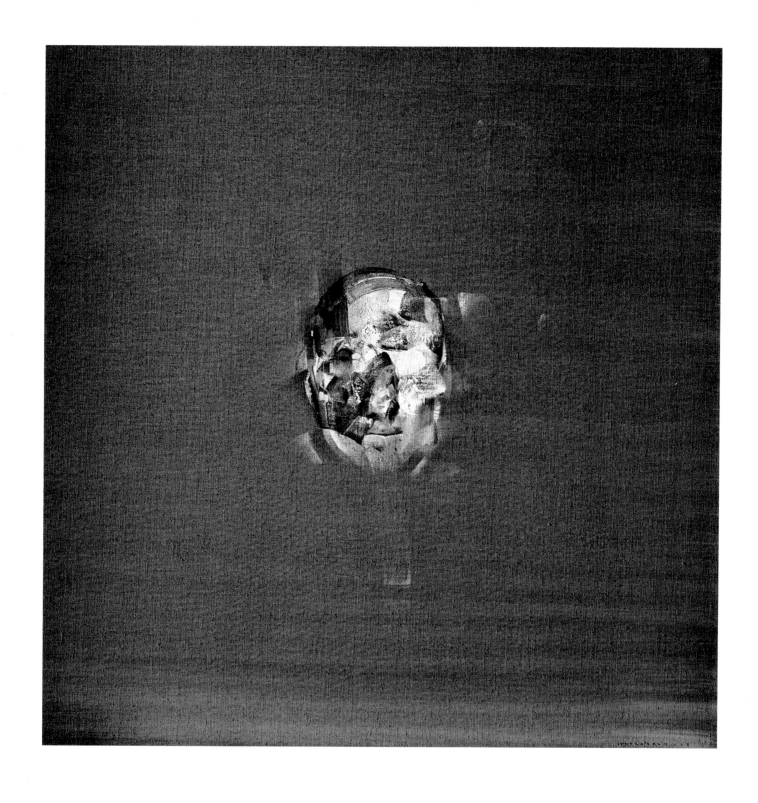

RECONSTRUCTED HEAD OF A MAN, 1968
oil on canvas, 73 x 73 cm (210)

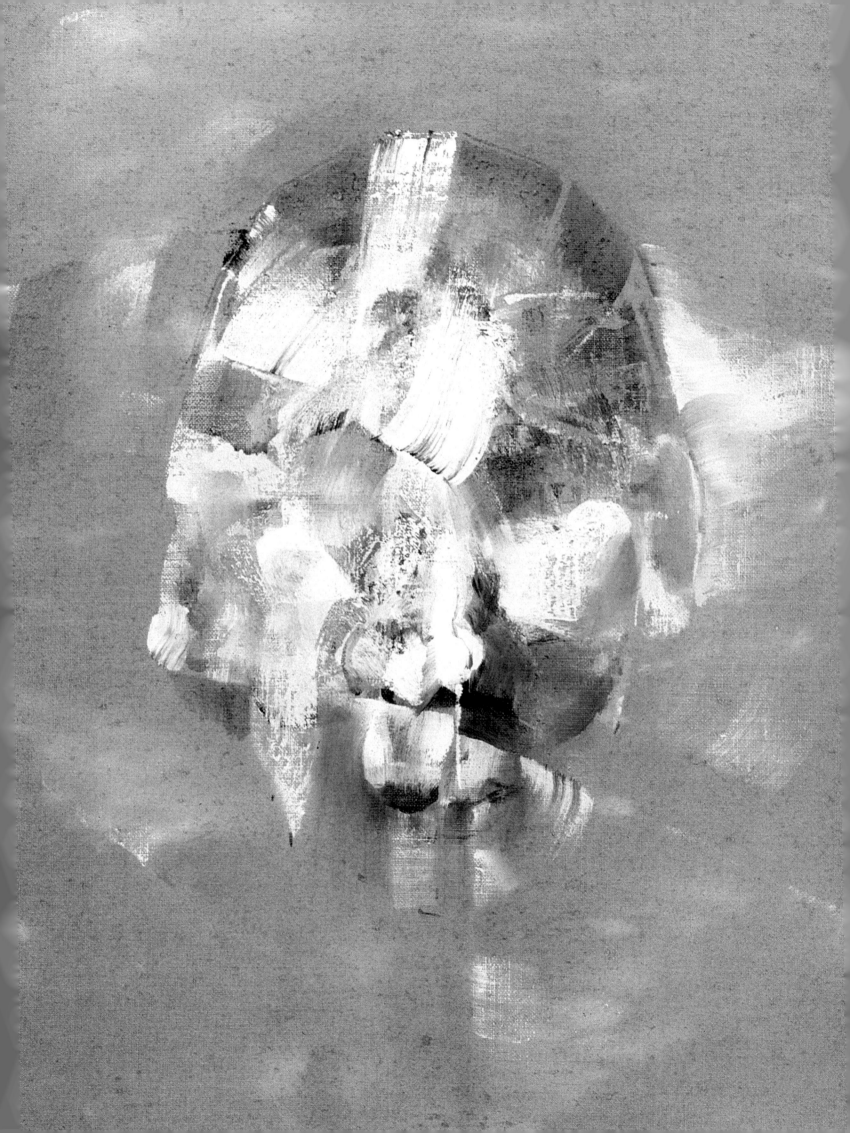

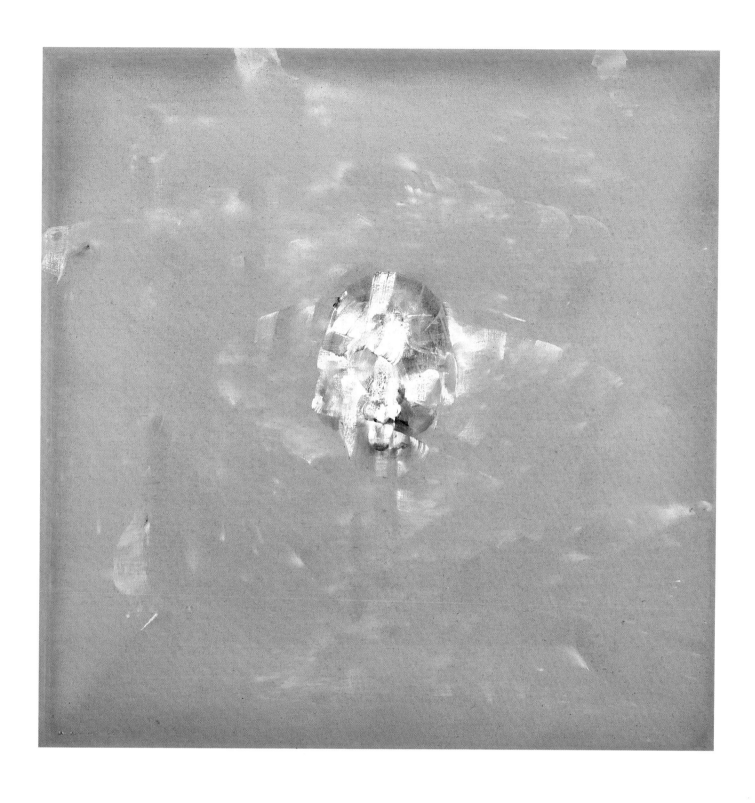

RECONSTRUCTED HEAD OF A MAN, 1968
oil on canvas, 73 x 73 cm (214)

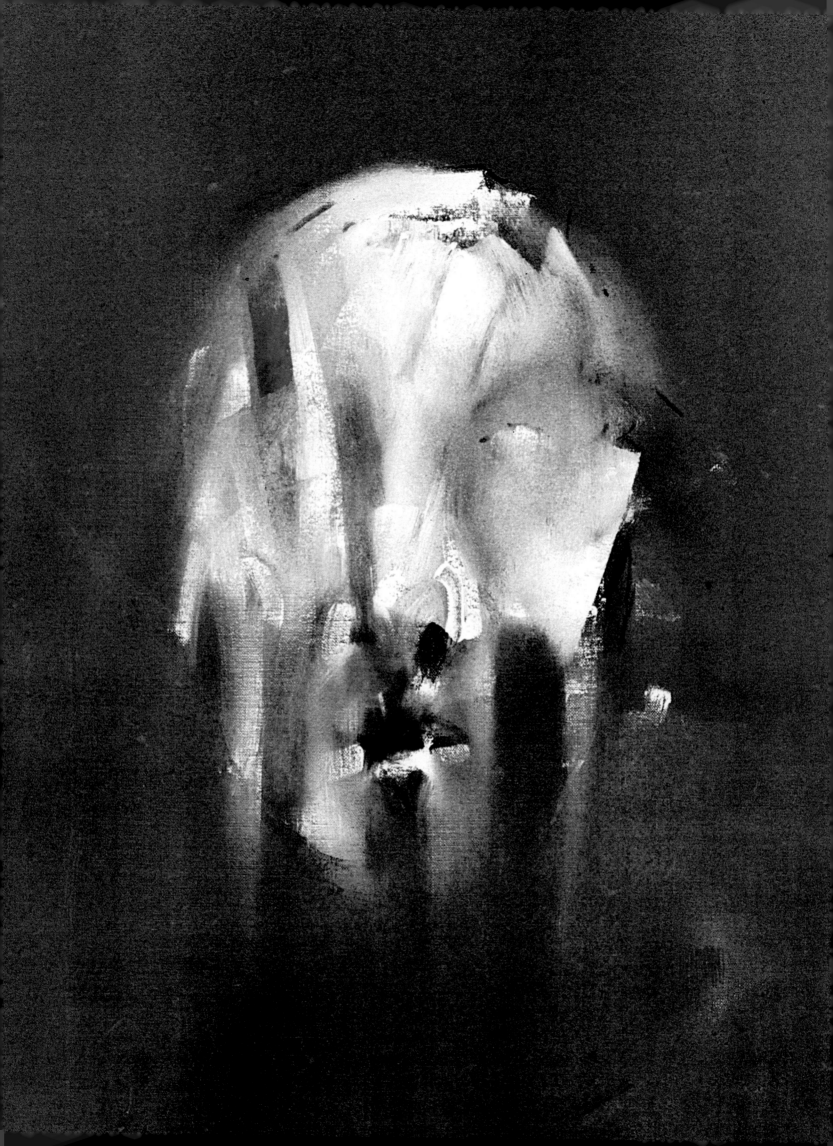

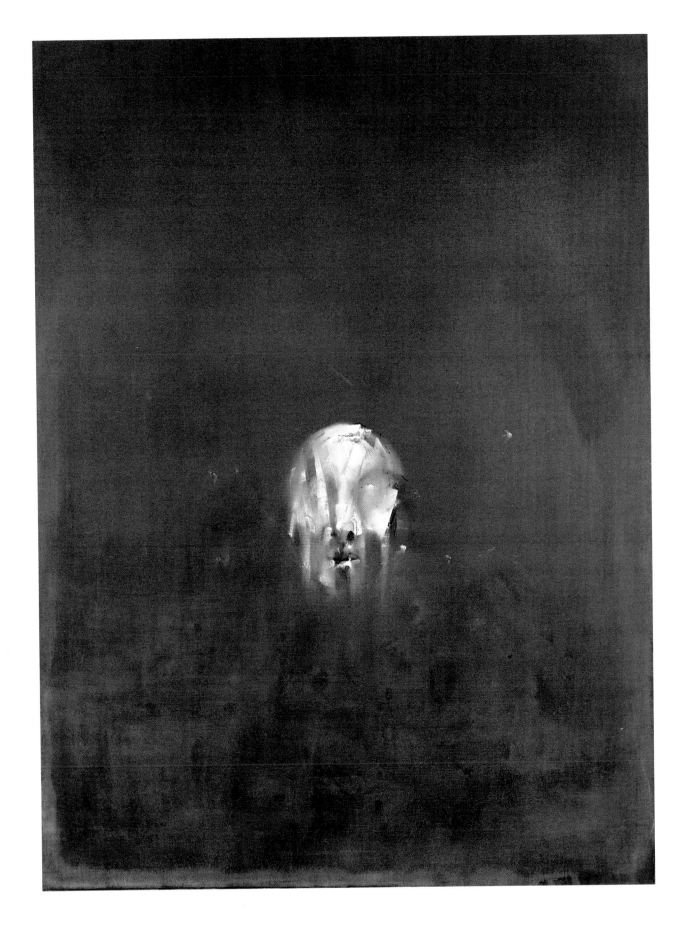

RECONSTRUCTED HEAD OF AN IRISH MARTYR, 1967
oil on canvas, 130 x 91 cm (180)

HEAD OF A BOY, 1970
oil on linen mounted on board, 40 x 33 cm (249 bis)

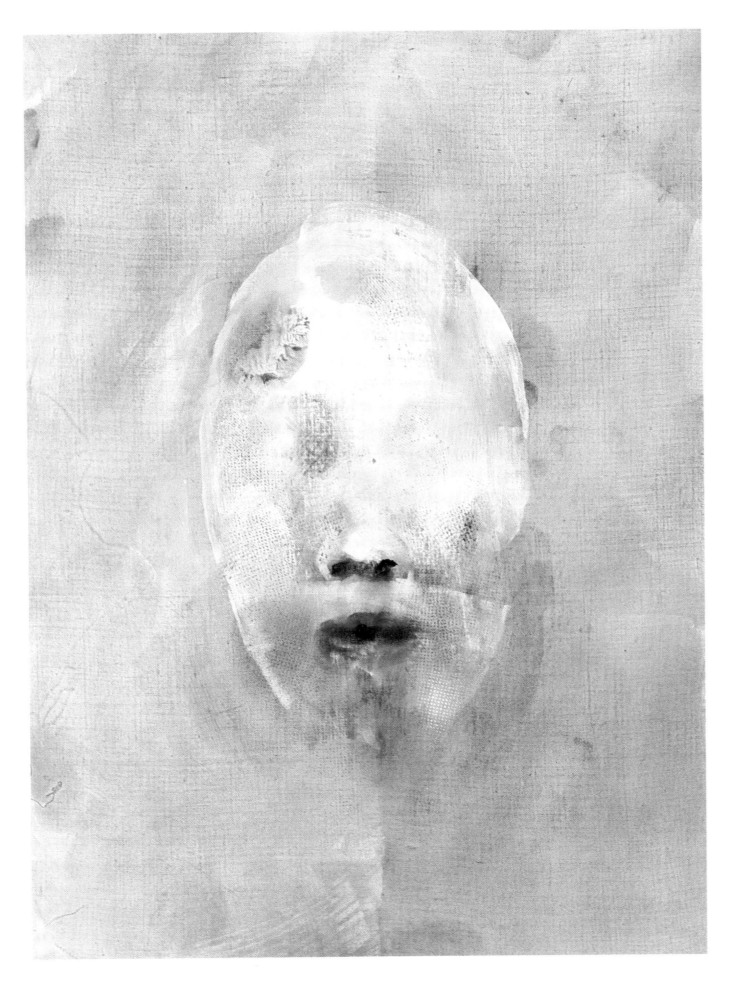

HEAD IN THE SUN, 1968
oil on canvas, 100 x 100 cm (215)

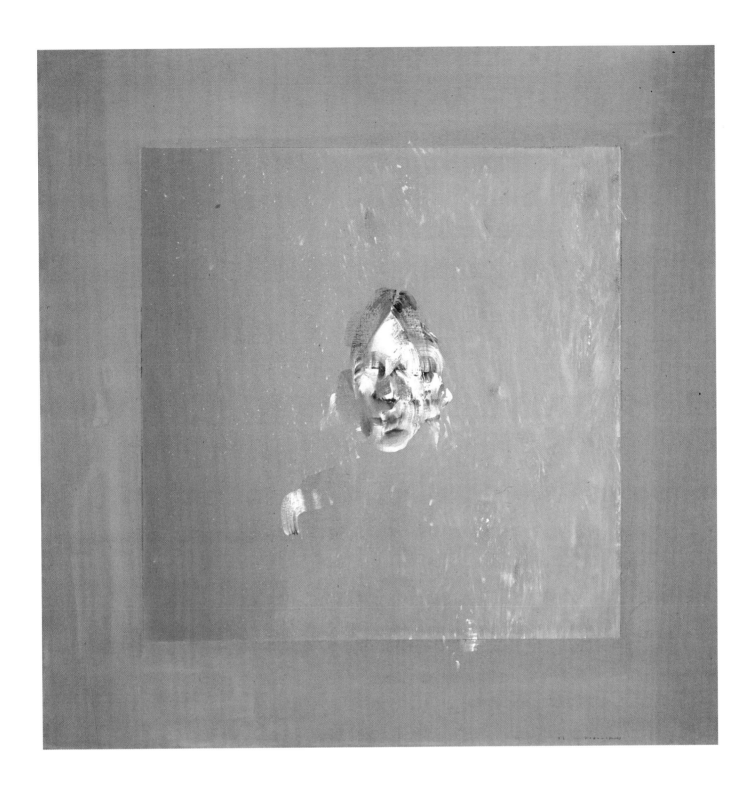

YOUNG WOMAN WITH CUT FLOWERS, 1967-70
oil on canvas, 146 x 114 cm (240)

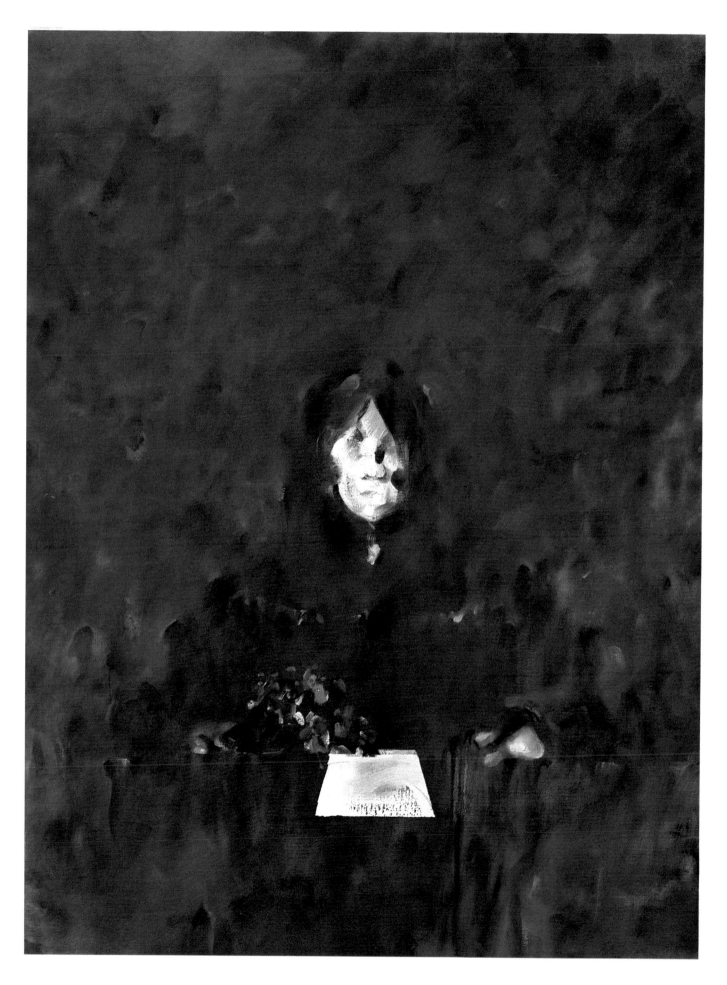

YOUNG WOMAN, 1968
oil on canvas, 73 x 73 cm (213)

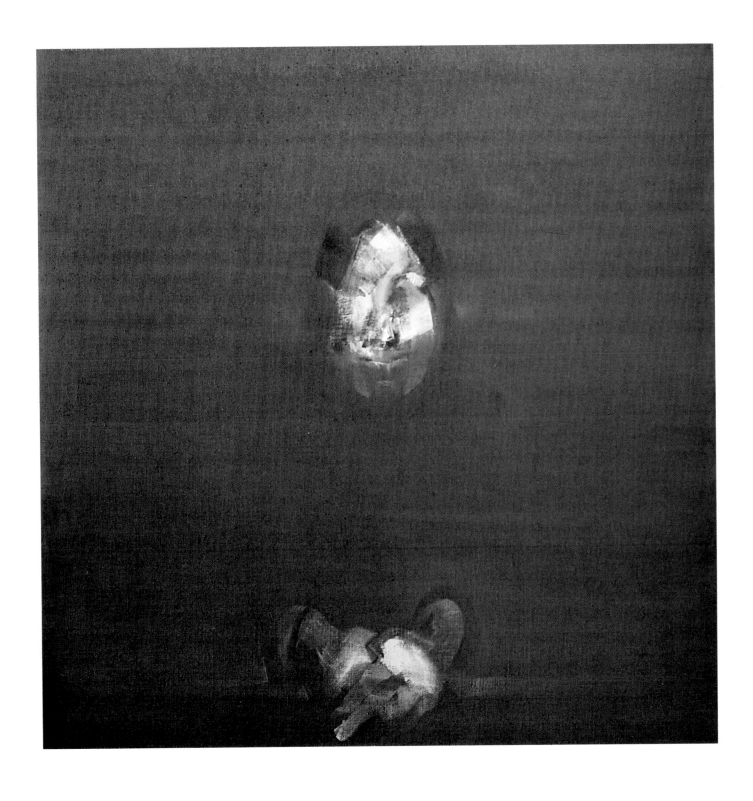

IMAGE OF ANNE, 1967
oil on canvas, 41 x 27 cm (197)

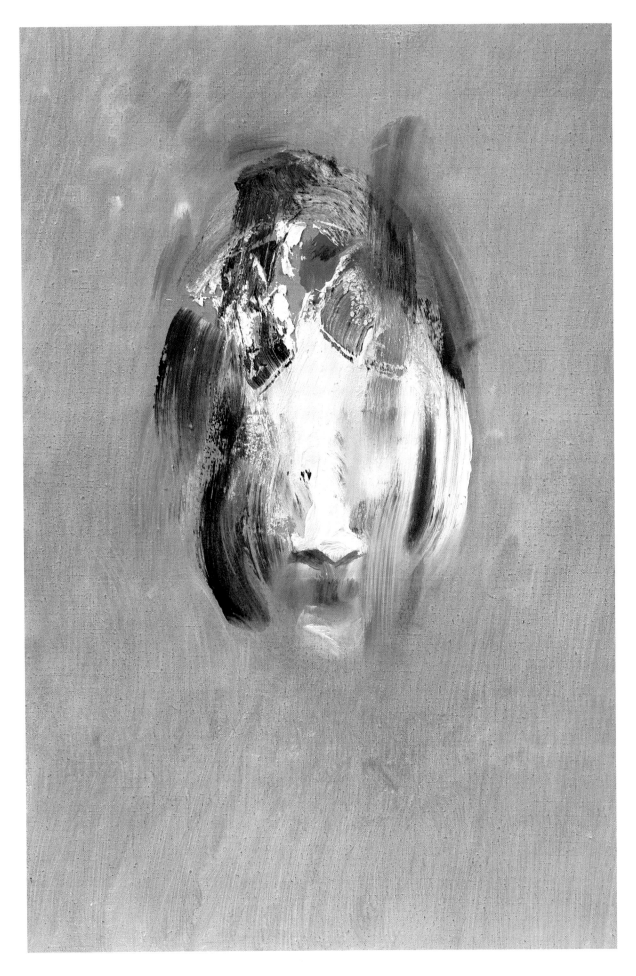

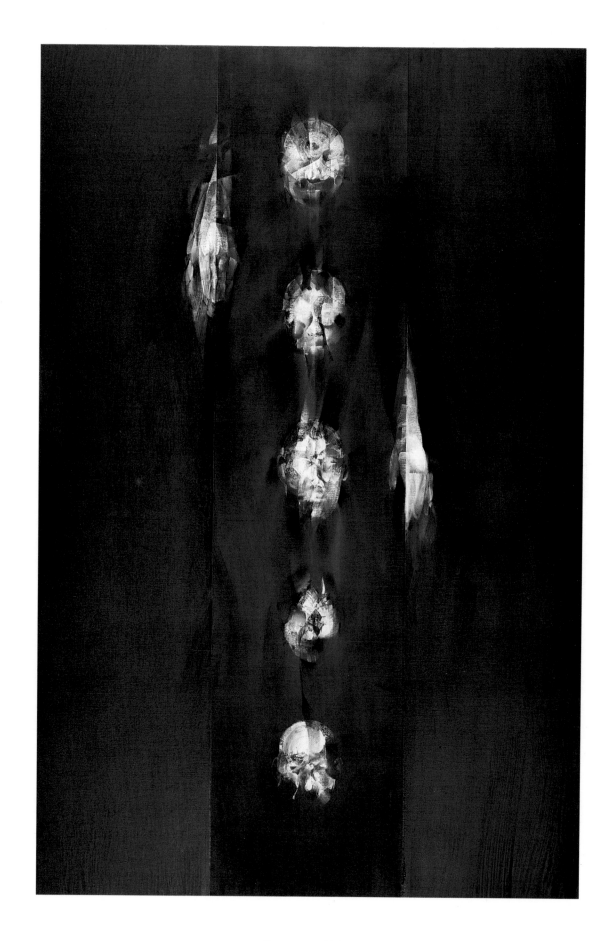

ENTREMONT, 1968
oil on canvas, 195 x 130 cm (220)

52

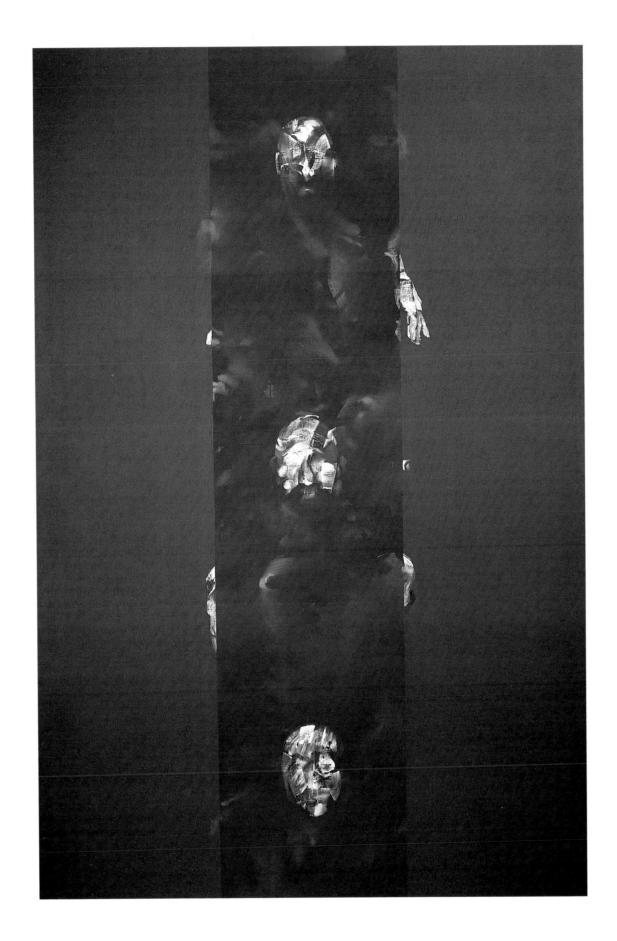

ENTREMONT, 1968
oil on canvas, 195 x 130 cm (219)

RECONSTRUCTED HEAD OF MY FATHER AS A YOUNG MAN, 1973
oil on canvas, 70 x 70 cm (339)

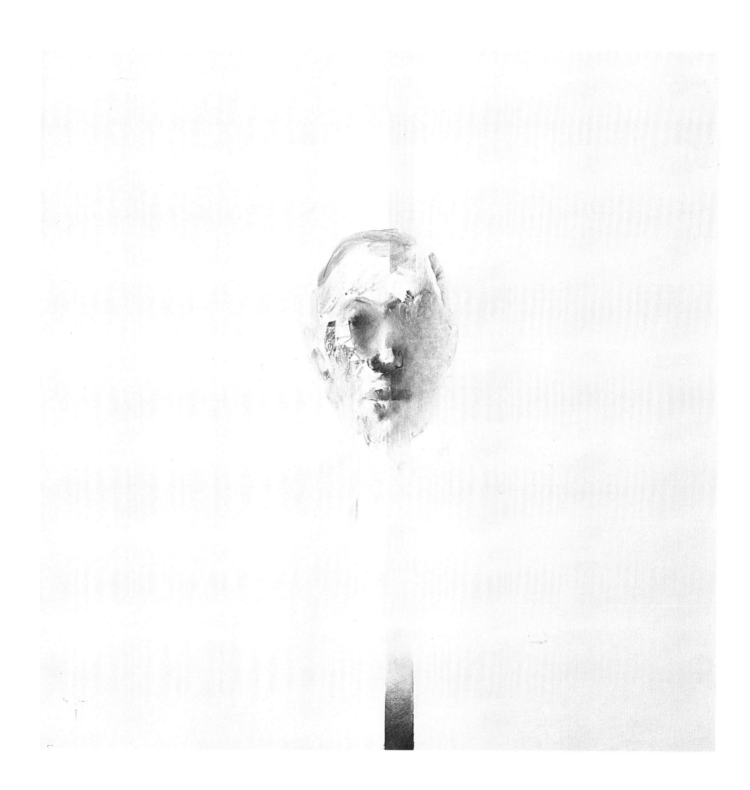

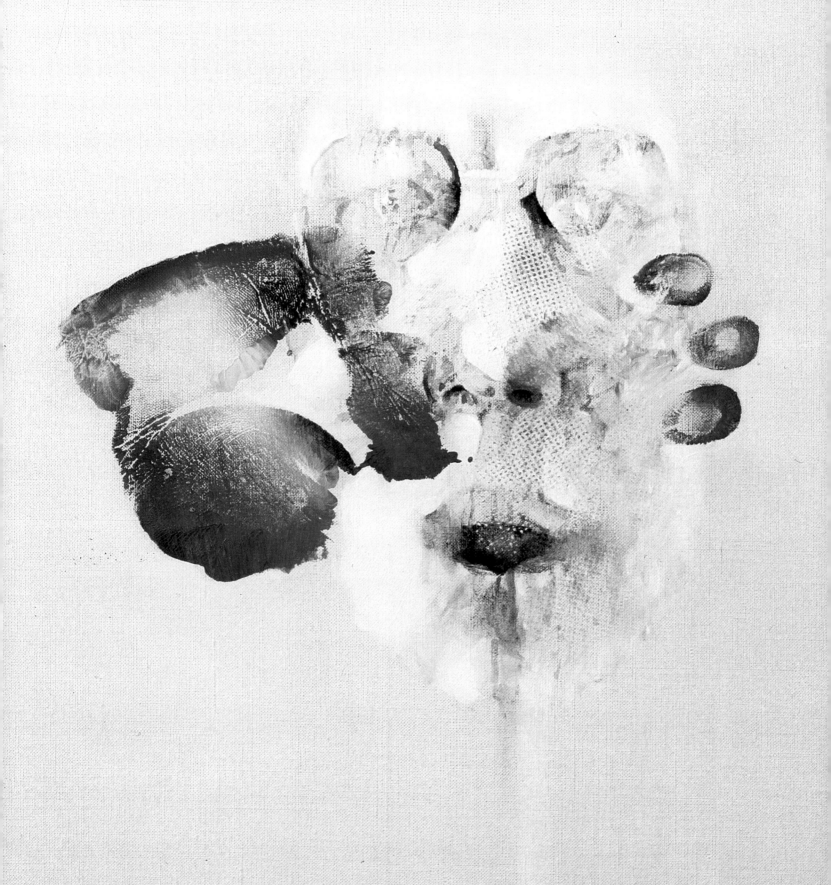

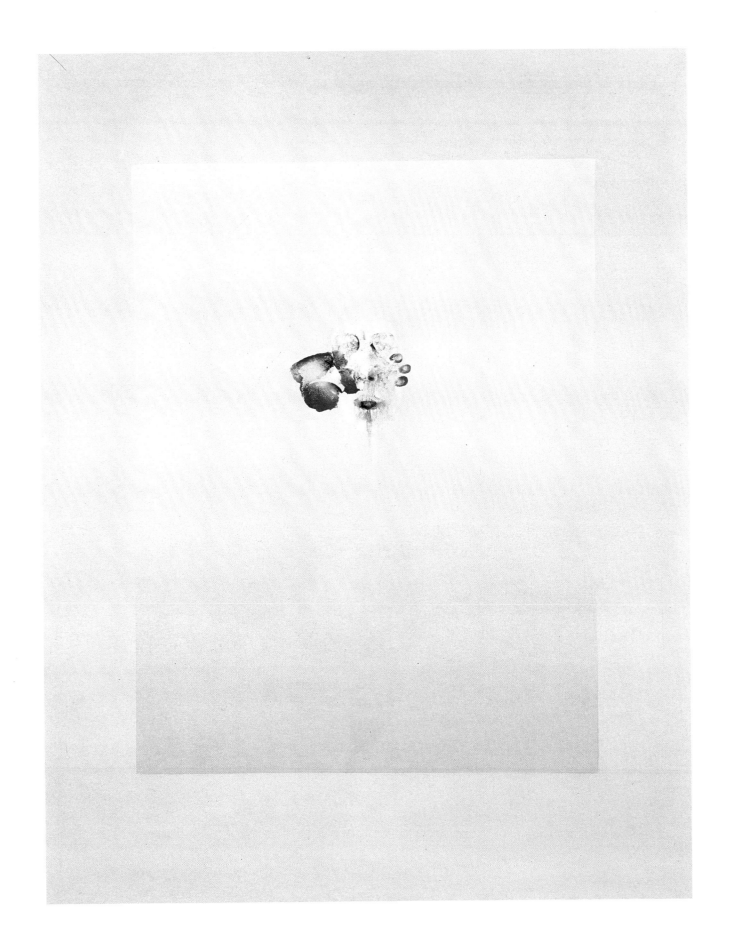

IMAGE OF MY FATHER AS A YOUNG MAN, 1971
oil on canvas, 146 x 114 cm (270)

NORTHERN IMAGE, 1971
oil on canvas, 146 x 146 cm (297)

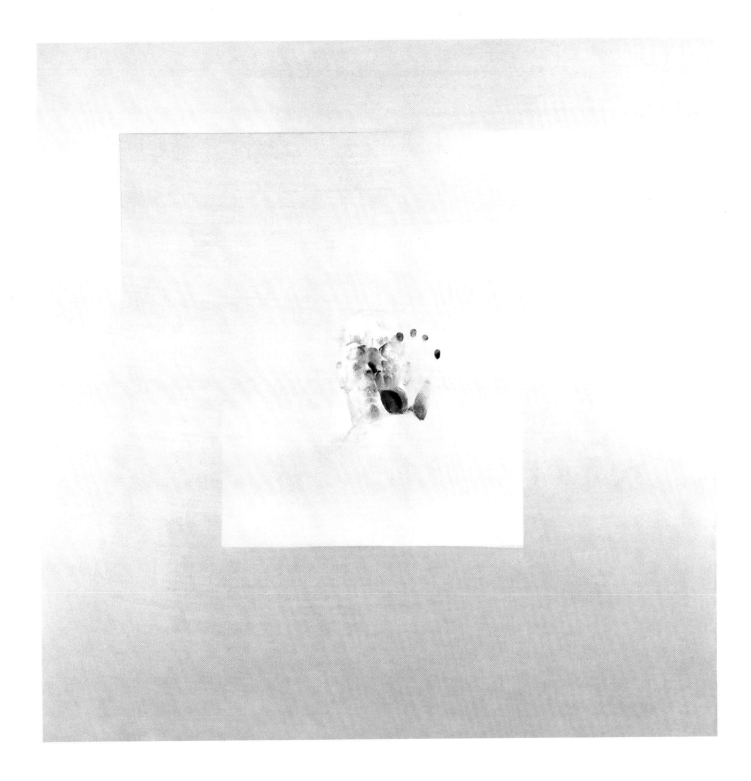

NORTHERN IMAGE, HEAD AND HAND, 1975
oil on canvas, 50 x 50 cm (370)

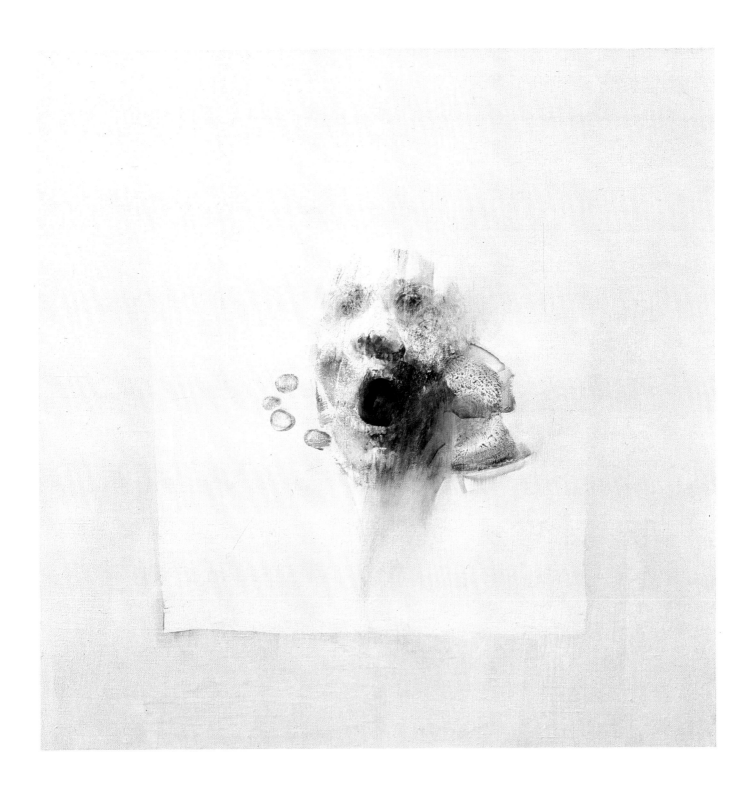

HEAD WITH OPEN MOUTH, 1971
oil on canvas, 46 x 38 cm (288)

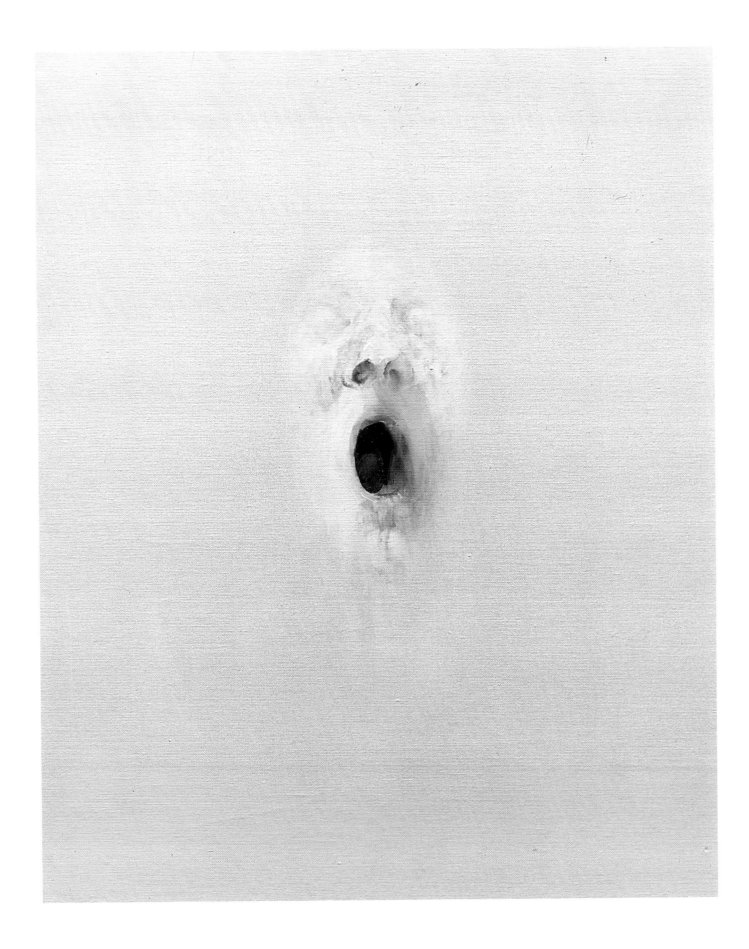

HUMAN IMAGE, 1996
oil on canvas, 118 x 89 cm (665)

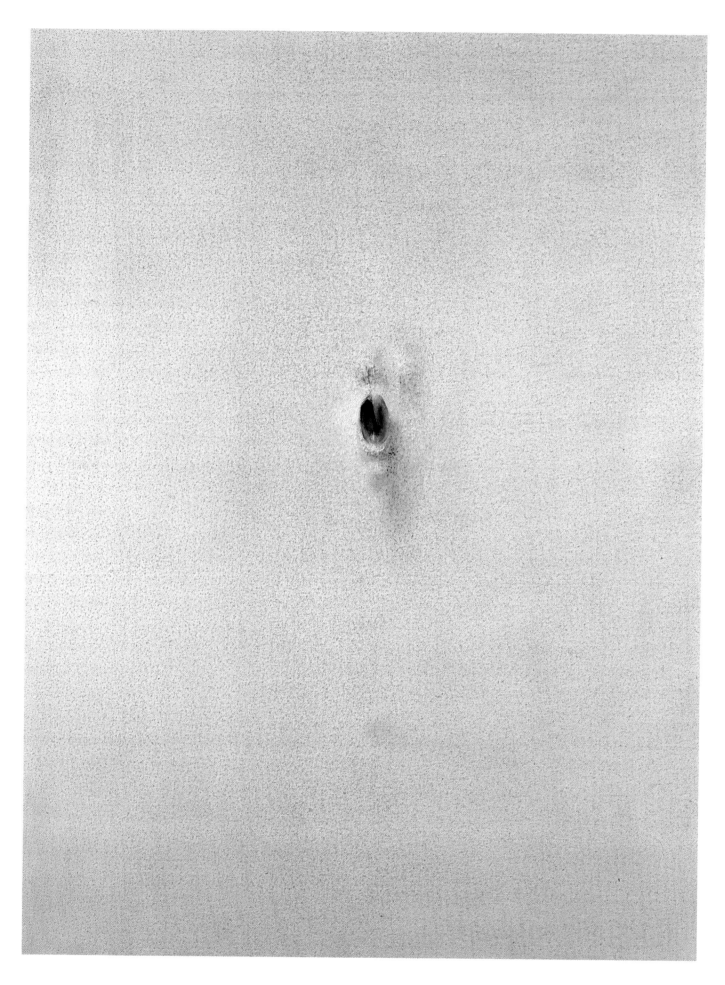

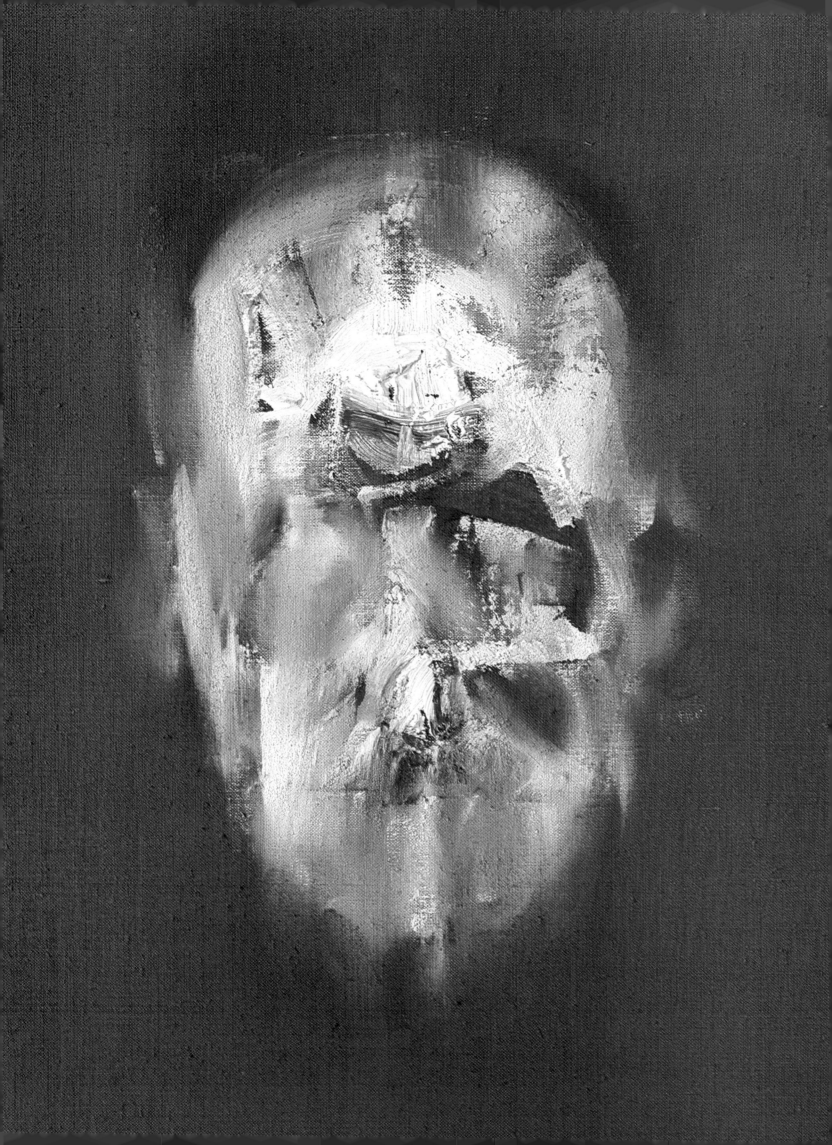

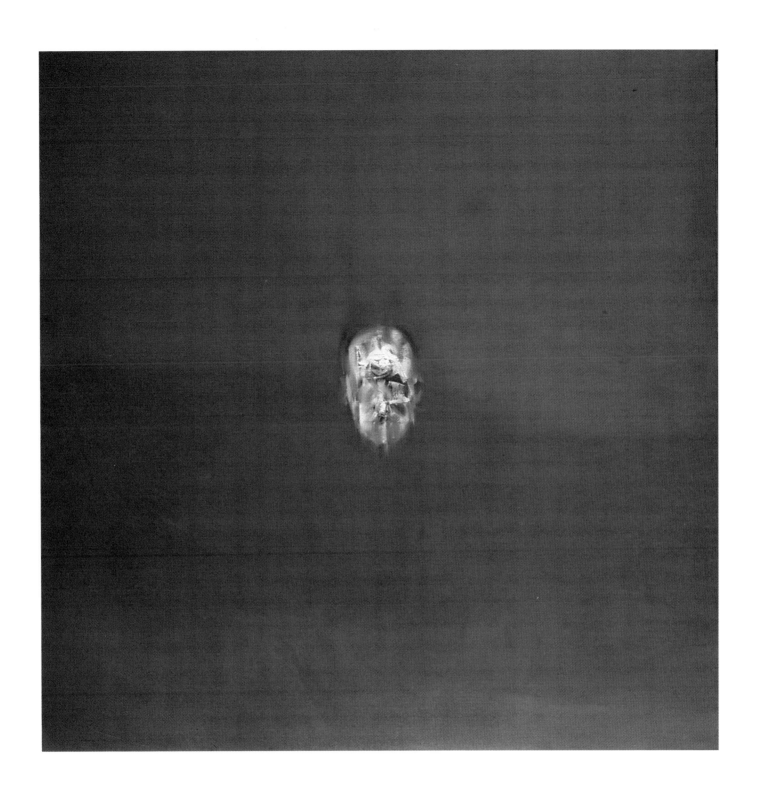

RECONSTRUCTED HEAD OF JAMES JOYCE, 1967
oil on canvas, 148 x 148 cm (181)

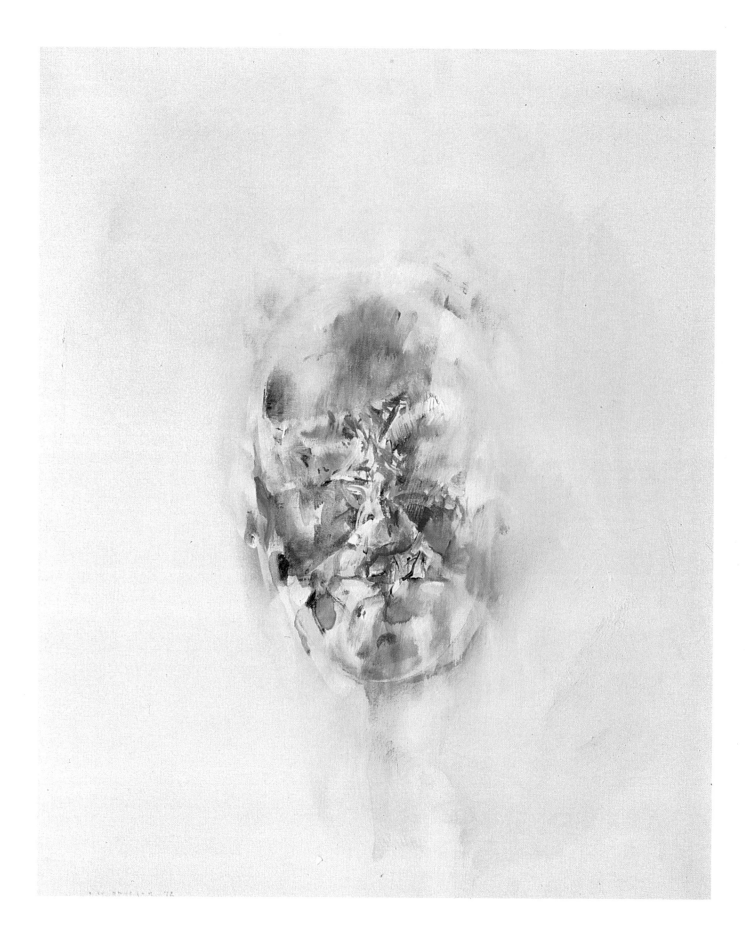

RECONSTRUCTED HEAD OF JAMES JOYCE, 1972
oil on canvas, 46 x 38 cm (307)

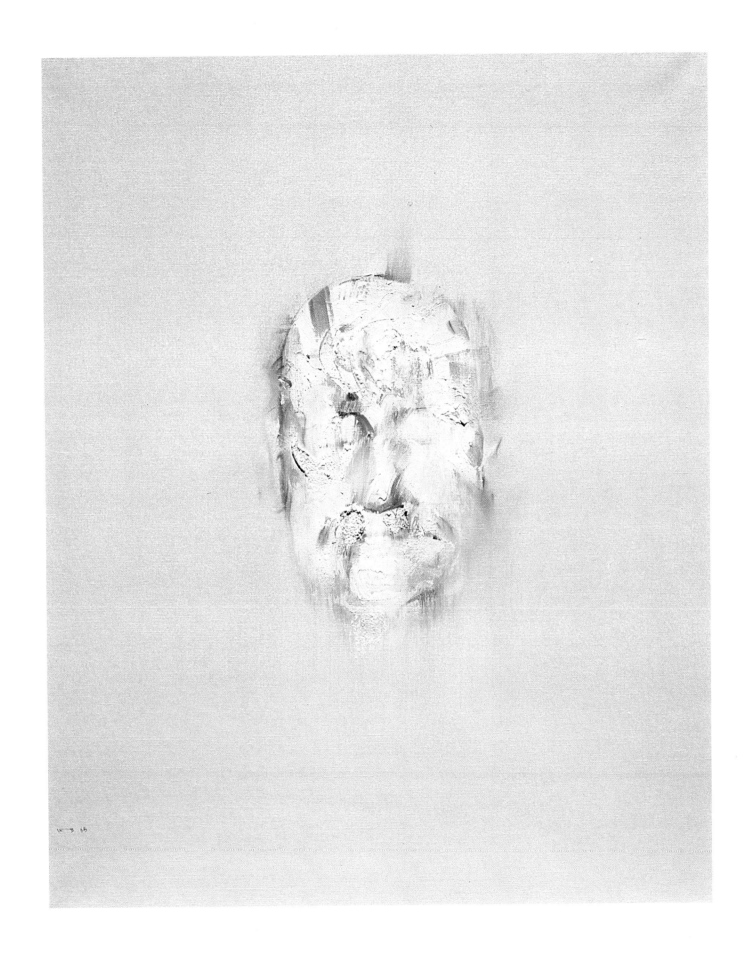

IMAGE OF JAMES JOYCE AS HIS FATHER, 1965
oil on canvas, 64 x 54 cm (152)

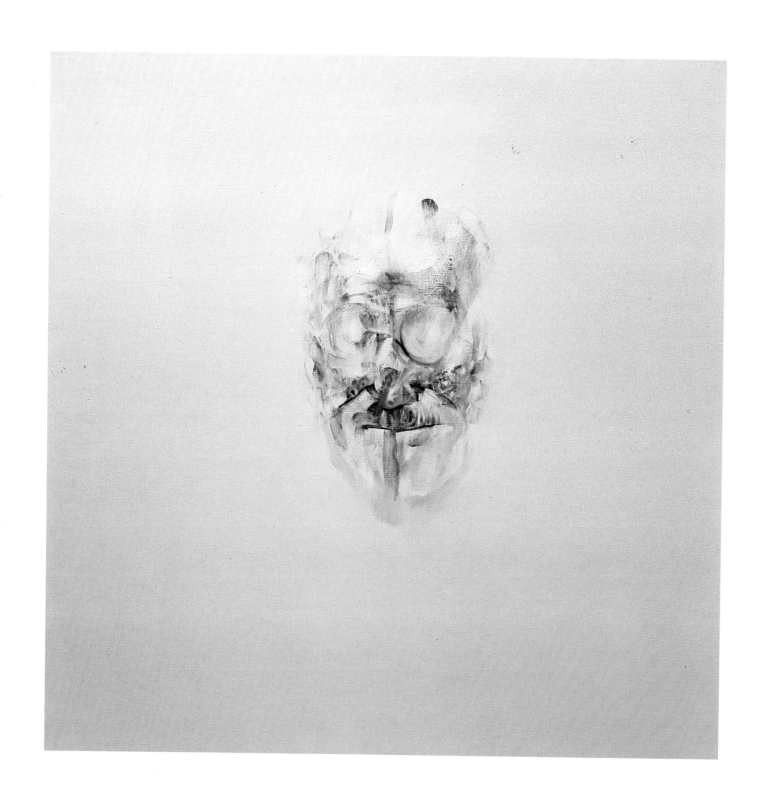

IMAGE OF JAMES JOYCE, 1977
oil on canvas, 70 x 70 cm (395)

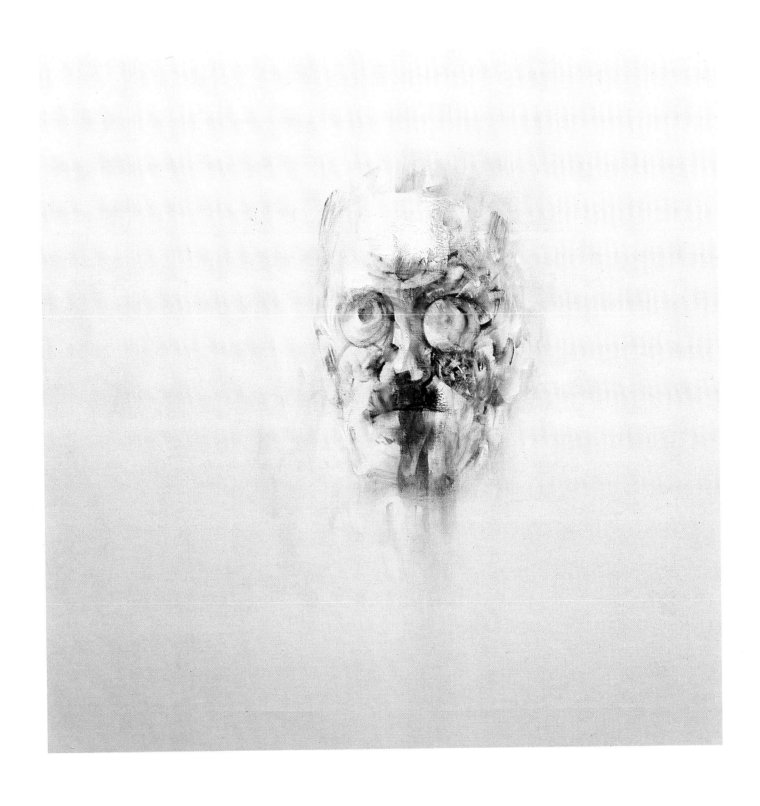

IMAGE OF JAMES JOYCE, 1977
oil on canvas, 70 x 70 cm (397)

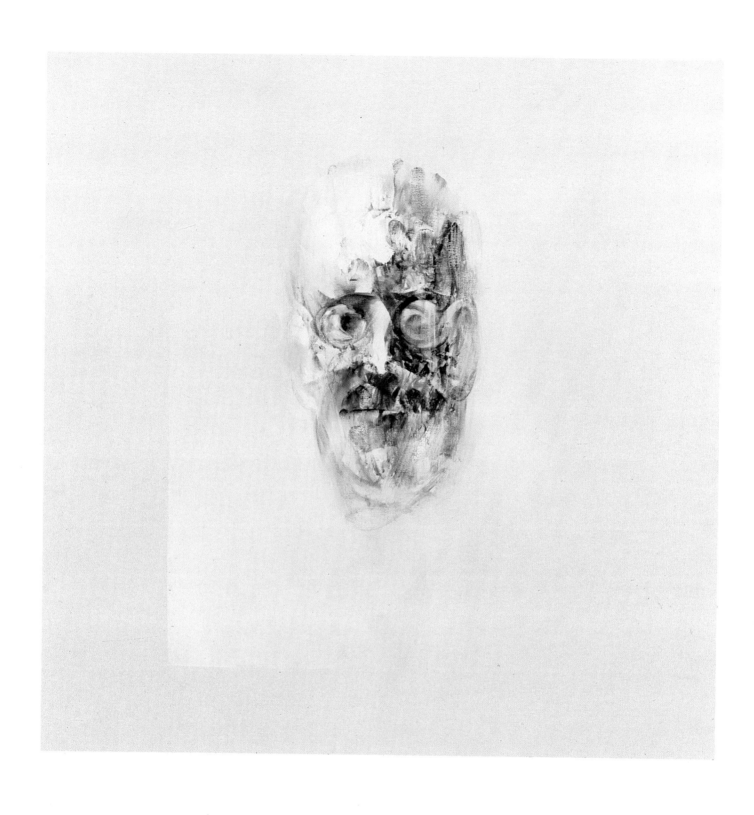

IMAGE OF JAMES JOYCE, 1977
oil on canvas, 70 x 70 cm (398)

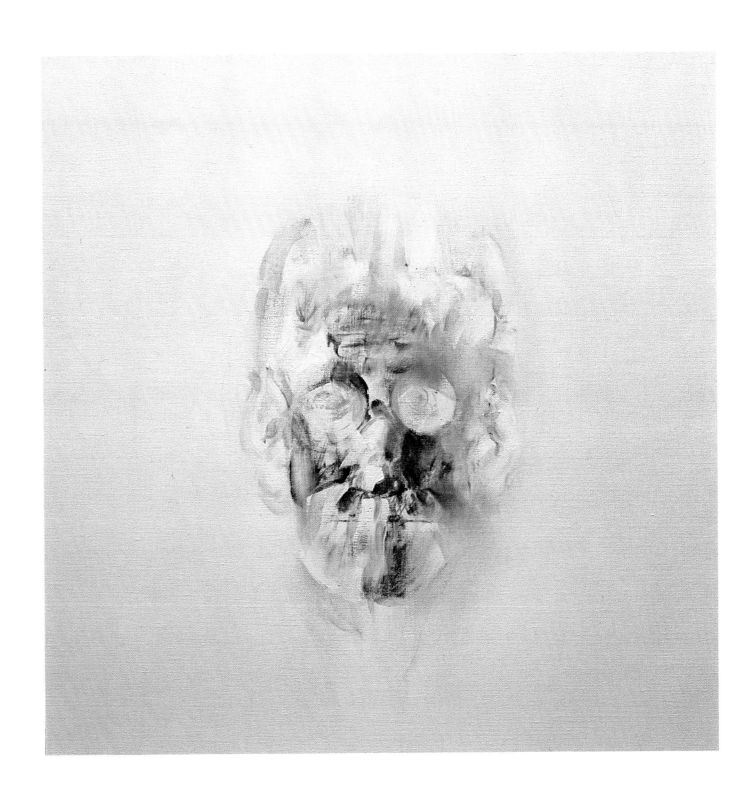

IMAGE OF JAMES JOYCE, 1977
oil on canvas, 70 x 70 cm (detail) (396)

IMAGE OF JAMES JOYCE, 1978
oil on canvas, 70 x 70 cm (detail), (406)

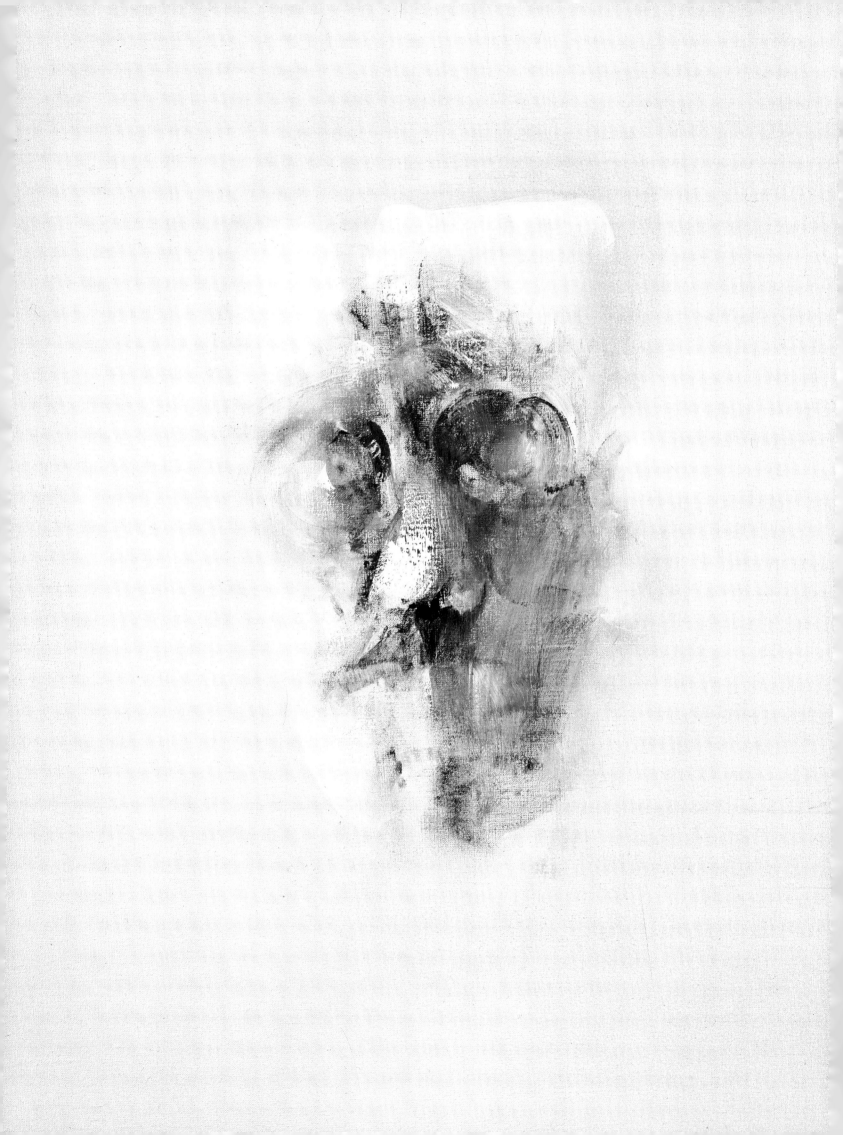

IMAGE OF JAMES JOYCE, 1994
oil on canvas, 92 x 73 cm (652)

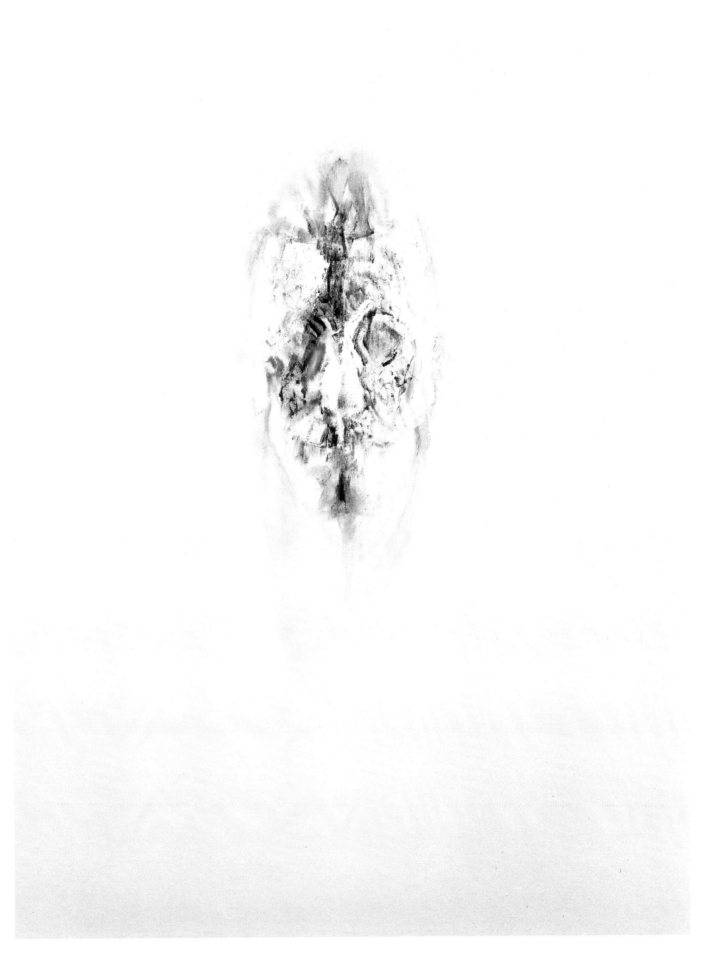

STUDY TOWARDS AN IMAGE OF WB YEATS, 1975
oil on canvas, 70 x 70 cm (detail) (385)

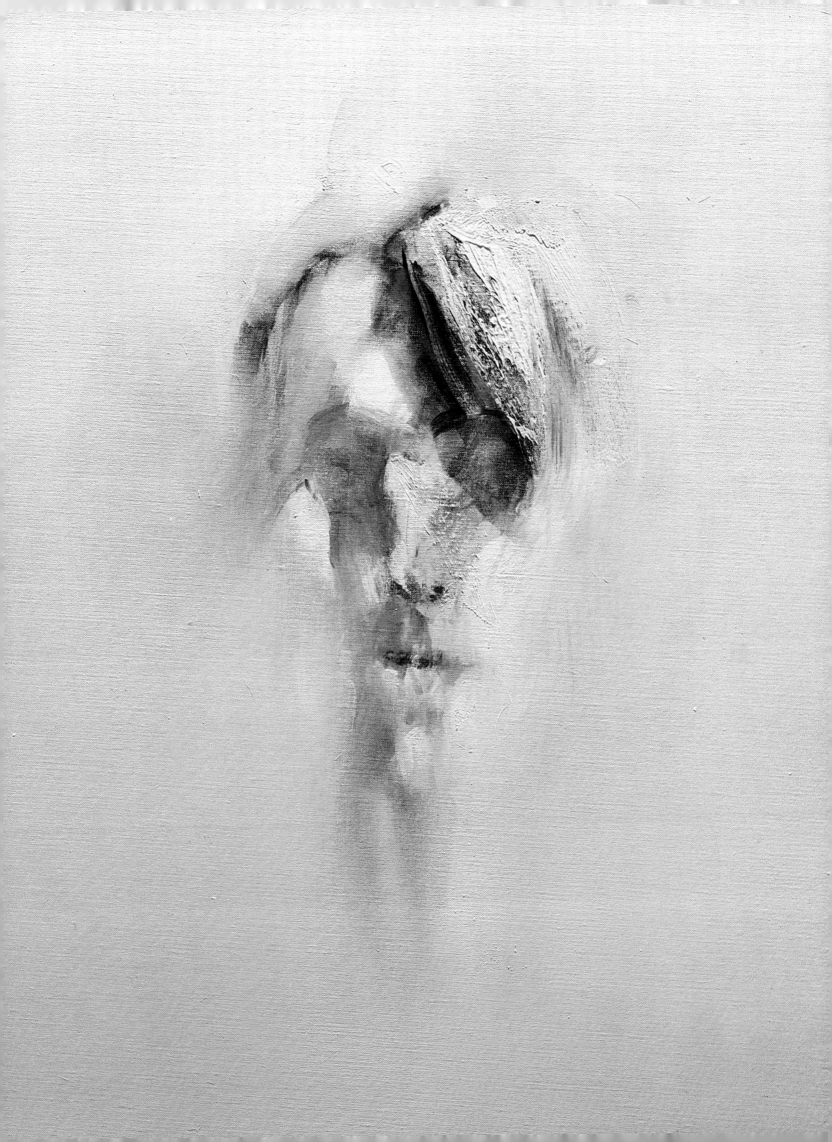

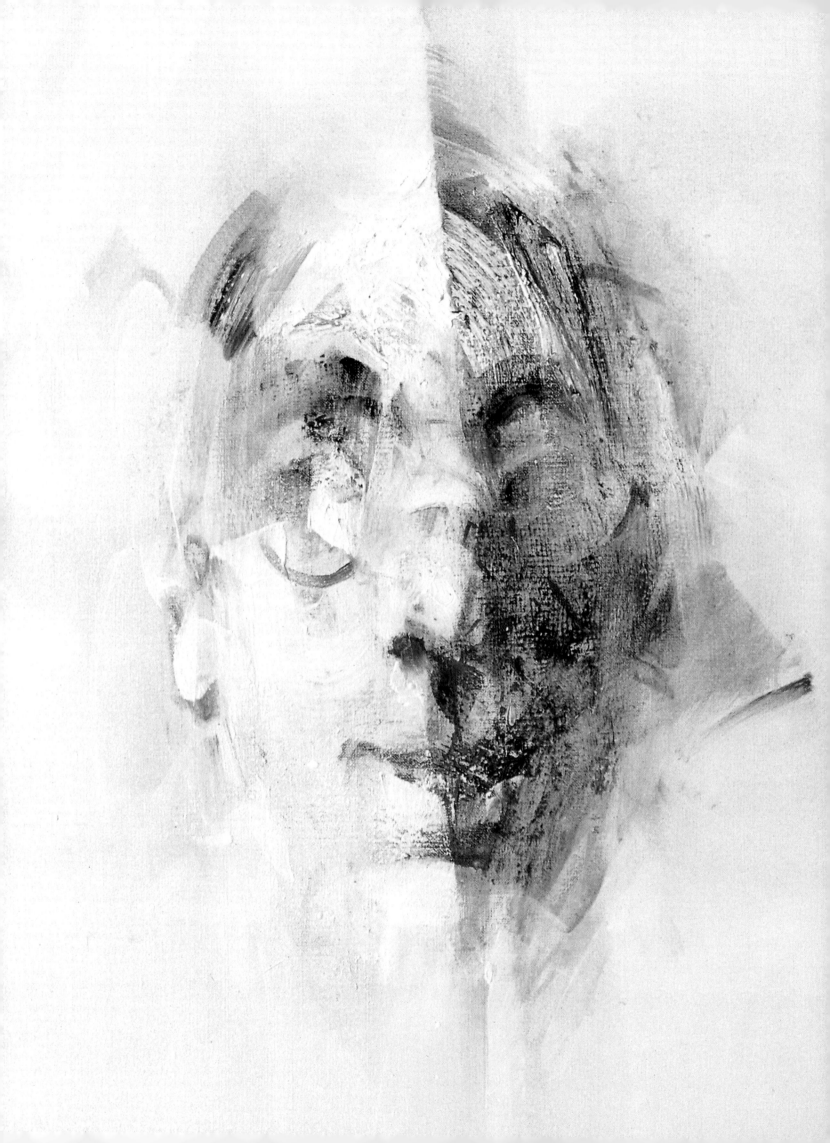

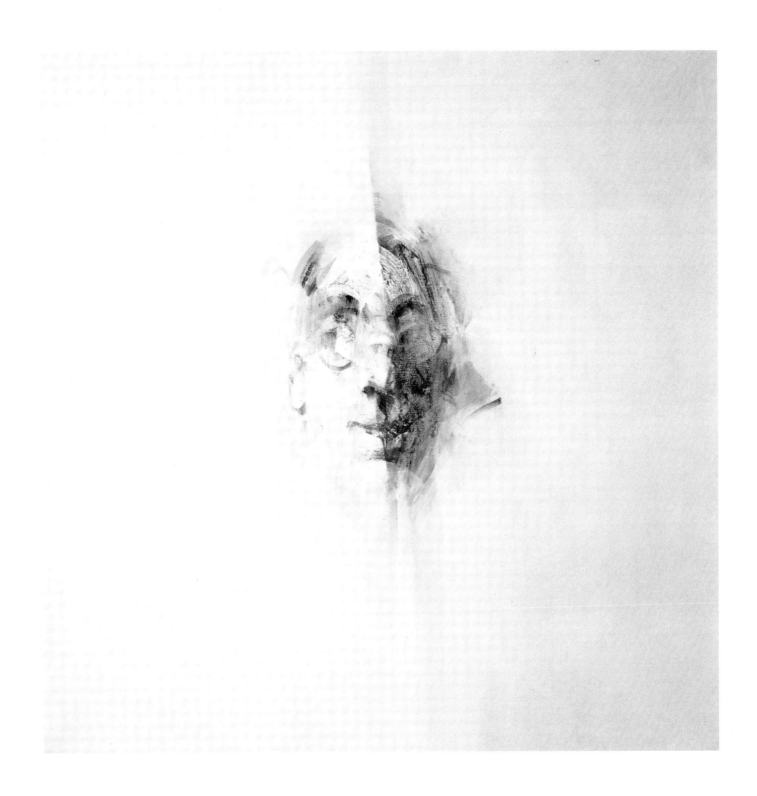

STUDY OF WB YEATS, 1975
oil on canvas, 70 x 70 cm (387)

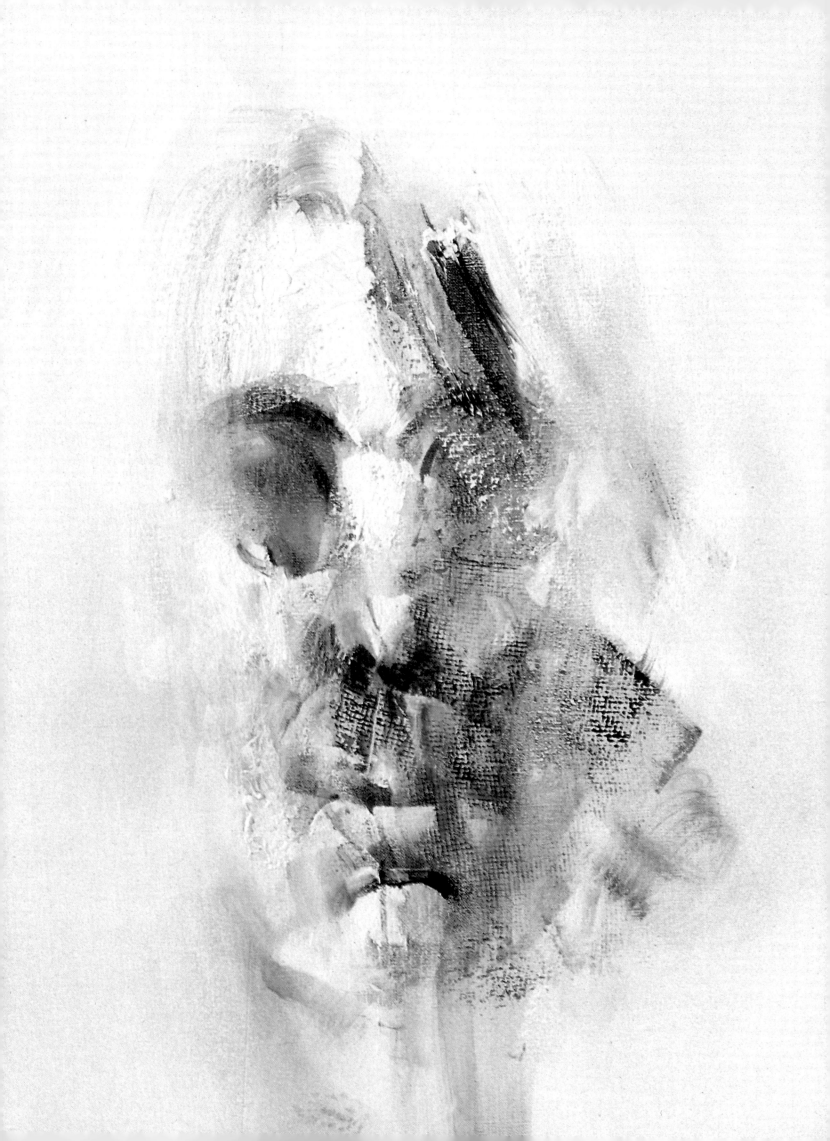

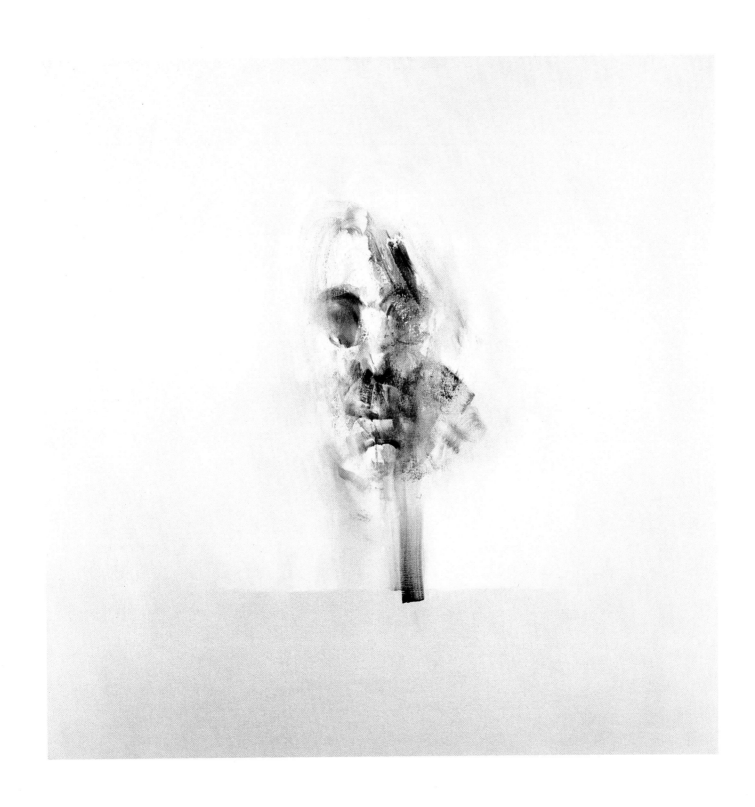

STUDY OF WB YEATS, 1975
oil on canvas, 70 x 70 cm (386)

IMAGE OF WB YEATS, 1989
oil on canvas, 80 x 80 cm (556)

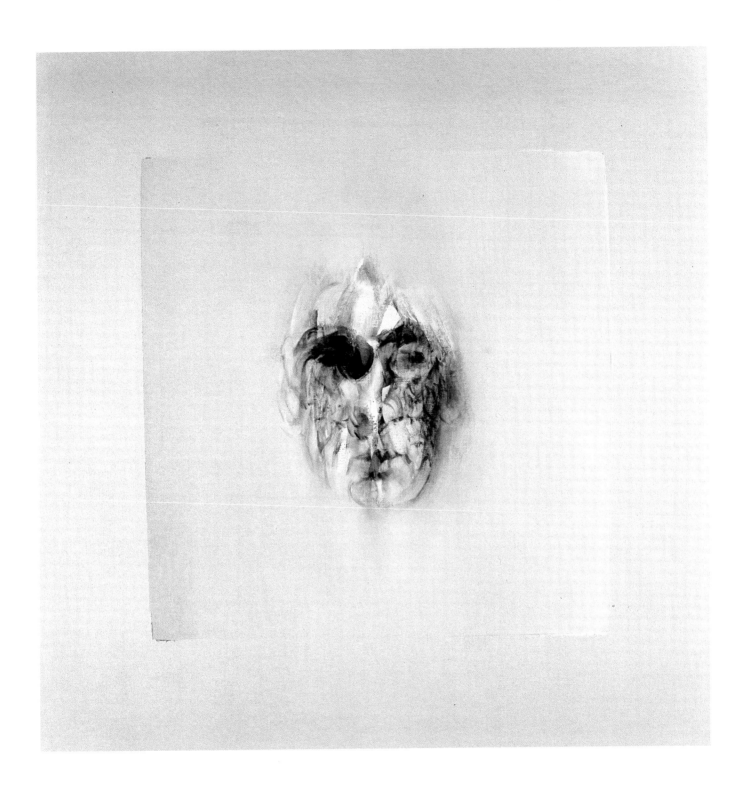

IMAGE OF WB YEATS, 1976
oil on canvas, 70 x 70 cm (detail) (392)

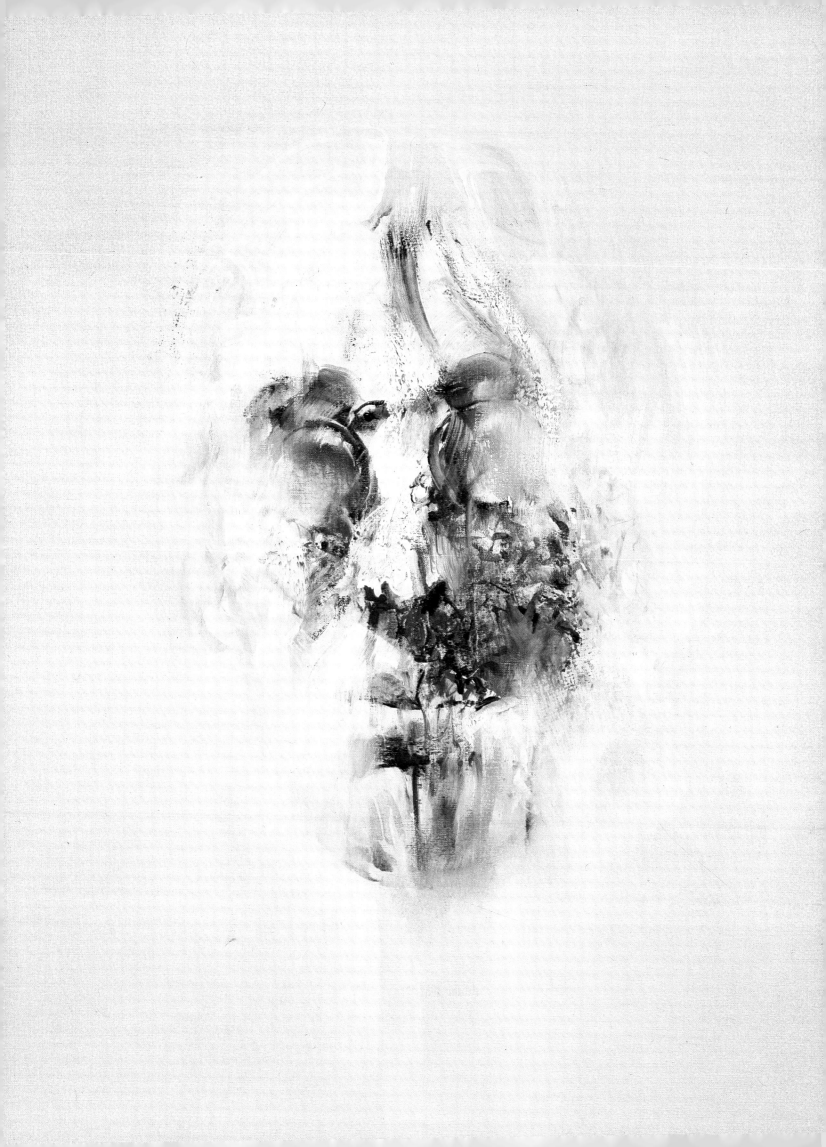

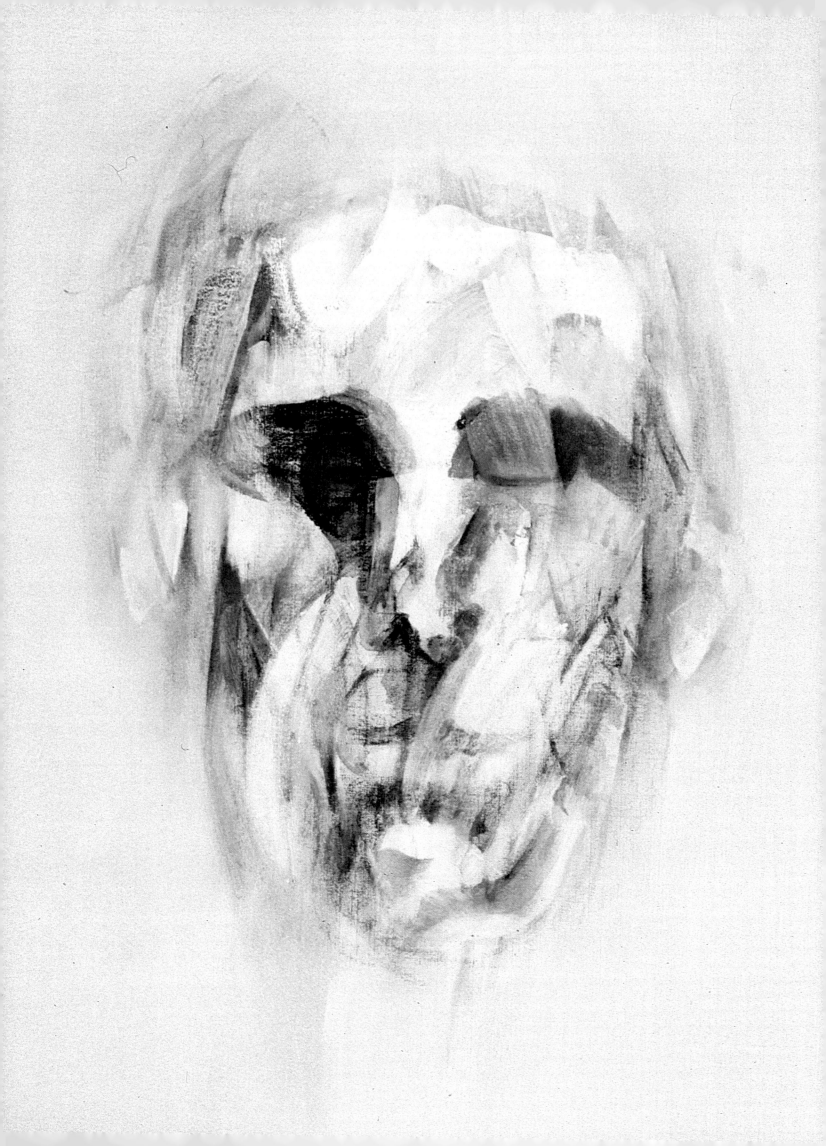

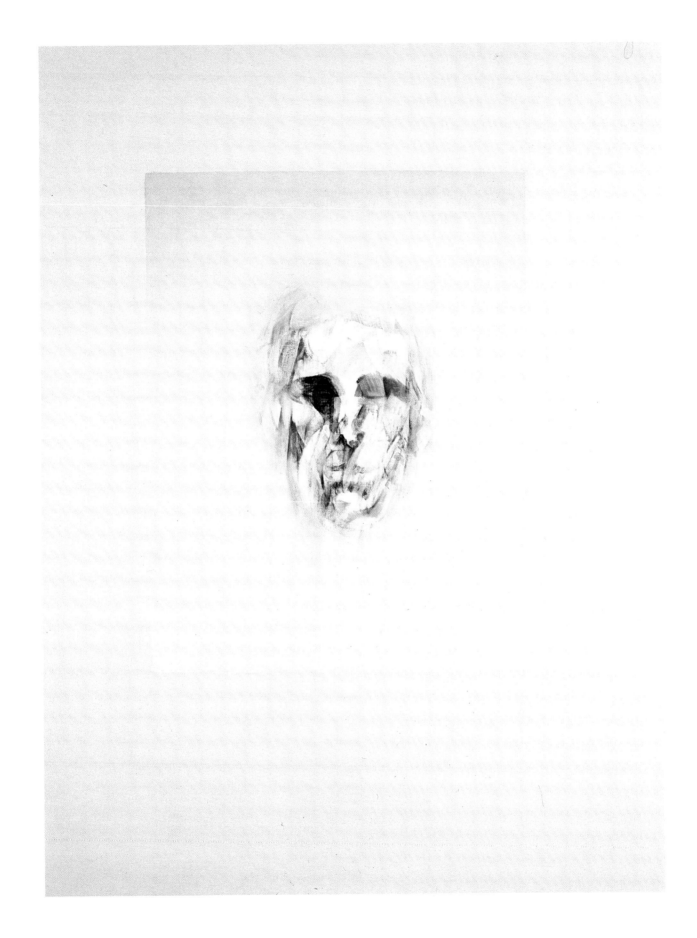

IMAGE OF WB YEATS, 1989
oil on canvas, 122 x 91 cm (555)

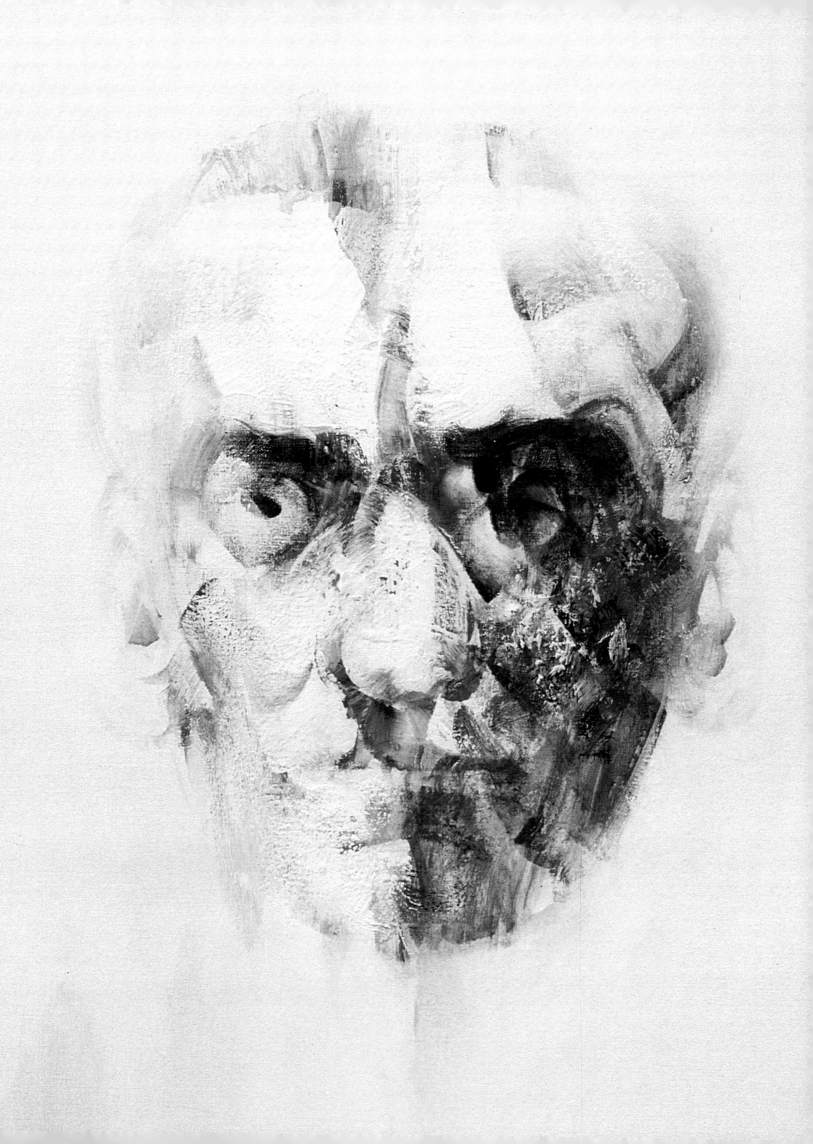

Image of Federico Garcia Lorca, 1977-78
oil on canvas, 146 x 114 cm (419)

IMAGE OF FEDERICO GARCIA LORCA, 1977-78
oil on canvas, 80 x 80 cm (detail) (410)

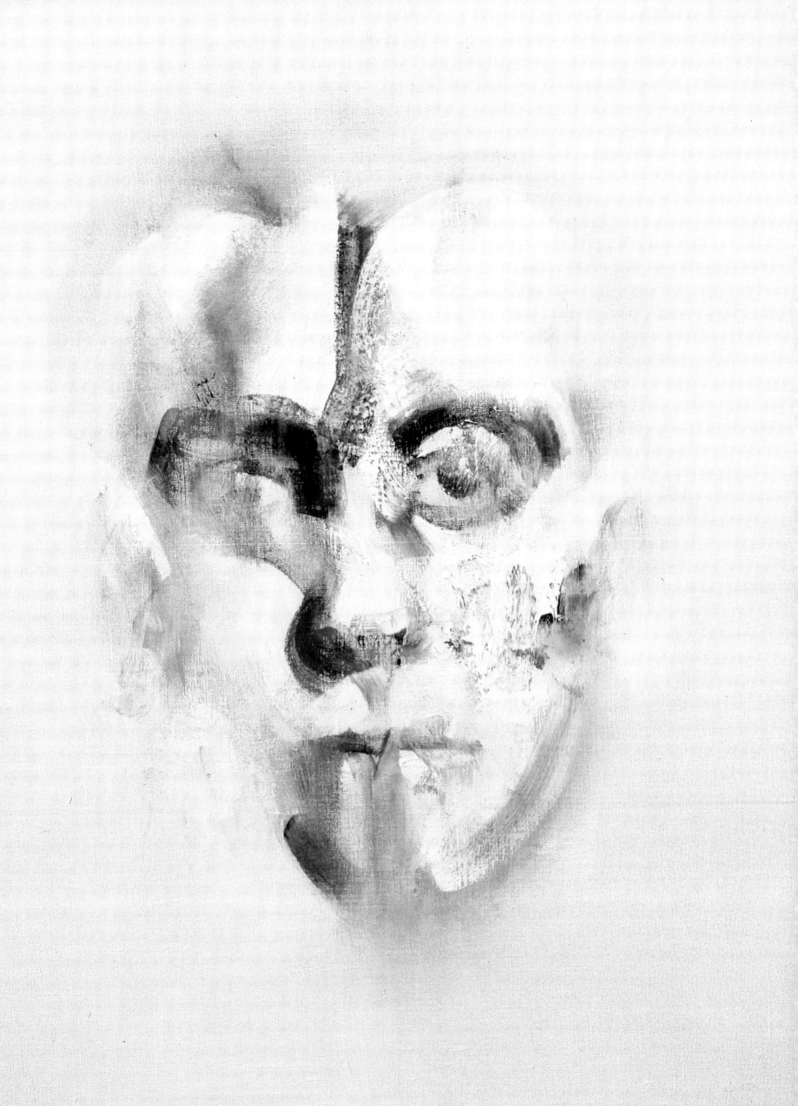

IMAGE OF FEDERICO GARCIA LORCA, 1977-86
oil on canvas, 80 x 80 cm (414)

IMAGE OF FEDERICO GARCIA LORCA, 1977-78
oil on canvas, 80 x 80 cm (detail) (412)

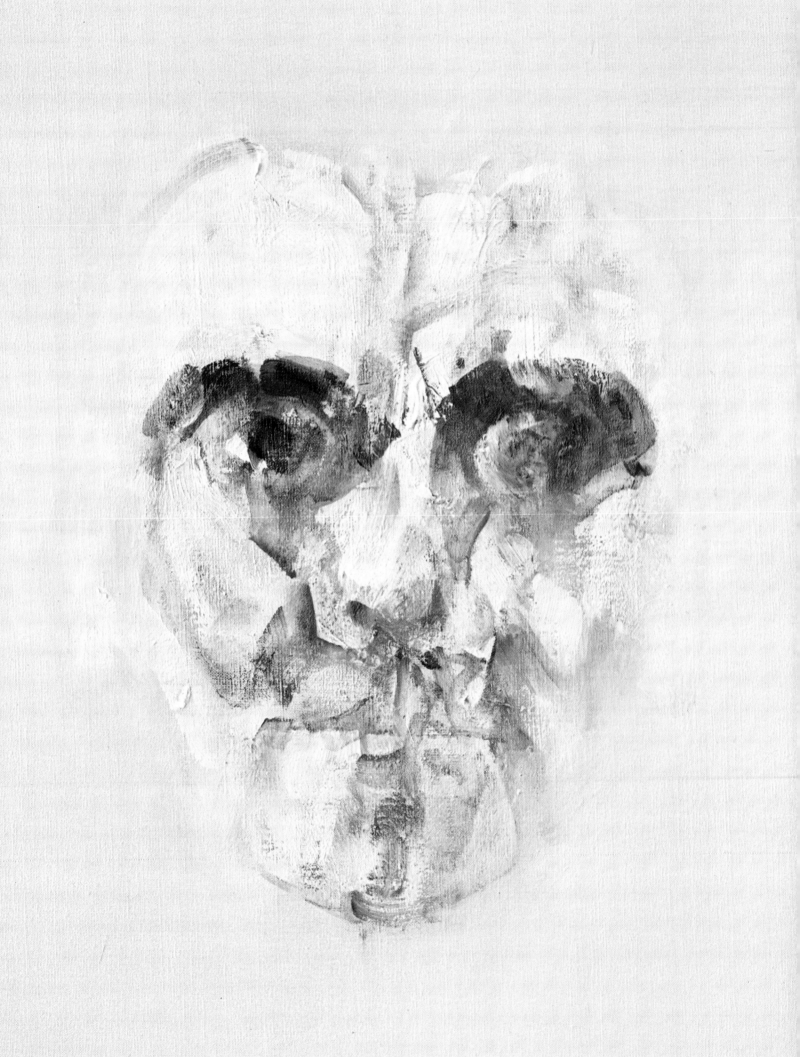

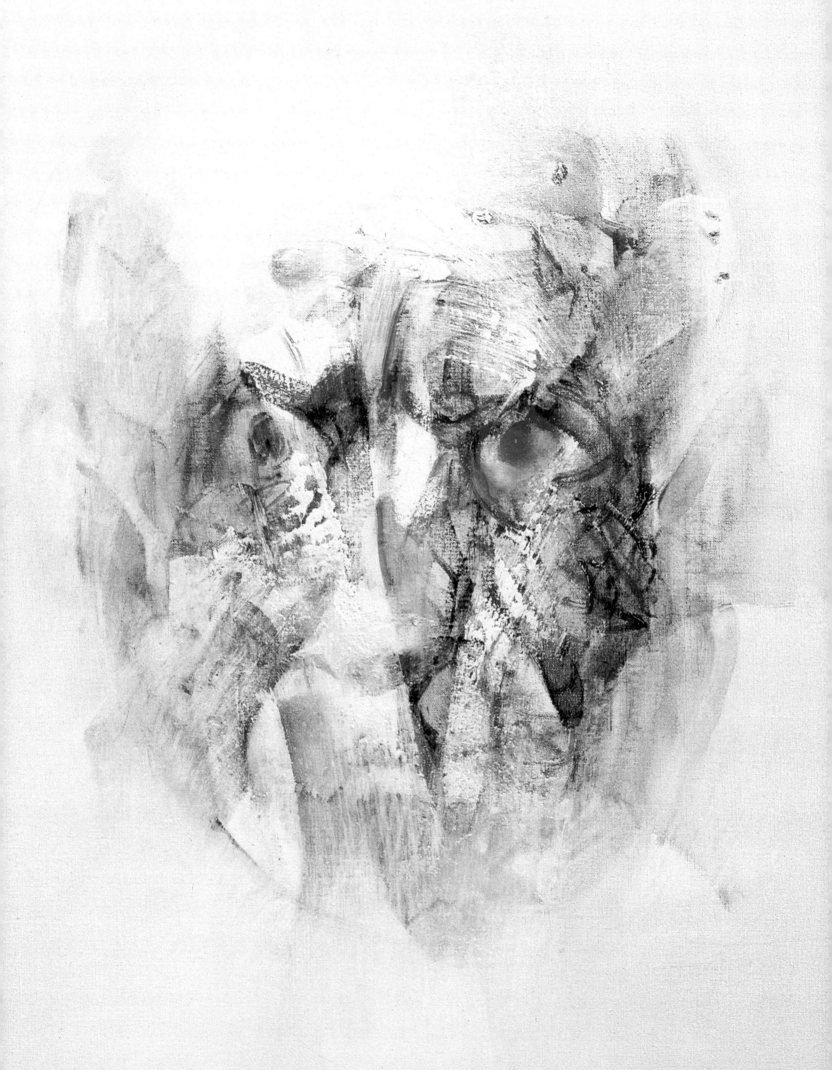

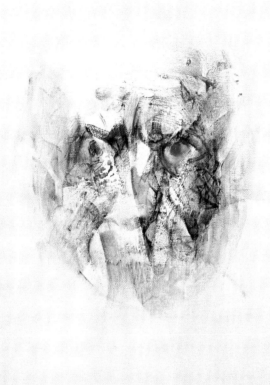

IMAGE OF PICASSO, 1983
oil on canvas, 80 x 80 cm (489)

IMAGE OF PICASSO, 1983
oil on canvas, 111 x 86 cm (491)

IMAGE OF PICASSO, 1983
oil on canvas, 100 x 100 cm (492)

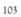

IMAGE OF FRANCIS BACON, 1985
oil on canvas, 100 x 100 cm (detail) (537)

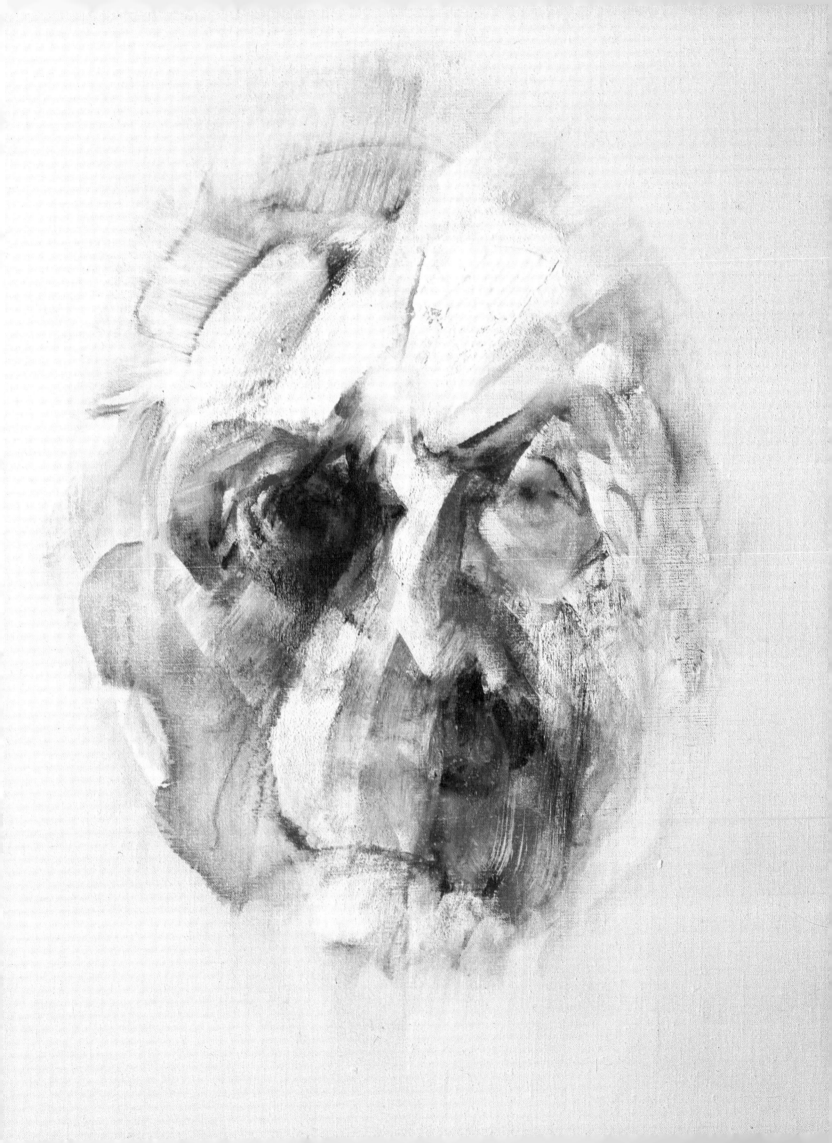

IMAGE OF FRANCIS BACON, 1979-86
oil on canvas, 80 x 80 cm (detail) (436)

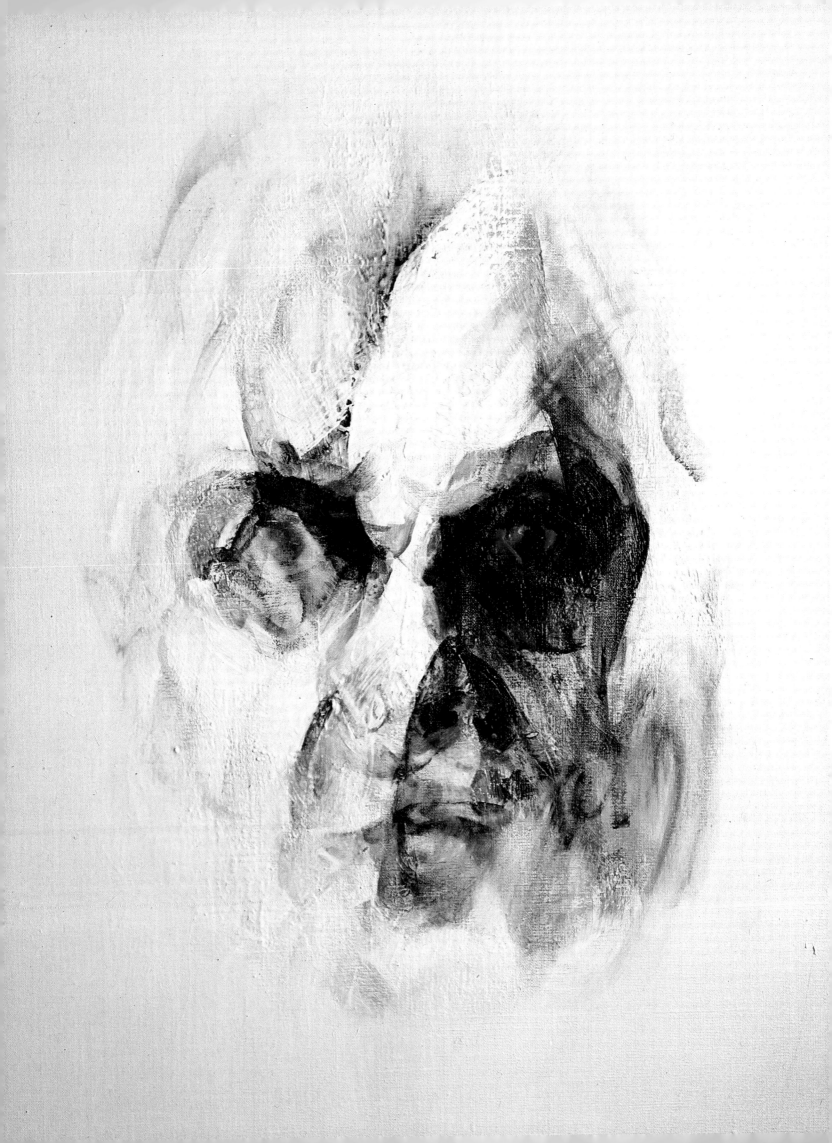

IMAGE OF FRANCIS BACON, 1990
oil on canvas, 116 x 89 cm (580)

IMAGE OF FRANCIS BACON, 1979
oil on canvas, 100 x 100 cm (detail) (441)

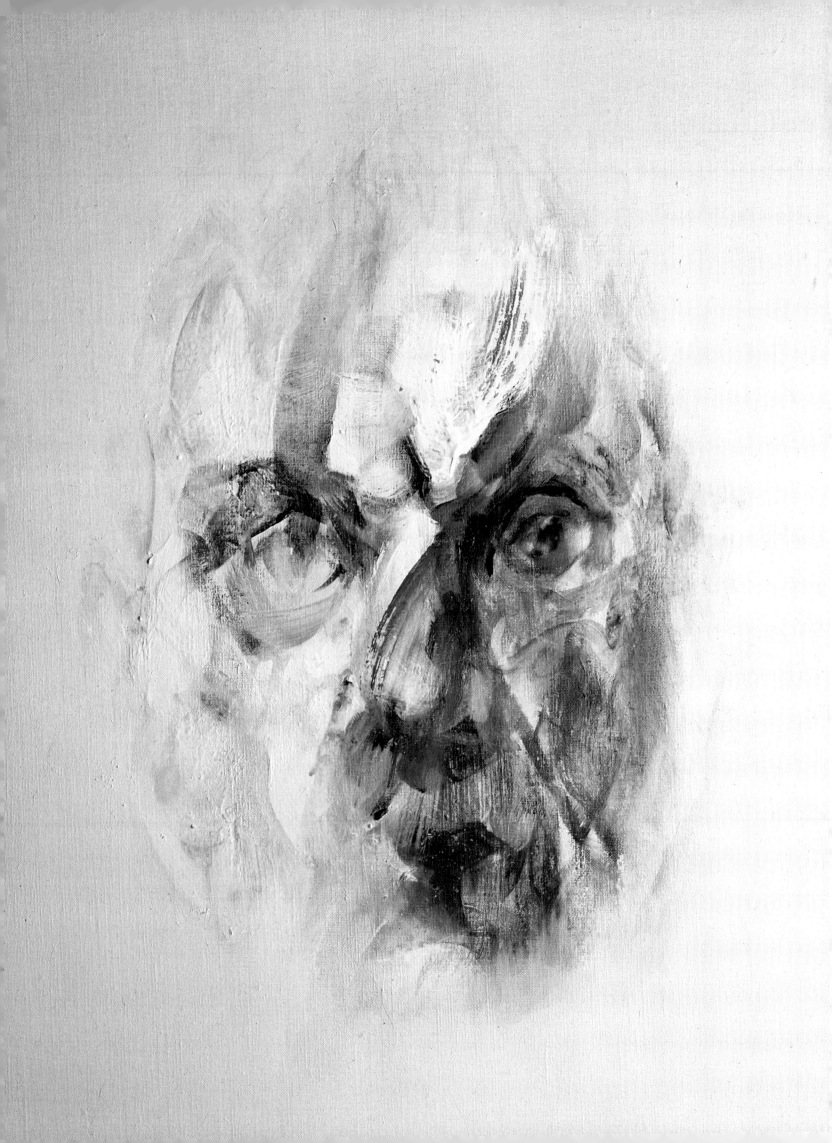

RECONSTRUCTED HEAD OF SAMUEL BECKETT, 1965
oil on canvas, 65 x 54 cm (171)

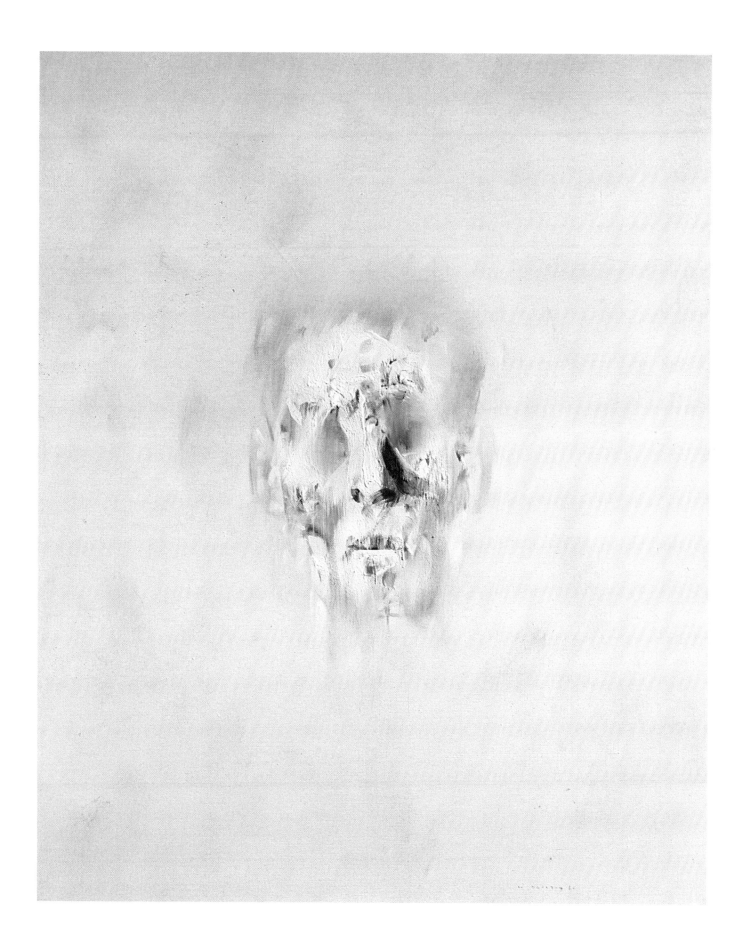

IMAGE OF SAMUEL BECKETT, 1988-89
oil on canvas, 80 x 80 cm (564)

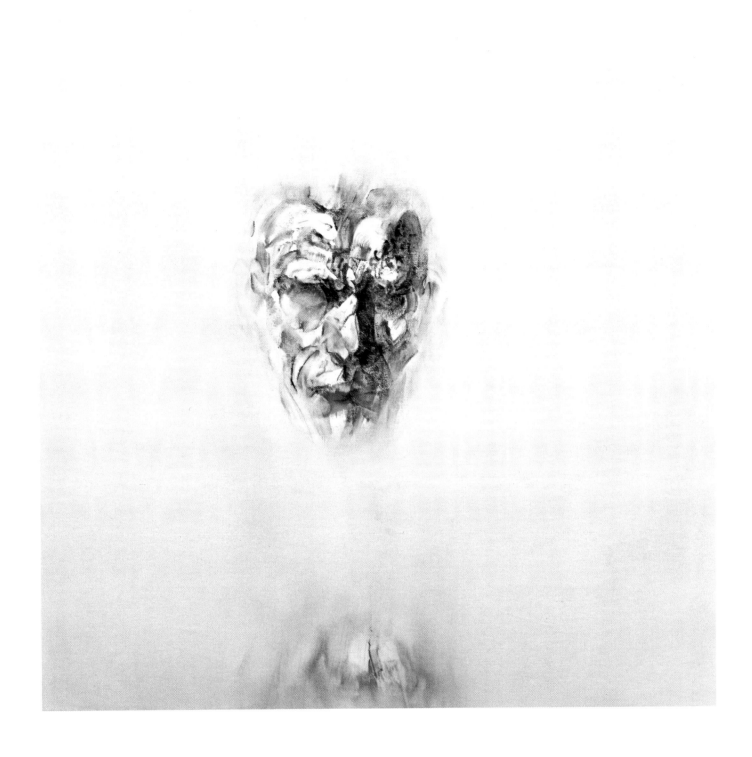

STUDY TOWARDS AN IMAGE OF SAMUEL BECKETT, 1988
oil on cotton sheet mounted on canvas, 92 x 73 cm (553)

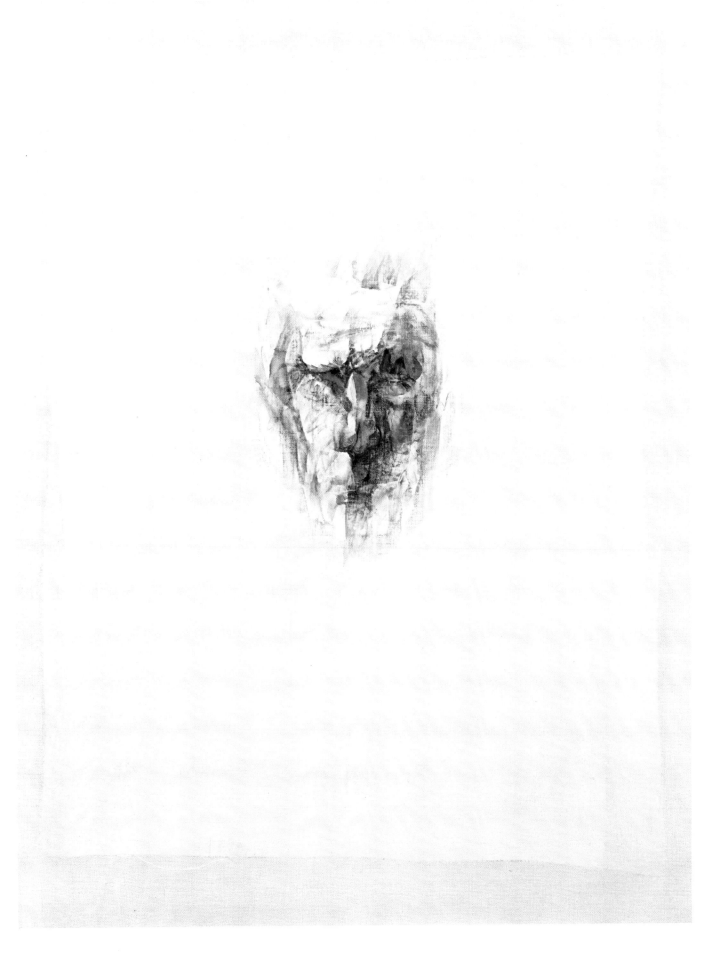

IMAGE OF SAMUEL BECKETT, 1989
oil on canvas, 80 x 80 cm (detail) (557)

page 120
IMAGE OF SAMUEL BECKETT, 1987
oil on canvas, 70 x 70 cm (detail) (544)

page 121
IMAGE OF SAMUEL BECKETT, 1987
oil on canvas, 65 x 50 cm (detail) (546)

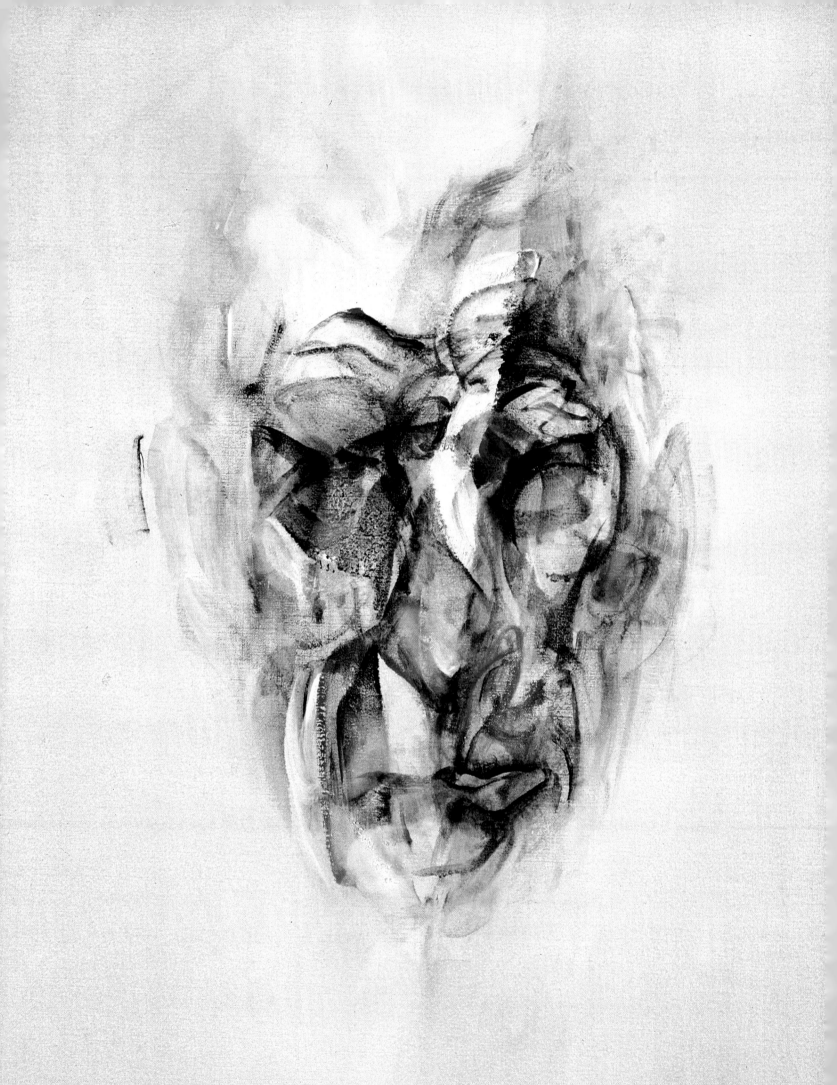

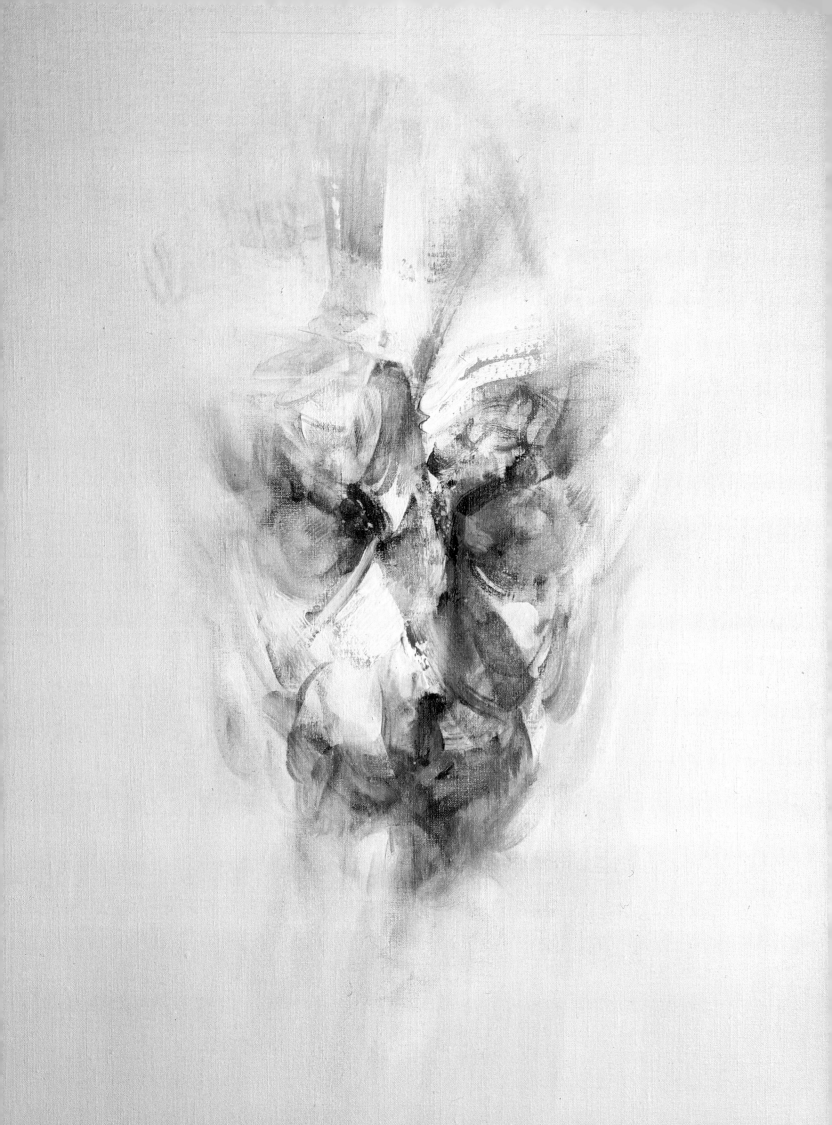

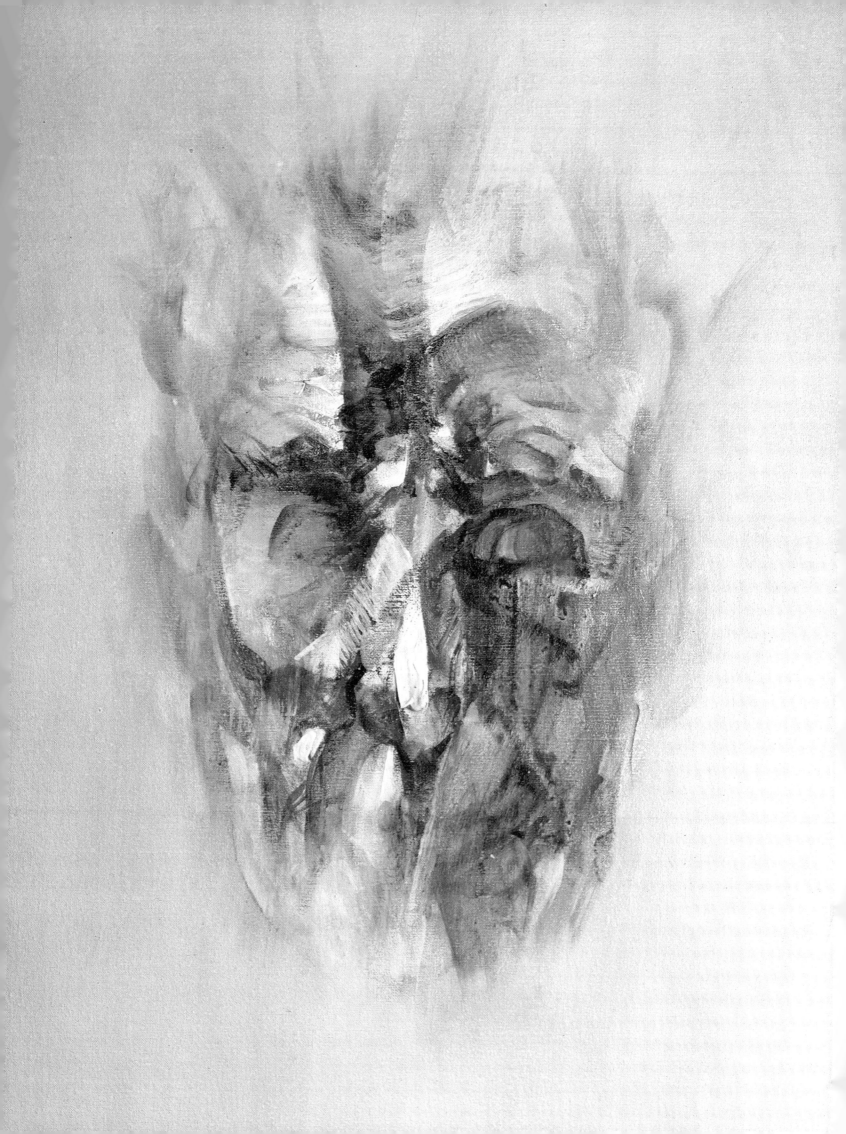

IMAGE OF SAMUEL BECKETT, 1994
oil on canvas, 92 x 73 cm (644)

page 124
IMAGE OF SAMUEL BECKETT, 1994
oil on canvas, 92 x 73 cm (645)

page 125
IMAGE OF SAMUEL BECKETT, 1954
oil on canvas, 92 x 73 cm (646)

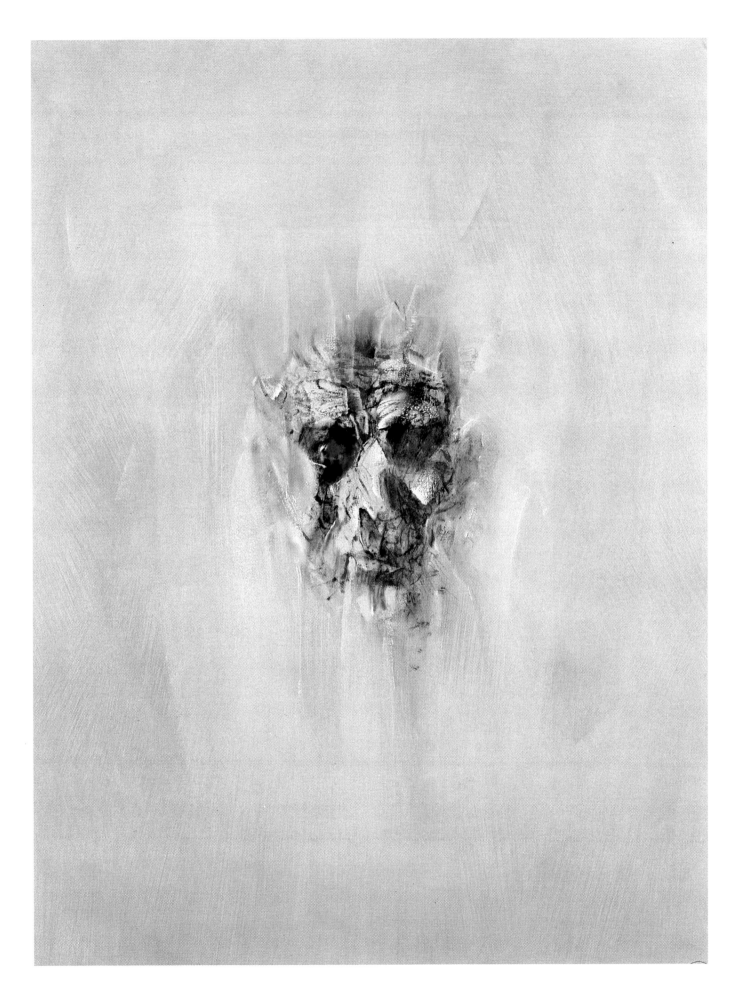

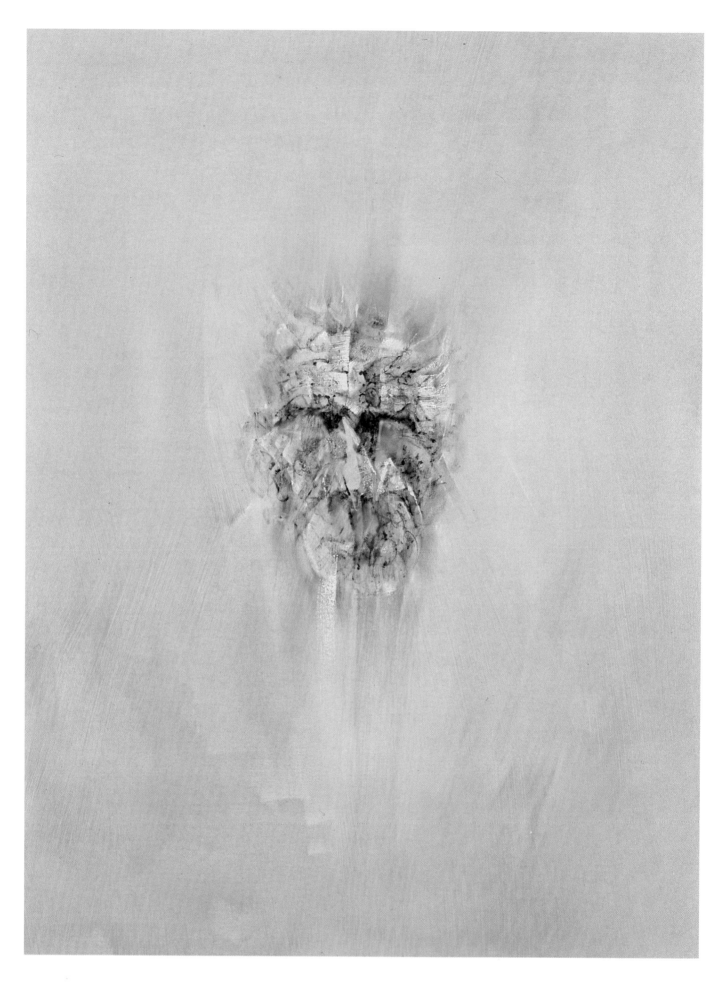

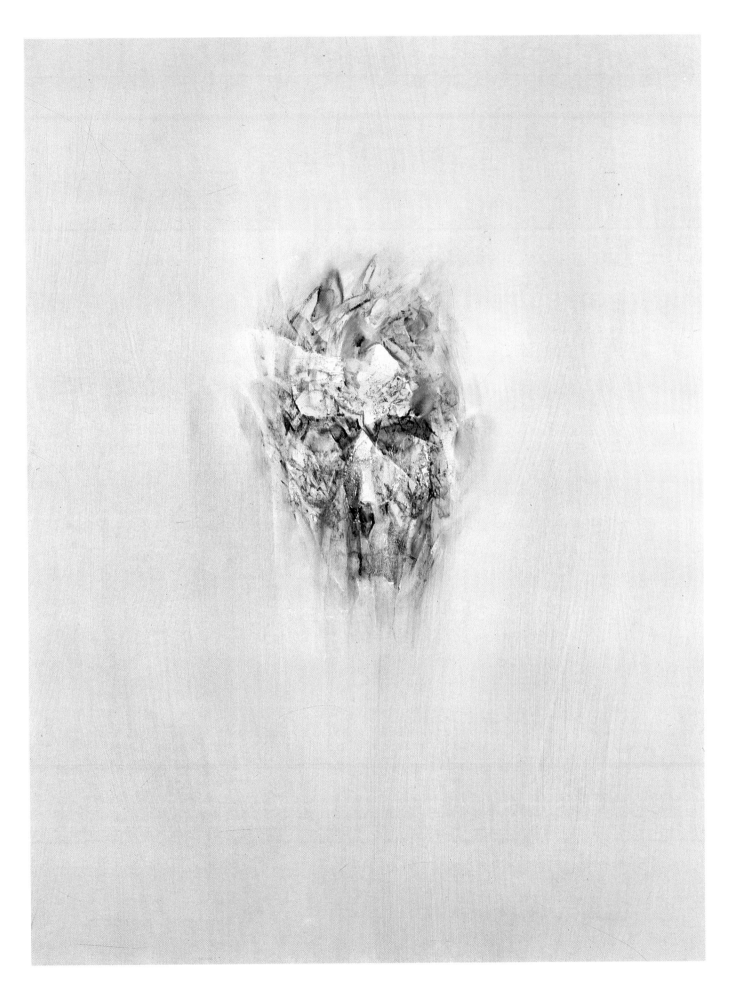

IMAGE OF SAMUEL BECKETT, 1992
oil on canvas, 146 x 114 cm (591)

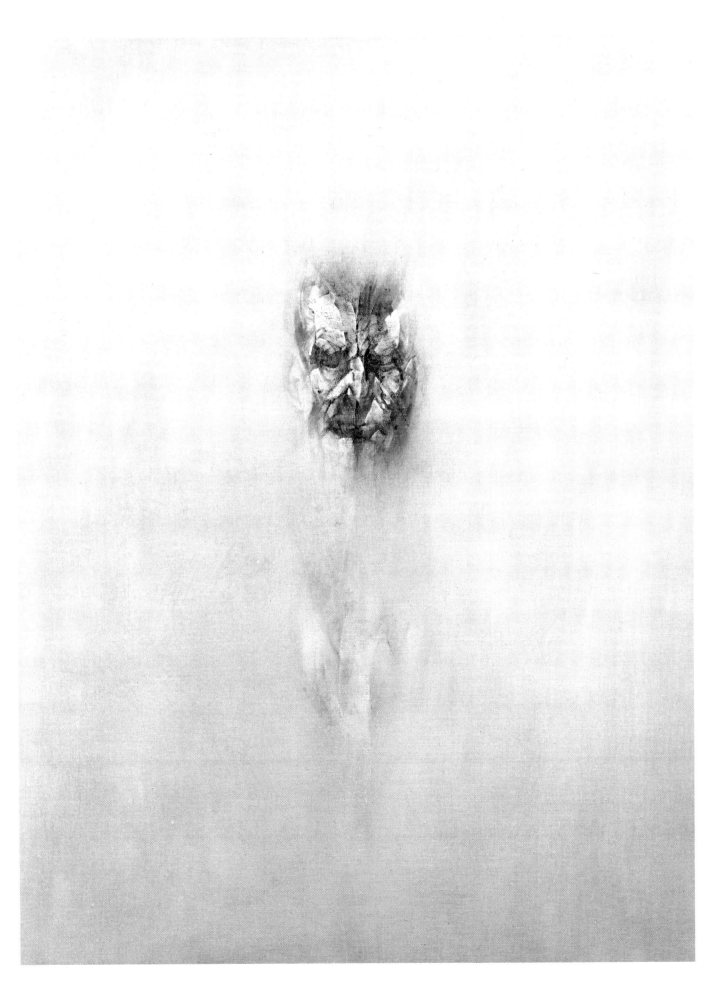

Image of Samuel Beckett, 1994
oil on canvas, 116 x 89 cm (642)

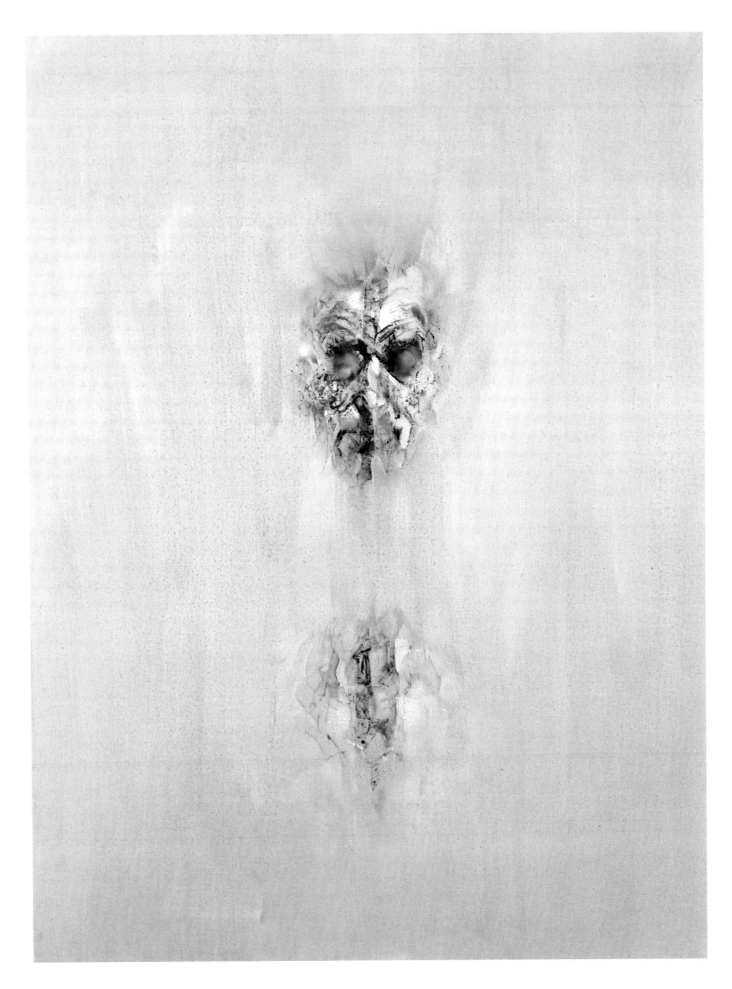

IMAGE OF SAMUEL BECKETT, 1994
oil on canvas, 116 x 89 cm (641)

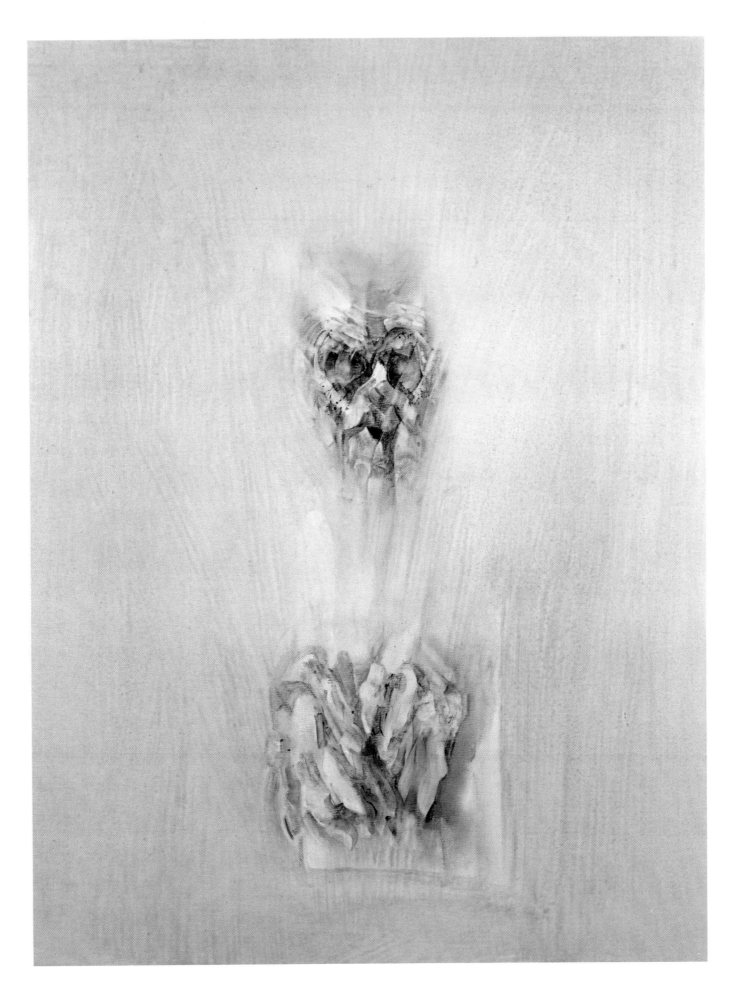

Image of Samuel Beckett, 1994
oil on canvas, 116 x 89 cm (640)

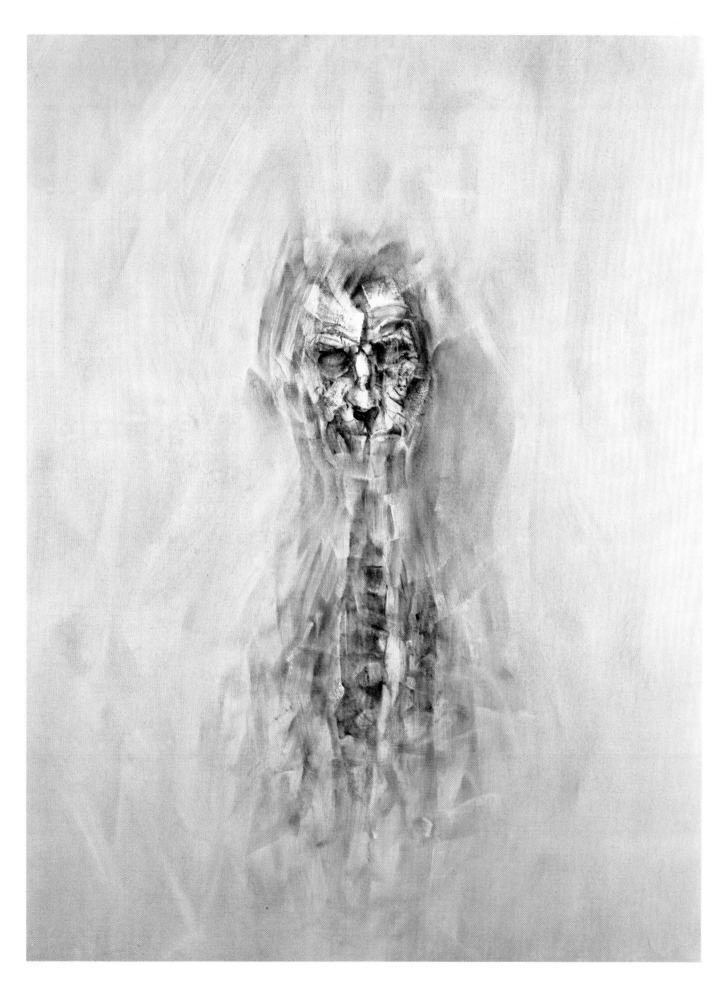

STUDY TOWARDS AN IMAGE OF SAMUEL BECKETT, 1992
Charcoal on canvas, 116 x 89 cm (593)

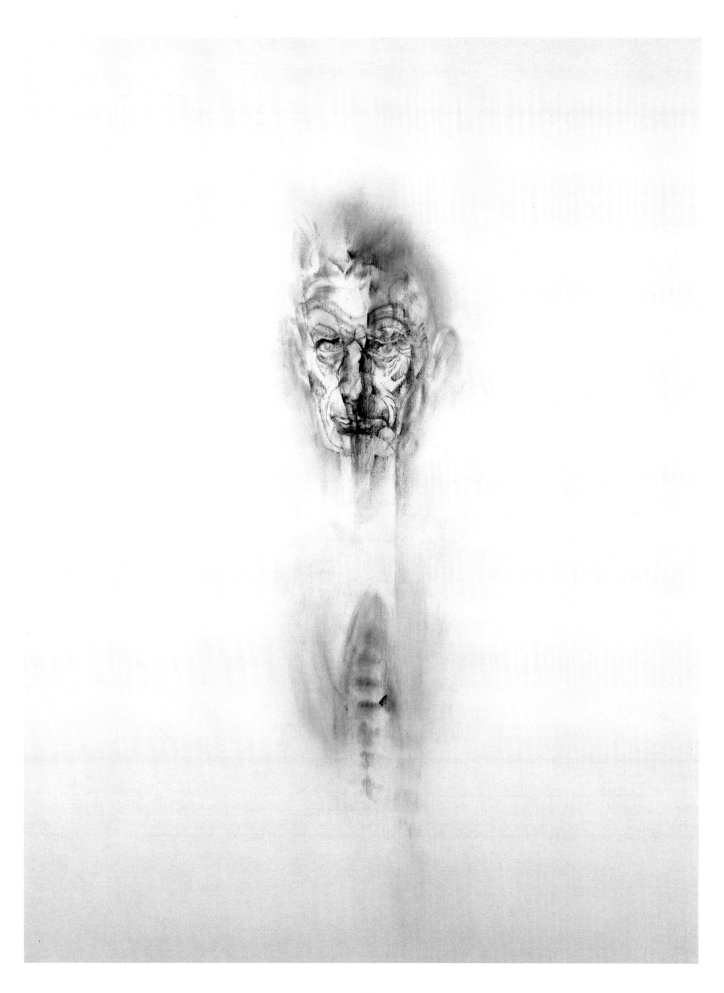

IMAGE OF SEAMUS HEANEY, 1994
oil on canvas, 92 x 73 cm (659)

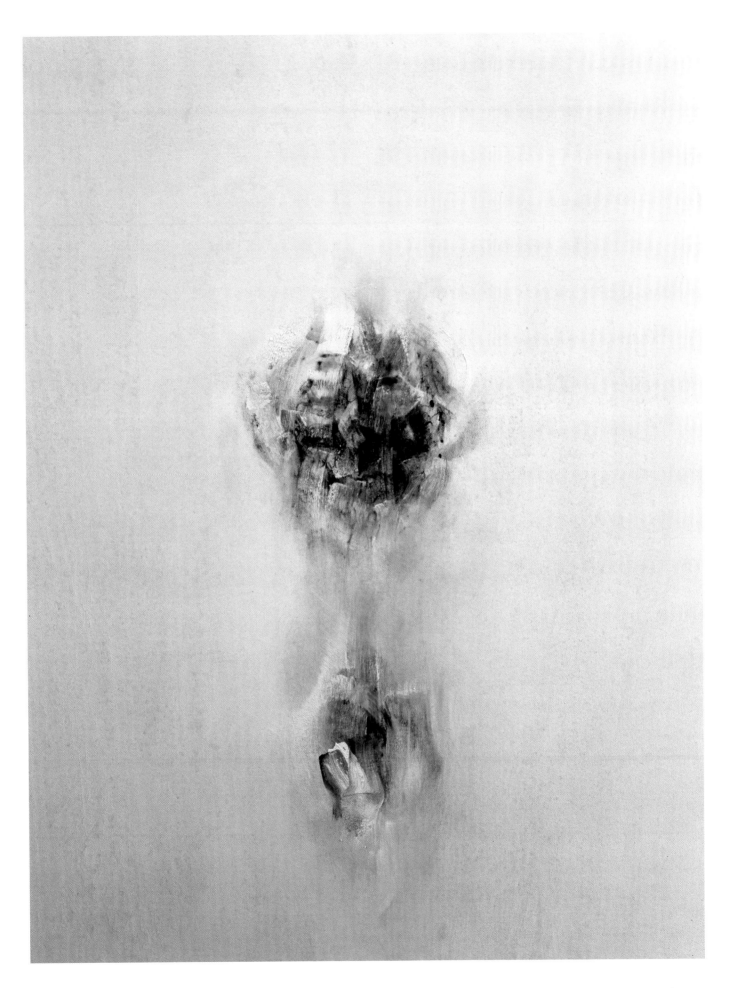

IMAGE OF SEAMUS HEANEY, 1994
oil on canvas, 116 x 89 cm (658)

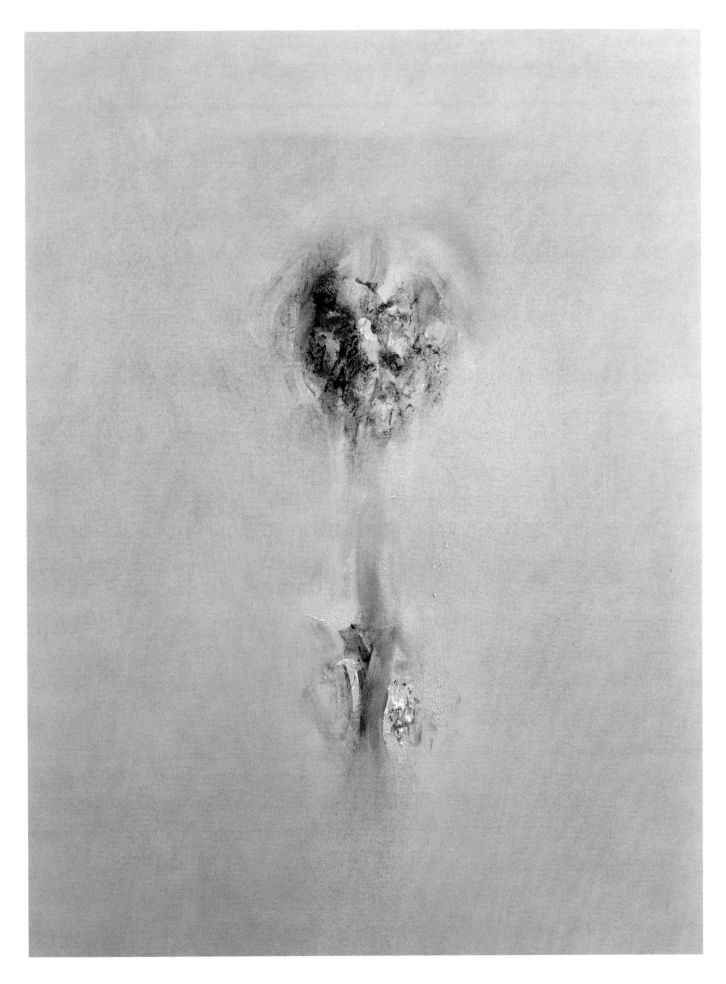

STUDY OF SELF, 1994
oil on canvas, 116 x 89 cm (643)

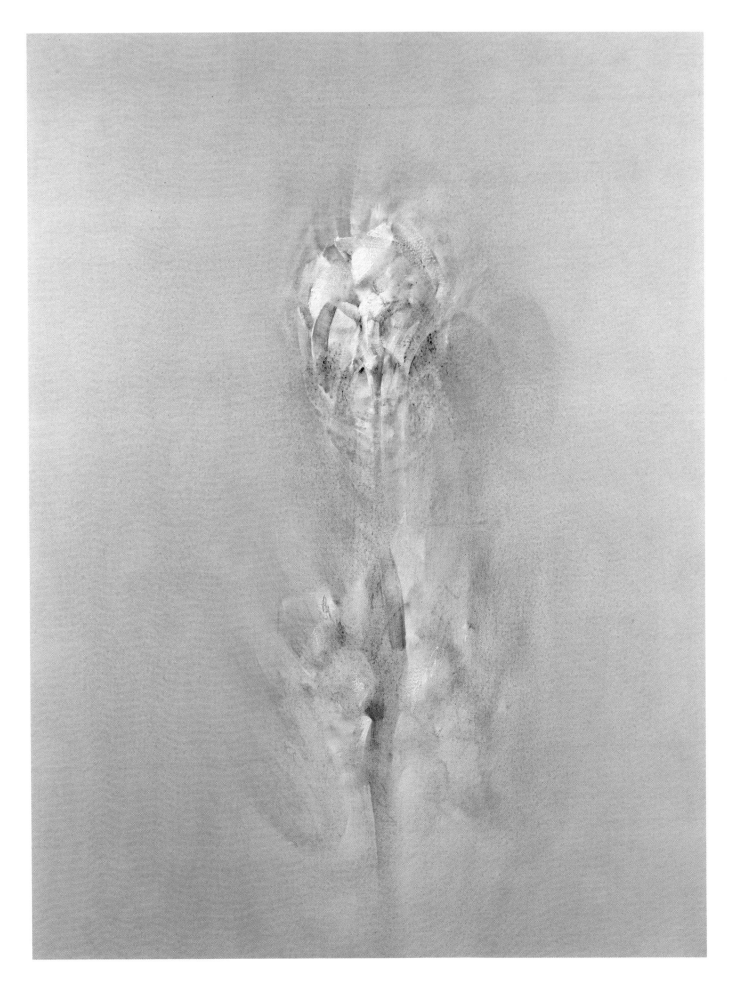

DESCARTES, 1995
oil on canvas, 55 x 46 cm (656)

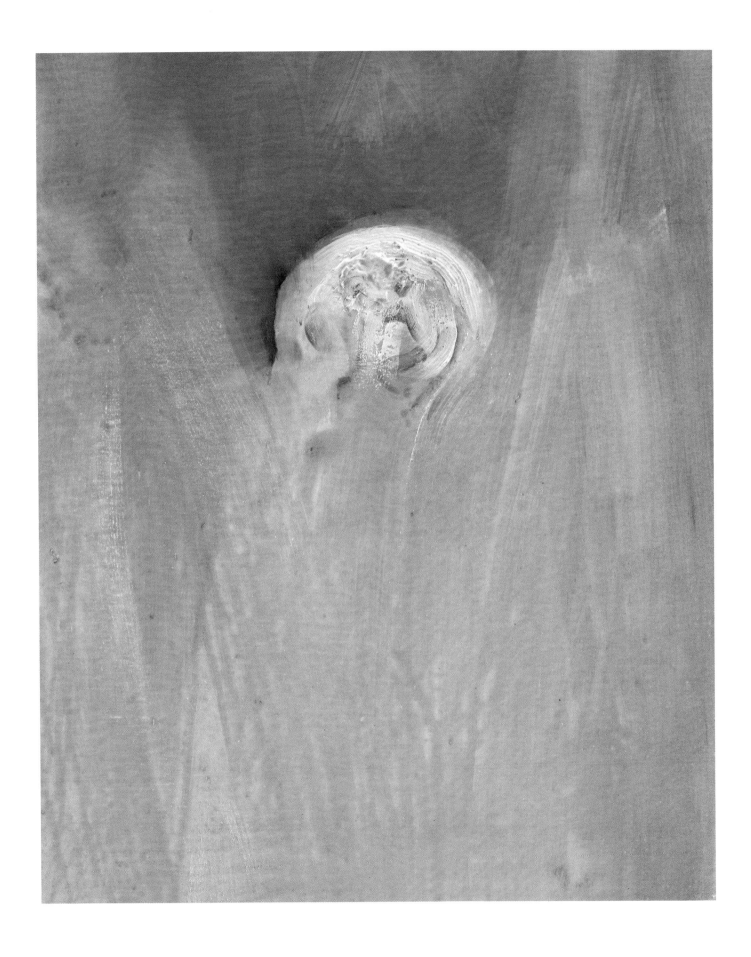

DESCARTES, 1995
oil on canvas, 116 x 89 cm (660)

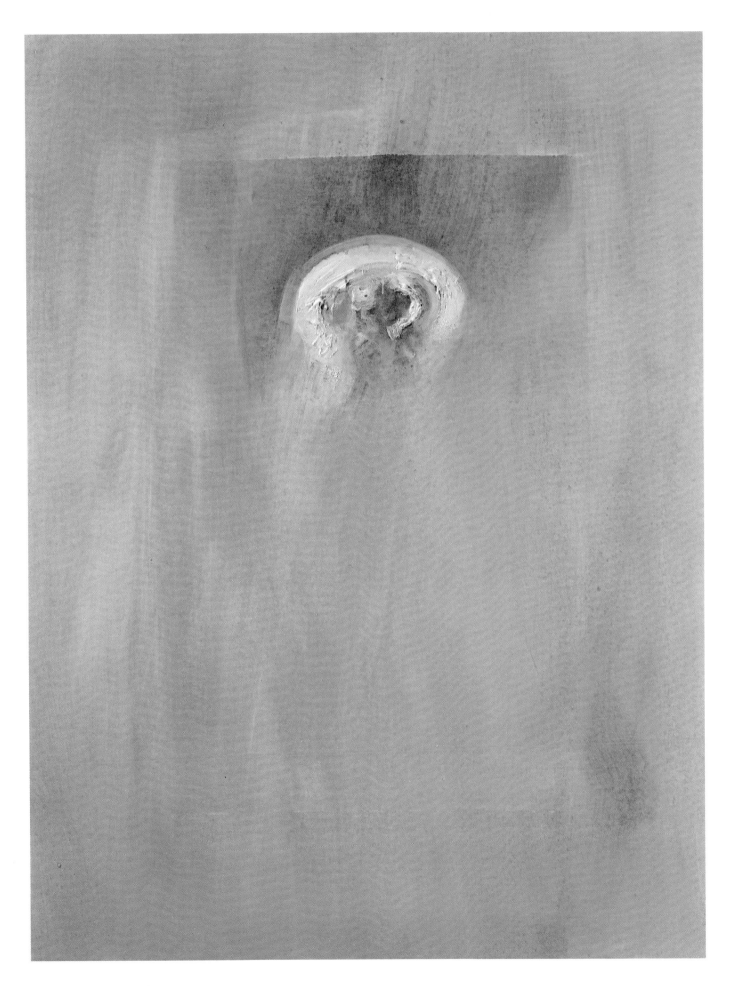

HUMAN IMAGE, 1996
oil on canvas, 116 x 89 cm (674)

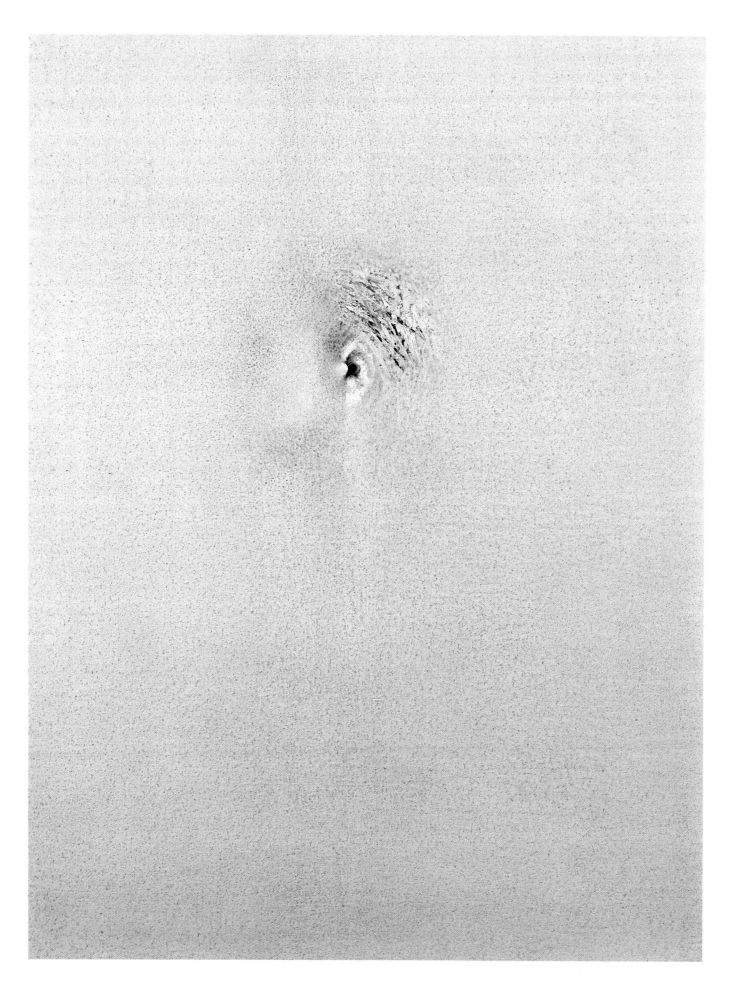

HUMAN IMAGE, 1996
oil on canvas, 92 x 73 cm (666)

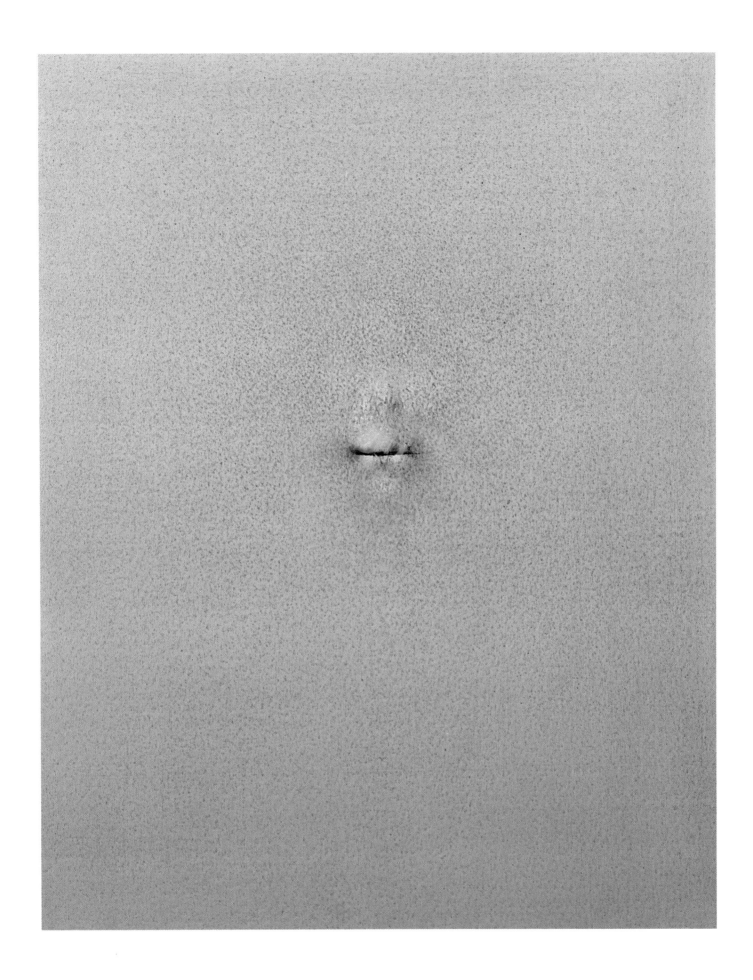

HUMAN IMAGE, 1996
oil on canvas, 92 x 73 cm (668)

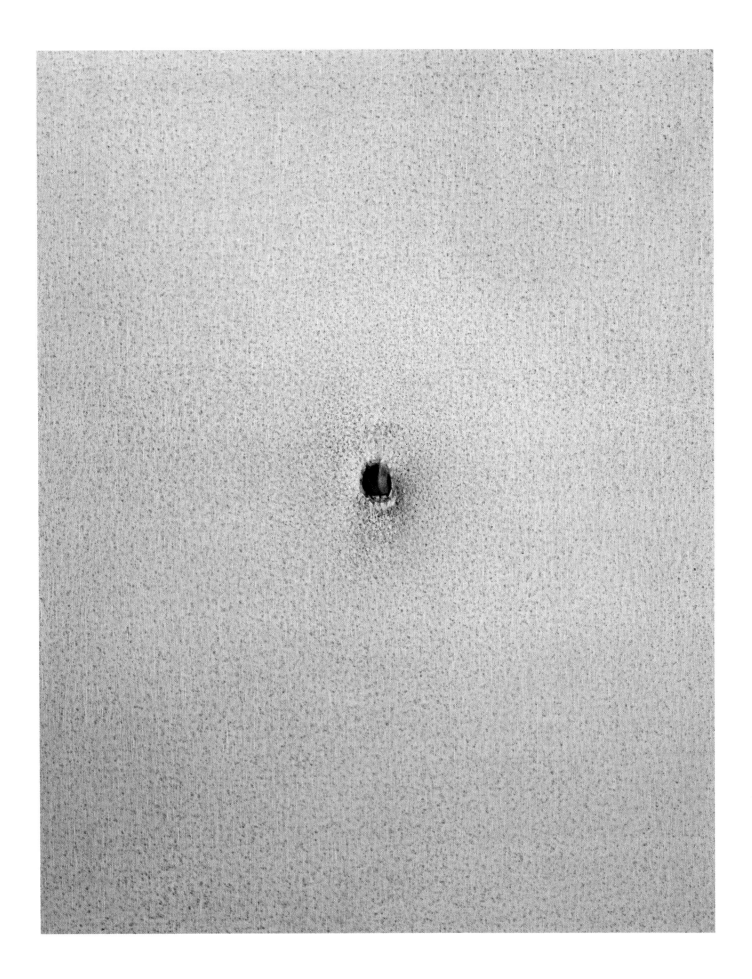

HUMAN IMAGE, 1996
oil on canvas, 116 x 89 cm (677)

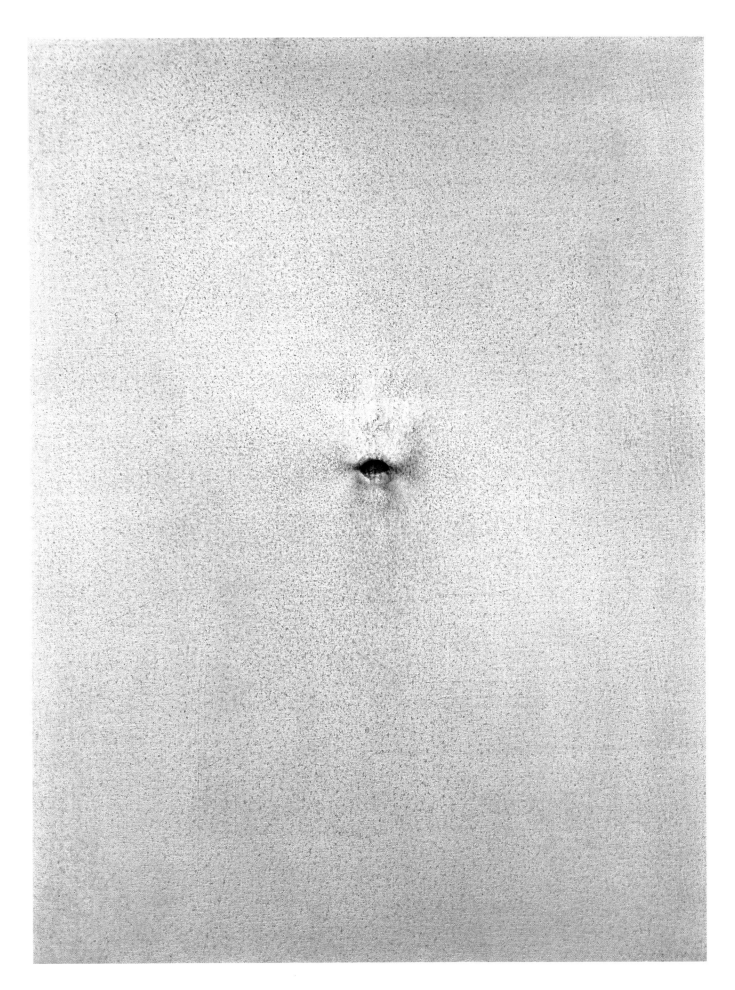

HUMAN IMAGE, 1996
oil on canvas, 146 x 114 cm (682)

LOUIS LE BROCQUY

THE HEAD IMAGE

l'Image de la Tête Humaine

UN ENTRETIEN AVEC LOUIS LE BROCQUY PAR GEORGE MORGAN

Cet interview a été enregistré lors de quatre rencontres, en 1995 et 1996, chez Louis le Brocquy dans son atelier située dans le sud de la France. Le texte a été abrégé et édité pour les besoins de la publication, mais le contenu et le ton reflètent fidèlement les pensées et l'état d'esprit de Louis le Brocquy lors de ces rencontres.

———

George Morgan – Il me semble que la caractéristique principale de vos images de têtes humaines, c'est leur répétition constante. Pourquoi la répétition obsédante de cette image? Qu'est-ce qui vous a amené à cette image?

Louis le Brocquy – Et bien, voyez-vous, afin de reproduire une image de l'être humain qui ait un sens aujourd'hui, il faut comprendre que certains facteurs qui se sont révélés au cours de ce siècle ont révolutionné notre manière de voir les choses. A cause de la photographie et du cinéma d'une part, de la psychologie d'autre part, nous ne pouvons plus considérer l'être humain comme une entité statique, qui ne serait sujet qu'à des changements d'ordre biologique. Nous ne pouvons plus voir les images de Dominique Ingres comme une représentation de la réalité de l'être humain contemporain, une réalité toujours changeante, cinétique et à multiples facettes. Le fait de remplacer une image unique et définitive par une série d'images non définitives a donc peut-être quelque chose à voir avec notre perception contemporaine, avec le fait de percevoir l'image comme une conception variable plutôt qu'une manifestation définitive au sens où on le faisait à la Renaissance. De nos jours, nous avons peut-être tendance à remettre les choses en question, à dé-construire et à analyser. La répétition/variation est un aspect de ce processus. La répétition n'était pas nécessaire à la Renaissance. Au contraire, le mode de pensée était représenté de manière linéaire, avec un début, un milieu et une fin, formant ainsi un tout, une plénitude. La répétition en revanche implique un mode de pensée non pas linéaire mais circulaire, une interprétation de la réalité comme une sorte de manège, une autre forme de plénitude, un autre tout dans lequel on peut entrer ou dont on peut sortir à tout moment. Cette dernière tendance, contre-Renaissance, est curieusement déjà présente ici et là dans notre tradition irlandaise, depuis le Livre de Kells et de Lindisfarne jusqu'à *Finnegans Wake*.

Quelle est l'origine de votre intérêt pour les têtes d'être humain? Quels ont été les facteurs émotionnels ou factuels qui ont déclenché cette découverte et qui font qu'elles ont pris un tel sens pour vous?

C'est le Musée de l'Homme à Paris qui est à l'origine de cette longue série d'images de têtes. C'est là, en 1964, que j'ai découvert les têtes peintes de Polynésie – des crânes dont on avait fait des moules en argile et qu'on avait peint de manière rituelle afin de contenir l'esprit. L'idée m'a vraiment passionné.

Est-ce que la découverte, plus tard, en Provence, de la dimension celtique de ce culte de la tête a également été une révélation?

Le fait de trouver ces sculptures en pierre grossière, systématiquement détruites par les Romains, comme l'ont été les Celtes eux-mêmes, en l'an 123 avant Jésus Christ, a en effet été une révélation. Mais vous savez, une révélation c'est essentiellement l'apparition d'une idée déjà latente dans l'esprit. En Irlande, j'avais connu des exemples isolés de la même culture, tels que la Tête Corlech aux trois visages. Tout cela s'est intégré dans le concept de la conscience humaine. Bien que la tête polynésienne m'ait fasciné, elle demeurait intensément étrangère. Je pouvais la comprendre d'un point de vue anthropologique, si je puis dire, plutôt qu'émotionellement. Le concept celtique reflétait en revanche mes propres sentiments.

Est-ce que ce culte de la tête est quelque chose que vous avez intégré à votre façon d'être? Est-ce que cela vous a affecté de manière existentielle? Ou était-ce simplement un outil et une technique qui vous permettent de poursuivre votre quête artistique?

Non, cela ne m'a pas affecté de manière existentielle. Cette pratique macabre datant de la Gaule m'était aussi déplaisante qu'elle l'avait été aux Grecs et aux Romains à qui l'on montrait, avec fierté, ces butins sacrés. En fait c'était une manière de trouver un chemin ou un moyen d'entrer dans un endroit invisible de la réalité, un endroit intangible sous l'apparence extérieur de l'être humain.

Et en même temps, cela vous donnait une sorte de point de vue.

Et un aperçu, j'espere.

A la suite de votre découverte en 1964 de ces deux cultes très différents de la tête, vous avez peint une série d'images de têtes, dont beaucoup étaient intitulées Tête Ancestrale. *Que recherchiez-vous?*

Ce que j'ai essayé d'évoquer dans ces tableaux, c'est la conception de vies humaines antérieures. J'ai tout fait afin de redécou-

vrir en imagination des traces visuelles d'êtres comme nous, d'êtres qui nous ont précédés historiquement et même préhistoriquement.

Considérez-vous cette activité picturale comme une sorte d'évocation, comme lors d'une séance spirituelle?

Non, cela reviendrait à évoquer la réalité visible. Le peintre évoque une réalité de l'esprit. Bien entendu je suis conscient que l'esprit se trouve non seulement dans les matériaux du peintre – dans la peinture même mais également dans la forme de l'objet peint. Je me souviens de l'émotion que j'ai éprouvée lorsque, il y a trente ans de cela, je suis tombé par hasard sur le crâne de René Descartes, qui était conservé dans une boîte en verre, dans la section authropologie du Musée de l'Homme – un dôme couleur ivoire, doux comme le sein d'une femme. Un simple morceau d'os peut-être mais, en fait, un tabernacle pour ce grand exemple de la conscience humaine.

L'anthropologue Joseph Campbell, dans The Hero with a Thousand Faces (le héros aux milles visages) décrit la quête héroïque en termes de différents masques portés par le héros alors qu'il poursuit son chemin jusqu'au périmètre de la conscience. Il semble y avoir une similarité avec la quête incessante et les visages changeants que l'on retrouve dans vos peintures.

Je n'ai pas lu Joseph Campbell mais j'aime beaucoup cette idée de différents masques portés par le héros. WB Yeats l'aurait peut-être aimée aussi, quand on pense à son masque, son alter ego, qui lui permettait d'aller plus loin encore dans la recherche de son identité et d'étendre encore davantage le vaste périmètre de son esprit. Cela me fait penser aux paroles poignantes de Samuel Beckett quant à la direction que prenait son art et ce qu'il appelait son échec:

> Car je me vois partir en mer
> de longues heures durant sans voir la terre
> je ne vois pas le chemin du retour ...
> Je n'entends pas la coque fragile touchant le rivage.

Les artistes dont j'ai fait le portrait encore et encore, tels que Yeats, Joyce et Beckett lui-même, je les ai envisagés de cette manière, essentiellement dans l'isolement de leur art, en dehors des circonstances.

Vous vous intéressez donc avant tout à leur être, à leur existence consciente.

Oui, et émerveillé par de tels exemples d'expérience humaine.

Votre choix du mot 'émerveillé' m'intéresse. Cela correspond à ce que je ressens au sujet de votre peinture: une sorte d'effroi mêlé d'admiration indéfinissable. Est-ce que c'est cela que vous recherchez?

L'émerveillement, me semble-t-il, est la chose la plus profonde en nous, trop souvent quelque chose qui disparaît avec l'enfance. Cela implique un état de non-connaissance, mais cela suggère aussi que l'on est conscient d'une signification possiblé et d'un mystère. C'est en s'abstenant d'imposer des idées conscientes, en laissant la peinture parler pour elle-même, que le peintre réussit parfois à susciter l'émerveillement.

S'il n'y réussit pas, alors sa peinture n'est pas réussie. Vous me demandez si j'allais, dans mes peintures, le plus loin possible vers la périphérie de la conscience. Je ne dirais pas du tout cela mais je pense que la conscience elle-même se trouve aux confins de ce que nous connaissons. C'est à la fois le plus familier et le plus distant de tous les problèmes – celui qui laisse la science perplexe parce que la science ne discerne rien au-delà de la nature de la conscience. L'oeil lui-même ne voit pas. La science peut analyser le comportement de la conscience – comme Freud et Jung l'ont fait – mais définir son identité comme on pourrait analyser les composants chimiques de l'eau n'est pas possible et à peine envisageable, autant que je puisse en juger.

Est-ce que cela vous décourage?

Non, au contraire. Cela m'incite à peindre à la recherche de cette réalité cachée que je ne pourrai jamais atteindre.

Est-ce que, en tant qu'artiste, vous essayez d'aller le plus près possible de ce périmètre? Est-ce que vous vous considérez comme un explorateur de nouveaux territoires? Ou est-ce que votre travail n'a rien à voir avec les mouvements artistiques contemporains, quelles que soient leurs diverses formes.

Que ce soit à Dublin, Londres ou ailleurs, je n'ai jamais appartenu à aucun groupe ou mouvement artistique. Cela ne m'intéresse pas beaucoup que mon travail soit jugé avant-garde ou autrement. A un moment ou un autre, mon travail a été critiqué ou ignoré de part et d'autre. A mon âge, je serais déçu, inquiet même, si les arts visuels n'avaient pas évolué. Sans aucun doute, ils ont évolué et cela me passionne d'être témoin des expériences imaginatives de ces dernières années. Mais, vous savez, ce qui m'intéresse moi, ce n'est pas d'aller loin mais en profondeur. Si mon travail a une quelconque originalité, comme celui d'un poète irlandais bien connu d'ailleurs, celle-ci a été obtenue en creusant. Une sorte de travail d'archéologie.

Une archéologie de l'esprit?

Oui, dans le sens que l'image n'est pas une représentation méticuleuse mais une découverte qui a pu, jusqu'à un certain point, se former elle-même, une image qui peut surprendre le peintre.

Aussi surprenante que l'image puisse être, les apparences et les formes extérieures continuent à jouer un rôle important dans votre travail.

L'apparence est très importante pour moi en tant que peintre. Dans le cas des images de tête, l'apparence signale l'identité. En essayant d'atteindre la réalité sous-jacente, je fais constamment référence à l'apparence extérieure – non pas comme on l'entendait à la Renaissance, mais simplement pour identifier l'essence de, disons, une pomme, un front ou une lèvre inférieure.

Dans vos images de têtes, est-ce que vous essayez mentalement d'aller en-dessous des apparences, au-delà de ce que vous avez appelé 'le rideau mouvementé du visage'?

Quand vous regardez des photos de quelqu'un éparpillées près d'un chevalet, près d'une image à mesure que celle-ci prend forme, inévitablement vous êtes attiré vers cette image. Stéphane Mallarme a appelé ce processus 'immersion'. Mais l'immersion peut être la cause de problèmes. Certaines personnes ont remarqué que plusieurs des images que j'ai peintes d'autres personnes ressemblent un peu au peintre. Je ne le vois pas moi-même. Cela n'était certainement pas mon intention mais je pense qu'il faut accepter cette ambivalence car l'image est reflétée dans la tête du peintre. Même les chèvres de Picasso ressemblent un peu à Picasso.

Est-ce que cet effet de miroir explique que vous aimez peindre la tête de face. Est-il important de voir la tête de face?

Franchement je pense que l'image de la tête d'un individu, qui inévitablement comprend quelque chose de sa réalité intérieure, doit être faite de face. Si la tête est vue de côté, de profil, l'individu est vu de manière plus objective, sans cette possibilité de voir à l'intérieur, implicite dans la rencontre face à face. Nous savons tous en effet que les yeux sont en quelque sorte des 'fenêtres' qui donnent sur une réalité invisible; leur expression a implicitement un sens très fort, même quand ils sont fermés. Sans aucun doute, la tête vue de face est, si je puis dire, plus pénétrable, plus transparente.

———

Vous avez souvent dit dans le passé que votre peinture était une forme d'exploration. A quel moment considérez-vous que l'exploration est finie, que la tête est réalisée, que vous avez fait ce que vous vouliez faire?

Vous posez là une question que l'on pose tout le temps aux peintres et qu'ils se posent eux-mêmes: quand une peinture est-elle finie? Il n'y a pas de réponse satisfaisante. Une peinture est finie quand elle est finie; quand on ne peut pas aller plus loin. On a fait quelque chose et on ne peut pas en faire plus, pour cette peinture là du moins.

Et si la peinture n'est pas réussie?

Il faut la détruire, elle a été détruite. En 1963, j'ai pratiquement détruit mon travail de toute l'année. J'étais désespéré à l'époque, mais je ne regrette pas ce que j'ai fait. J'étais parti dans une mauvaise direction. Mon amie, Joan Mitchell, aurait attribué ces tableaux à 'Henry'. Henry, pour Joan, est le singe tapi en chacun de nous et qui doit être fermement rejeté.

Est-ce qu'il vous est arrivé de regretter d'avoir détruit une toile?

Oui, souvent. Voyez-vous, à part Henry, il y a deux personnes qui sont impliquées dans un tableau. D'abord, il y a le peintre lui-même, qui travaille, impliqué directement dans sa toile; et puis il y a l'observateur, qui juge objectivement non seulement le peintre en train de travailler mais aussi le tableau fini. Ce dernier perçoit la structure picturale de manière plus précise peut-être mais peut très bien ne pas deviner la force inconsciente à l'origine du tableau. Et de temps à autre il détruit un bon tableau.

Est-ce que vous suggérez que l'artiste n'est pas le meilleur juge de son oeuvre?

En général, l'artiste a une compréhension de son oeuvre plus profonde que toute autre personne. Mais il n'est pas infaillible et lorsqu'il se trompe, cela peut avoir des conséquences désastreuses. Il y a quelques années, René Gimpel, marchand de tableaux parisien, qui parrainait Haïm Soutine, lui avait fourni, gratuitement, une gouvernante. Elle avait cependant la responsabilité de retirer les portraits avant que l'artiste ait peint les mains. Voyez-vous, c'est à ce moment là que Soutine considérait son travail comme fini et qu'il le détruisait presque toujours. C'est donc grâce à cette gouvernante inconnue que ces tableaux d'une urgence extrême, aux mains incomplètes, existent encore aujourd'hui.

Où situez-vous votre oeuvre par rapport à la peinture contemporaine?

Ce sera à d'autres de répondre à cela mais naturellement j'ai ma propre idée sur ce que j'ai essayé de découvrir au cours des années à travers mon travail de peintre et sur la direction de mon oeuvre aujourd'hui.

Ne pourrait-on pas dire cependant que la peinture est devenue moins pertinente? Est-ce qu'il n'y a pas eu un changement progressif dans les formes de l'art visuel? Il me semble que l'art contemporrain basé sur des techniques conceptuelles, environnementales et photographiques, a, en grande partie, remplacé la peinture.

Oui, bien des questions essentielles de notre époque, à la fois sociales et esthétiques, sont désormais exprimées par des moyens autres que la peinture, tels que par une autre conceptualisation de la réalité, par une nouvelle organisation de l'environnement, de nouveaux comportements et la photographie. Je pense que cette multiplication des moyens en ce qui concerne l'art visuel est une bonne chose et que cela mènera à de nouveaux modes d'intérrogation et de compréhension sur une plus grande base sociale.

Mais ces nouvelles formes ne vont-elles pas remplacer la peinture? Après environ six siècles, est-ce que vous les artistes vous n'êtes pas arrivés à une impasse.

Pas le moins du monde. Reconnue ou non, la peinture demeure aujourd'hui essentielle. La peinture n'a de limites que l'inspiration humaine.

Vous avez consacré la plus grande partie de votre vie à la peinture. Pensez vous que la peinture possède une qualité essentielle qui lui est propre?

Dans les mains d'un artiste, que son oeuvre soit abstraite ou figurative, la peinture peut devenir musique: une chose vibrante en elle-même.

Mais la peinture a également une autre ambivalence magique, une transformation à l'intérieur d'elle-même où la peinture, tout en conservant son identité matérielle, devient image et l'image, qu'elle soit une surface rectiligne ou une botte d'asperges, est transformée en peinture.

C'est Malraux qui disait que: 'le vingt et unième siècle sera mystique ou ne sera pas'. Pensez-vous que l'art ou la conscience

humaine en général va évoluer vers le genre d'exploration dans laquelle vous êtes engagé, l'exploration de l'émerveillement, l'exploration d'une spiritualité intérieure?

En étudiant la peinture, je me suis, bien, sûr demandé dans quelle sort d'ère nous étions entrés avec le vingtième siècle. J'ai même écrit quelque chose sur ce sujet quand j'étais professeur – invité au Royal College of Art au début des années cinquante.[1] Il me semblait alors que l'on pouvait observer dans la culture occidentale, depuis ses origines, une suite d'époques prolongées, de longues périodes où alternaient une perception de la vie tournée vers l'intérieur et une autre tournée vers l'extérieur. Nous savons tous qu'il ne faut pas trop simplifier les choses mais il me semblait alors que nos origines culturelles en Egypte, en Mésopotamie et dans la Grèce primitive représentaient une réalité tournée vers l'intérieur, une réalité conceptuelle. Puis, vers le cinquième siècle avant Jésus Christ, cette vue des choses semble avoir été suivie, de manière dramatique, par notre premier âge de la perception, âge scientifique, tourné vers l'extérieur: l'ère de la Grece antique et de Rome. Cela a changé à nouveau avec les styles byzantin, romain et gothique, lorsque nous nous sommes à nouveau tournés, sous une forme ou une autre, vers la spiritualité hiératique, comparable à une mosaïque de Ravenne. Vous devez admettre que lorsque nous sommes entrés à nouveau dans le monde du visible et du tangible, par le biais de la Renaissance, quand un ciel bleu est apparu au-dessus de nous, si je puis dire, remplaçant l'or byzantin de l'infinité. Mille ans après, le vieux monde classique renaissait et allait durer six cent ans encore.

Et maintenant?

Et maintenant? Et bien est-ce que, au tournant de ce siècle, nous ne sommes pas entrés à nouveau dans un nouvel âge immatériel, tourné vers l'intérieur? Est-ce que Cézanne en proclamant que 'la réflexion modifie la vision ' n'est pas revenu à une vision conceptuelle, à 'l'or' byzantin, à la 'réduction à la surface picturale'? Est-ce que l'espace 'en boîte' et anti-Renaissance de Cézanne ne révèle pas la matière sous forme de plans cristallins, matière qui allait être encore davantage déconstruite par Picasso et ses pairs?

Et pour ce qui est de l'avenir?

Comme André Malraux l'a observé, personne ne peut dire comment l'époque dans laquelle nous vivons va évoluer, mais au milieu des années cinquante, il me semblait que le vent avait tourné, que tous les signes visibles pointaient, tel un drapeau, dans l'autre direction, qu'avec l'avènement du vingtième siècle, un nouvel âge avait commencé.

Vous semblez creuser vers une sorte de noyau essentiel, ce que le critique Michael Gibson a appelé une 'quidditas' ou essence. Comment cette essence peut-elle surgir d'une tête? Qu'est-ce que vous en concluez?

Evidemment il n'est pas possible de peindre l'esprit. On ne peut peindre la conscience. On commence avec la connaissance, que nous avons tous, que la réalité humaine la plus significative se situe en deçà de l'apparence physique. Afin donc de reconnaître cela, de le sentir en tant que peintre, j'essaie de

peindre l'image de la tête à partir de l'intérieur, en quelque sorte, travaillant par couches ou plans successifs, ce qui implique une certaine transparence instable. Ce qui reste au bout du compte – si je suis de quelque façon que ce soit satisfait de l'image qui en ressort – c'est la suggestion d'une certaine turbulence sous la surface picturale, sous l'apparence externe de l'image. C'est tout ce que je puis dire.

Vous travaillez sur les têtes depuis trente ans. Il y a une continuité dans la façon dont vous travaillez. Est-ce que vous pensez qu'il y a eu une évolution?

Ma crainte est qu'elles soient vues comme quelque chose de répétitif et de monotone. Voyez-vous, ma quête se centre sur quelque chose de très précis, c'est une approche presque minimaliste qui exclue toute surface fortement animée ou toute utilisation libre de couleurs. Je creuse un trou très étroit, si je puis dire.

Est-ce que parfois vous avez envie de peindre autre chose, de vous étendre à d'autres domaines?

Parfois oui, je peins en effet des images de la nature: des colombes, des fleurs, des fruits, des déconstructions de paysages à l'aquarelle, ou cet ensemble de peintures les *Processions*; l'existence, si vous voulez, à un autre niveau. Cependant, il semble que je revienne toujours à ce qui est central: cette unité sociale et indivisible, l'être humain dans sa matrice d'isolement.

Qu'est-ce que le mot 'matrice' signifie pour vous?

Je me souviens qu'une fois vous avez fait référence aux pensées de Lao Tsu à ce propos, en ce qui concerne sa vision d'une matrice primordiale où toute réalité demeure non-née, une présence universelle, destinée à produire toute matière et toute vie.

En ce qui concerne ma peinture, je ne prétends pas à tant de profondeur! Mais on peut voir que l'image vient d'une matrice comparable ou d'un fond sans limites, ce que le critique Pierre Schneider à appelé 'un fond perdu'.

Est-ce que vous voyez dans ce phénomène, un phénomène purement physique ou est-ce qu'il y a, pour utiliser un mot problématique, des manifestations spirituelles?

Je pense qu'il y a une dimension spirituelle. La raison pour laquelle ce mot est problématique est qu'il est souvent compris dans un sens ésotérique. Pour un peintre, je pense que cela devrait simplement signifier les valeurs qui se trouvent au delà de son monde matériel, dans le monde de l'esprit.

Les têtes que vous peignez, du moins telles je les perçois, sont des paradoxes. Un critique anglais, Matthew Arnold, a écrit un jour que l'esprit celte est paradoxal dans sa nature: émergence/ immergence, apparence et ce qui se trouve au-delà de l'apparence. Que pensez-vous de ces paradoxes?

Je crois que j'ai toujours pensé que la peinture était en général ambivalente. C'est l'ambivalence de la réalité d'une peinture ou de ce qu'elle implique; sa ressemblance et sa différence par

rapport à la réalité du monde même, son aspect *autre*. Et puis en ce qui concerne ces images déconstruites de têtes que je peins, je vois une ambivalence singulière dans le fait que certains facteurs du monde réel – l'espace, le temps, les circonstances – ne sont pas représentés ou sont tout simplement absents.

Vous utilisez constamment des mots tels que 'tâtonnement', 'recherche', 'découverte' à propos de votre peinture. Est-ce que cela veut dire que lorsque vous peignez vous ne savez pas vraiment où vous allez?

Lorsque l'on peint, on ne se rend pas toujours tout à fait compte de ce que la peinture signifie. La signification s'impose petit à petit. Dans une de mes premières peintures, comme A *Picnic* en 1941 par exemple, je voulais simplement explorer l'art de peindre – le monde de Degas et la manière de peindre des Ukyo-e japonais. Il s'est passé beaucoup d'années avant que je ne perçoive la nature surréelle de l'image que j'avais peinte: trois individus ensemble pour un pique-nique, et en même temps isolés l'un de l'autre autour d'une nappe nue. Sans que je le sache à l'époque, la peinture semble impliquer que l'individu est essentiellement seul – chacun de nous seul dans le jardin entouré de murs qu'est la conscience. Bien sûr, nous regardons l'autre par-dessus le mur, mais même les amoureux ne peuvent pas entrer dans l'esprit de l'autre. Peut-être que la fonction la plus merveilleuse de l'art, quelles que soient ses formes, est que chacun de nous peut, dans une certaine mesure, prendre part à une conscience individuelle. Ce qui m'intéresse, cependant, c'est que cette compréhension, à la fois banale et profonde, m'est venue de la peinture, de l'acte de peindre.

Est-ce que vous exprimez toujours cette solitude dans les têtes que vous peignez?

Certainement chacune d'entre elles est isolée. Mais il y a quelque chose qui tient du paradoxe. Dans chaque peinture, une image particulière de tête prend sa place seule sur la toile mais cette présence solitaire est également en chacun de nous, elle est notre potentiel, ce que nous atteignons.

Une question plus personnelle, est-ce que la peinture est un moyen d'exorciser votre propre solitude, un moyen de créer une relation peut-être avec la solitude d'un autre?

Je ne pense pas que ce soit le cas. Au cours de ma longue vie, j'ai souvent été seul, mais j'en ai jamais consciemment souffert en conséquence. Bien sûr, l'enfant aurait peut-être un point de vue différent mais il ne me l'a pas fait savoir! Non, je ne dirais pas que j'ai cherché dans la peinture un moyen de compenser ma solitude à aucun moment donné.

Vous pensez donc que ce qui vous intéresse n'est pas d'ordre personnel mais plutôt lié à la condition humaine?

Oui, je pense que la solitude est peut-être la réalité la plus profonde de l'individu; mais souvenez-vous, une telle connaissance de la condition humaine est obtenue, en tant que peintre, essentiellement par ou suivant la logique particulière de l'acte de peindre. En faisant une centaine d'images de Joyce, sous différents aspects, j'en suis venu à comprendre non seulement sa

singularité mais aussi son isolement plein de fierté, sa solitude. J'avais le sentiment, dans une petite mesure, d'être entré dans cette solitude. Non, non pas entré mais de l'avoir touchée.

D'autre part, en dehors du monde de la peinture, je me souviens, c'était en 1944 à Dublin, le grand physicien Erwin Schrödinger nous expliquait que 'la conscience est un singulier dont nous ne connaissons pas le pluriel' et 'ce qui semble être la pluralité n'est qu'une suite de différents aspects d'une même chose.' [2] Cette pensée m'impressionne toujours profondément.

Comment cette vue de la conscience comme une chose unique et indivisible vous affecte-t-elle en tant qu'artiste?

Si la conscience est réellement une chose unique qui se retrouve en chacun de nous, il est évident qu'elle est développée de manière plus audacieuse chez certains êtres humains. C'est peut-être la raison pour laquelle j'ai été amené à peindre de grands artistes. L'art a son propre mode de pensée, et peut-être qu'en tant que peintre, je comprends mieux l'image d'un artiste que celle d'autres penseurs.

Et probablement que la pluralité de vos peintures de têtes n'est que la représentation de différents aspects d'une même chose. Que pourrait être cette chose?

Oui, je suppose que je suis enclin à voir ces têtes de personnes totalement différentes comme ayant un lien fondamental entre elles, chacune étant un aspect d'un tout. Mais ne diriez-vous pas que chacun de nous est une partie d'une seule et même chose, que nous appelions cette chose humanité, conscience ou le 'quelque chose sans forme et omniprésent' de Lao Tsu ou une des différentes interprétations religieuses de cette même chose?

Quelle est votre vue de la conscience par rapport à vous-meme?

Et bien, pendant longtemps j'ai pensé que ma propre conscience n'était pas entièrement mienne, que c'était quelque chose de plus vaste, de plus profond que cela. Après tout, comme nous tous, je suis un descendant de la pré-histoire. Mes jambes ne sont pas tout à fait mes jambes. Ce sont, pour ainsi dire, des jambes paléolithiques empruntées le temps d'une vie.

———

En 1975, vous avez commencé cette série d'images avec WB Yeats. Comment en êtes-vous venu à Yeats? Quel a été le stimulus?

L'origine de ces multiples images de Yeats vient de la Galerie Börjeson à Malmö qui tenait à préparer un ensemble d'estampes en hommage aux lauréats du prix Nobel. Autant que je m'en souvienne, il y avait quelque trente nations qui avaient obtenu un ou plusieurs prix Nobel. Des artistes représentant ces pays avaient été choisis en vue de faire une estampe pour rendre hommage au lauréat du prix Nobel de leur pays. Karel Appel représentait les Pays Bas, Miró, je me souviens, l'Espagne et ainsi de suite. Il se trouvait que je représentais l'Irlande. Parmi les lauréats irlandais à cette date – Beckett n'avait pas encore reçu le prix – j'ai choisi Yeats comme sujet parce que je pensais qu'il était le plus représentatif et parce que je l'avais connu quand j'étais enfant. J'ai fait un certain nombre d'études pour mon aquatinte définitive et j'avais été frappé par

la diversité de ces dernières. C'est à ce moment-là que je me suis rendu compte qu'un portrait ne pouvait plus être l'entité stable, immuable comme dans la vision de la Renaissance, que le portrait à notre époque ne peut pas avoir de finalité visuelle. C'est délibérément que j'ai continué à faire ces images, j'ai fait plus d'une centaine d'études de Yeats au fusain, à l'aquarelle et à l'huile. Elles ont été exposées au Musée de l'Art Moderne de la ville de Paris en 1976 et je me souviens le critique du *Monde* était venu à l'exposition et avait dit: 'Comment pouvez-vous dire que ce sont toutes des portraits de Yeats? Elles me semblent toutes très différentes les unes des autres et certaines lui ressemblent à peine.'

Quelle a été votre réponse?

Je lui ai répondu que je m'étais posé la même question, que je pouvais voir, et c'était vrai Théodore Roosevelt dans l'une et Marlon Brandon dans l'autre. Tout ce que je pouvais lui dire c'est qu'à chaque fois j'avais cherché à représenter Yeats et que c'était la seule chose constante dans tout cela. Par ailleurs, Anne Yeats à écrit dans le *Quotidien de Paris* que ces images lui rappelaient tout à fait son père tel qu'elle se souvenait de lui. J'aimerais pouvoir croire qu'au-delà de la ressemblance photographique, Anne avait peut-être aperçu quelque chose de Yeats de bien plus profond et qui lui était familier.

En peignant le portrait de Yeats, avez-vous été influencé par sa théorie du Masque comme expression de l'alter ego, de l'autre?

Bien sûr, le concept du Masque chez Yeats comme on le trouve dans *A Vision* et de manière récurrente dans sa poésie a beaucoup à voir avec son image. Le Masque de Yeats, son alter ego, était certainement dans ma propre tête quand je faisais ces études ambivalentes du poète.

Puisque nous parlons de masques, vous avez un masque mortuaire en bronze de James Joyce dans votre atelier. Est-ce que Joyce a une signification particulière pour vous? Il me semble qu'il à eu une influence fondamentale sur vous?

Je ne suis pas un expert de Joyce pas plus d'ailleurs que de Yeats, mais son oeuvre, sa vie, son être ont pris de plus en plus d'importance pour moi. Peut-être plus à cause de cet aspect de lui qui est singulièrement celtique, pas dans un sens nationaliste, mais au sens profond, c'est-à-dire un mode de pensée circulaire plutôt que linéaire.

L'image de Samuel Beckett semble également avoir eu beaucoup d'importance pour vous dans votre travail?

Oui, peut-être encore plus que ces images de Yeats ou de Joyce et à laquelle je reviens constamment. Peut-être que le courage, la ténacité, la rigueur, l'ironie et l'humanité que l'on trouve dans son oeuvre, je les ai compris d'autant mieux que je le connaissais bien.

Vous avez fait aussi le portrait de Shakespeare. Il n'y a aucun portrait de Shakespeare dont on soit sûr de l'authenticité. Est-ce que cela vous a gêné?

Lors de ma première exposition à la Galerie Jeanne Bucher en

1979, Jean François Jaeger m'a suggéré Shakespeare. Au départ, j'ai résisté, et puis, après réflexion, j'ai commencé une série de tableaux à l'huile et d'aquarelles par pure curiosité, pour ce qui en ressortirait. Etait-ce présomptueux? Je ne sais pas. Je me souviens que John Russell dans le *New York Times* avait utilisé le mot 'présomption' dans un compte-rendu qui par ailleurs était élogieux. Pour moi ces *Studies towards an Image of William Shakespeare* étaient en fait un jeu de l'imagination. A ce propos, on ne pouvait pas tirer grand chose des deux seules images authentiques de Shakespeare. L'une, une très mauvaise gravure faite par un contemporain dont j'ai oublié le nom. L'autre, une sculpture posthume en bois, d'abord peinte puis blanchie à la chaux, peinte et repeinte au cours des ans. Les deux ne portent aucune ressemblance l'une avec l'autre et ne montrent en rien la présence du plus grand des écrivains anglais et qui appartient au monde.

Vous peignez rarement des têtes de femmes, en dehors de quelques études de votre femme Anne. Pourquoi cela?

Je trouve difficile de peindre une tête de femme. La femme est peut-être plus vulnérable à la distortion. C'est vrai, j'ai souvent peint Anne, mais l'image mentale que j'ai de sa beauté entrave la découverte formelle lorsque je la peins.

Est-ce que vous préférez éviter les associations plus émotionnelles ou sensuelles liées au visage féminin?

Je dirais que mes propre sentiments émotionnels et sensuels par rapport à l'image de la femme sont les mêmes que lorsque je peignais les premières 'presences' – surtout des corps féminins – dans lesquelles l'aspect sensuel est tout à fait évident. C'est en tous cas ce que Herbert Read avait ressenti. Je me souviens qu'il avait dit dans sa *Lettre à un jeune peintre* que 'l'erotisme est intense' mais que seule la contemplation posée permettait de révéler 'toute la force des images érotiques'. Mais les têtes, c'est une autre histoire. Qu'elles soient d'hommes ou de femmes, leurs associations érotiques sont peut-être moins directes, étant donné qu'elles sont isolées sans le contexte du corps auquel elles appartiennent.

Est-ce que l'art est donc exclusivement une question de découverte formelle? Quelle place attribuez-vous dans votre conception des choses à la notion traditionnelle de 'beaute', cette 'joie éternelle'?

La découverte formelle est certainement au centre de l'art de peindre. Cela vient sans aucun doute du sentiment du sens des choses. Le sens des choses, tout comme l'émerveillement, n'est pas facile à formuler. Mais sans la signification, la forme picturale demeure quelque chose de mou et de décoratif. Je dirais qu'il y à le même lien avec la beauté en peinture. Sans la signification, la beauté risque d'être dépourvue d'intérêt un. La beauté, c'est aussi la signification.

Dans beaucoup des premières 'presences' et dans certaines des plus récentes têtes, il y a ce qui semble être la représentation de centres d'énergie, quelquechose qui ressemble à des chakras. Est-ce que c'était votre intention?

Je pense qu'elles peuvent être un peu considérées comme cela. Elles pourraient être comparés à des chakras parce qu'elles ne

sont pas des manifestations d'entités matérielles. A mon avis, elles représentent des sentiments – moitié physiologique, moitié sensoriel.

On a parlé de votre peinture comme d'une forme de découverte ou de recouvrement … le recouvrement de quelquechose de perdu. Vous semblez avoir une fascination pour les choses perdues, ou du moins absentes, un peu comme l'obsession de Seamus Heaney pour les Bog People, le Tollund Man. Dans son poème 'Strange Fruit', il fait référence à une tête de jeune fille. Voici les premiers et derniers vers:

> *Voici la tête de la fille, telle une gourde exhumée*
> *Un visage oval, la peau rabougrie, des noyaux de pruneaux*
> *à la place des dents.*
> *Ils dégagèrent la fougère humide de ses cheveux…*
> *…sans nom, terrible,*
> *Fille décapitée, qui voit plus loin que la hâche*
> *Et la béatification, plus loin que*
> *Ce qui avait commencé à ressembler à de la révérence.*

Dans cette représentation de la tête, il y a un élément de terreur, de 'terrible beauté'. Et cela est également très présent dans votre oeuvre, il me semble. Qu'en pensez-vous?

Il y a bien des années de cela, au milieu des années soixante dix, je crois, je suis allé à une exposition à Belfast. Dans le train, sur le chemin du retour, je passais de wagon en wagon pour me chercher une bière et, vous ne le croirez pas, je suis tombé par hasard sur Seamus Heaney. Je le connaissais à peine à l'époque mais nous avons passé le reste du trajet ensemble. Curieusement, nous venions tous les deux de lire *Bog People* ('Les gens de la tourbière') de PV Glob. Chacun de nous était hanté par l'Homme de Tollund, la Fille de Windeby et d'autres sacrifiés dans une tourbière à l'Age de Fer, laquelle les avait préservés parfaitement. Oui, je pense en effet que cet aspect *terrible* se retrouve dans mon oeuvre.

Est-ce que vous voyez donc une affinité entre ce culte des gens de la tourbière et votre propre découverte ou redécouverte des têtes?

Une des raisons pour lesquelles je m'intéressais tant à ces gens de la tourbière c'est que, comme les têtes polynésiennes, ils incorporaient et semblaient préserver la présence humaine. Leur visage, tordu par le poids de la tourbe, semblait indiquer encore davantage une émotion qui n'était pas recherchée, une émotion calme, hors du temps, qui les libérait même des terribles circonstances de leur mort.

Vous avez dit quelque part que votre oeuvre n'était pas une forme d'auto-expression. Et, en effet, votre oeuvre est à bien des égards extrêmement impersonnelle. Il y a dans les visages, une absence singulière d'émotion. Les yeux, quand ils sont présents, ont souvent un regardf fixe.

Je me rends compte que certaines de ces images de têtes peuvent apparaître comme impersonnelles dans leur isolement. Elles peuvent même être dérangeantes. Mais, vous savez, lorsque j'ai peint Federico Garcia Lorca, j'avais peur pour sa vie, tout autant que lui-même. Mon but est de sortir l'image de son contexte de la vie sociale ordinaire, de la placer en dehors du temps et des circonstances.

En un sens, elles suggèrent l'immortalité?

Elles pourraient être décrites comme des exemples de l'*idée* d'immortalité. L'idée se place dans une attitude métaphysique de l'esprit. Il est tout à fait raisonnable de dire que, puisque notre réalité est vécue dans le temps, ce qui est passé n'est pas réel; c'était réel. Pourtant pouvons-nous croire que ce qui est réel maintenant, en ce moment même, deviendra irréel? C'est une question métaphysique. Lorsque j'essaie de peindre l'image d'une personne, qu'elle soit vivante ou morte, elle demeure un élément d'un continuum et ce continuum est quelque chose qui forme un tout, c'est comme ça que je le vois. Ça forme une sorte de réalité qui, selon moi, ne peut pas disparaître complétement. De toutes façons, les conditions qui entourent le domaine dans lequel se situe ma peinture sont au-delà de cette considération de disparition. C'est un domaine dans lequel la notion de temps n'opère plus.

Récemment vous avez fait l'expérience d'une nouvelle série de peintures que vous avez intitulées Images Humaines, *et qui évoquent les différents orifices ou ouvertures du corps humain d'une façon plus ou moins explicite – la bouche, l'oreille, le nombril, etc. Qu'est-ce qui vous a amené à aborder ce thème?*

Je me souviens que le peintre polonais Jankel Adler m'avait dit que 'lorsque l'inspiration se manifeste, c'est sur le chevalet, pas au chevet.' C'était comme ça pour lui, et pour moi aussi, en cette matière. Et pourtant, il est curieux que cette idée me soit venue pendant la nuit, sortie littéralement de la pénombre. Ce que j'ai vu, ce dont j'ai pris conscience, était une surface picturale avec des trous et des fentes, suggérant un passage depuis ce qui est physique et extérieur dans la réalité humaine intangible de l'intérieur.

Cette nouvelle série se rapporte clairement à vos premières oeuvres. Et pourtant la façon dont vous traitez certaines des ouvertures 'humaines' les moins explicites, frise l'abstraction, embrassant un certain souci minimal. Considérez-vous ces oeuvres comme un nouveau départ ou une autre expérience dans votre voyage d'exploration de l'esprit?

Toutes les images importantes, je suppose, proviennent d'une expérience passée, même celles qui ont pour nous une signification à venir. Oui, bien sûr, je reconnais la réapparition des 'images présentes' dans les années cinquante, ainsi que les bouches ouvertes de la série *Têtes Ancestrales*. Bien sûr, dans ces premières oeuvres, la bouche ouverte pourrait déjà être interprétée comme une ouverture dans une surface. Vous avez raison aussi, lorsque vous suggérez que dans ces toutes premières oeuvres, une bouche isolée sur la toile et extraite du contexte du visage, peut paraître abstraite, un trou abstrait dans la surface d'une peinture minimale. Mais telle n'est pas mon intention.

Vous avez intitulé ces oeuvres Images Humaines, *et pourtant un grand nombre d'entre elles ont très peu de ressemblance avec la forme humaine en tant que telle. La façon très économique dont vous les peignez, suggère que vous vous éloignez de la dimension humaine vers une dimension métaphysique plus quintessentielle. Je sais que vous avez toujours affirmé un grand souci de l''humain', du moins dans son sens le plus évident. Est-ce que je me suis donc trompé?*

Depuis plus de quarante ans maintenant, j'essaie d'une façon ou d'une autre d'évoquer une sorte de signe qui pourrait éclairer cette réalité invisible que nous appelons conscience. L'apparence humaine se rapporte bien évidemment à tout ceci, mais elle ne constitue pas un élément central. Au fur et à mesure que vous vous rapprochez de ce centre intangible, qui est à la fois familier et mystérieux, vous avez peut-être tendance à pencher inévitablement vers le métaphysique, comme vous le suggérez. Mais la quête reste la même.

On observe dans ces tableaux un grand souci de la qualité de la peinture du pigment, de ce qui se passe sur la toile. On a dit, à ce sujet, que la surface devient présence. Est-ce que cela se rapporte bien à la façon dont vous travaillez ici?

Oui, tout à fait. Je m'efforce d'atteindre ce but depuis longtemps. En 1961, Robert Melville a dit à mon sujet que je m'efforçais de produire une identité substantielle de la surface et de l'image'. Peut-être y suis-je enfin parvenu.

Ces oeuvres sont remarquables en tant qu'événements ambivalents. Elles créent ce sentiment de frayeur et d'excitation que j'ai déjà mentionné, la terreur de quelque chose au-delà, et pourtant elles représentent aussi les moments d'un commencement, presque comme la première ondulation ou la 'soupe cosmique', pour ainsi dire, comme le chaos primordial forme la première bouche, le premier mot.

Il est plutôt extraordinaire que vous fassiez référence ici à la 'soupe cosmique' et autres éléments primordiaux. Afin d'activer, de donner de l'énergie à ces tableaux, j'ai dû appliquer plusieurs couches de peinture très diluée sur des toiles préparées. Il en a résulté une texture formée de grains et particules – particules 'primordiales', si vous préférez – qui pourraient s'amalgamer en une image humaine réduite à sa plus simple expression, émerger et s'ouvrir.

Il semble qu'il y ait un élément de violence dans ces oeuvres. Beaucoup d'entre elles suggèrent une déchirure ou une crevaison de la toile.

Je suppose que la violence existe dans chacun de nous, et nous sommes tous outrés par la violence de notre vie de tous les jours. On pourrait très bien interpréter mon image comme une bouche, isolée au milieu de la toile, comme un cri ou un hurlement, ou l'expression d'une indignation. Regardez autour

de vous. Tout cela existe! Mais on pourrait aussi voir un passage vers l'intérieur.

Ces tableaux évoquent également une hantise profonde, ce que Heaney a appelé une 'porte sur la pénombre'. Les têtes donnent déjà l'impression d'aller et venir entre le monde des apparences et la réalité derrière la toile. Vous avez ouvert la toile ici sur l'espace au-delà, un espace de mystère et de peur qui se profile et s'infiltre déjà. Je serais tenté de vous poser cette question naïve: 'Qu'y a-t-il de l'autre côté?'

Oui, pour moi, la bouche ouverte, la fente d'une bouche fermée, l'entaille profonde du nombril, l'oeil, l'oreille sont en premier lieu des ouvertures sélectives dans l'opacité du corps – des points d'entrée dans l'obscurité ou dans ce qui n'est pas visible, la réalité de l'être intérieur, l'autre 'côté'. Vous souvenez-vous d'une photo célèbre prise par mon vieil ami Henri Cartier-Bresson? On y voyait un homme regardant par un trou dans la barrière de toile qui entourait une arène apparemment provinciale. Je me trouve dans la même situation que le photographe (qui incidemment, est aussi peintre). Contrairement à l'homme qui regarde par le trou, témoin conscient du drame qui se déroule de l'autre côté, Cartier-Bresson ne perçoit que le trou dans la toile, au-delà de laquelle, à son sens, l'observateur fait une expérience dramatique consciente. Je suppose que c'est cette conviction excitante qui a poussé le photographe à prendre sa photo, motivé par la signification d'un trou dans une barrière de toile associée à l'expérience consciente cachée de l'autre côté. J'ai tendance à considérer les 'trous' dans mes tableaux, de la même façon.

Louis, nous arrivons à la fin de cet entretien. Avez-vous un dernier mot à ajouter?

Il faut que je réfléchisse. Non, pas vraiment...

Comment voulez-vous que l'on se souvienne de vous?

Je m'étais dit une fois, il y a bien longtemps quand j'ai commencé à peindre, quand j'essayais d'apprendre à peindre, que je serais très heureux si je pouvais atteindre le statut d'un bon peintre, ou être considéré comme tel. Et bien, de temps à autre, au cours des années, il m'est arrivé de penser qu'en peignant et par la peinture, il m'avait été accordé peut-être quelque chose de plus, qui me permettait de comprendre peu mieux le sens de la vie.

[1] 'Thoughts on our Time and Jean Lurçat', Louis le Brocquy, *Ark 17* (Royal College Art, London, 1956)
[2] *What is Life?* une série de conférences sur la génétique, donnée par le Professeur Erwin Schrödinger, Trinity College, Dublin

George Morgan, Maître de Conférence en littérature anglaise à l'Université de Nice, est spécialisé en littérature celtique. Il est également auteur de nombreuses études sur la poésie irlandaise et galloise, poète et traducteur de poésie.

Entretien avec Louis le Brocquy

MICHAEL PEPPIATT, 1979

Cet entretien est un concentré de plusieurs heures de conversation échangées dans l'atelier où travaillent le Brocquy et sa femme Anne Madden. Au cours d'une de ces rencontres, six têtes nouvelles de Beckett disposées en demi-cercle dominaient l'espace du haut de leurs chevalets; la fois suivante, ce furent celles, à peine achevées, de Bacon. L'ambiance inquiétante et sévère qu'elles dégageaient se dissipa pendant la conversation, remplacée par une impression plus humaine. Sur le mur du fond, le masque mortuaire de James Joyce, intériorisé et serein, surveillait la scène d'un léger sourire de bronze. Sous ces regards scrutateurs naissait l'impression que tout n'était que surface et apparence: les têtes peintes et les têtes parlantes n'étant que deux couches d'une illusion destinée à disparaître.

———

Michael Peppiatt – Pendant les cinq dernières années vous avez peint des centaines de portraits de Yeats, Joyce et Lorca. Vous avez maintenant commencé de Beckett et de Bacon. D'où vous vient cette fascination pour la tête et la tête seule?

Louis le Brocquy – Cela a commencé après avoir traversé une très mauvaise année, une année aveugle, pour ainsi dire, pendant laquelle aucune image ne se présentait. C'était en 1963. Pendant les six ou sept années précédentes, j'avais travaillé à une série de personnages – ou plutôt a ce que je nomme des «présences» – sur fond blanc, lorsque brusquement le flot des images s'est interrompu. À la fin de cette année, j'ai détruit quarante-trois mauvais tableaux. En étant arrivé là, j'étais moi-même en très mauvais état évidemment, et ma femme proposa un voyage à Paris, comme si c'était un endroit où nous allions pouvoir découvrir quelque chose de nouveau. Et, curieusement, j'y ai fait ce qui devait être une découverte vitale: les masques de Mélanésie et de Polynésie du Musée de l'Homme. Ce sont, comme vous savez, des crânes en partie remodelés avec la glaise, peints d'une façon décorative – souvent avec des coquillages à la place des yeux. Ils m'ont énormément impressionné et peu après, j'ai commencé à peindre des têtes, des têtes privées de corps, si vous voulez, et même privées de tout contexte. Un peu plus tard, en 1965, je me suis trouvé près d'Aix-en-Provence, à Entremont et Roquepertuse, en présence d'un autre exemple du culte de la tête – celte, cette fois. Et cette deuxième rencontre confirme mon impression que la tête est une sorte de boîte magique retenant l'esprit prisonnier.

Vous parlez maintenant de têtes sculptées, je pense.

Oui. Vous pouvez en voir des vestiges aux musées d'Aix et de Marseille. Il reste peu de chose de la culture celte, vous savez. Les Romains l'effacèrent systématiquement, ils détruisirent *l'oppidum* d'Entremont aussi bien que le sanctuaire de Roquepertuse. Il est vrai que les Celtes avaient eux-mêmes des mœurs assez déplaisantes, celle entre autres de couper la tête de leurs prisonniers et de les porter à la ceinture.

Comme les Scythes…

Oui. D'ailleurs, j'ai été frappé par l'idée que les Celtes pourraient d'une façon ou d'une autre descendre des Scythes. Leur art présente des rapports assez évidents. Mais, comme je vous le disais la culture celte en Gaule fut détruite par les Romains: les druides furent repoussés au fond des forêts et pourchassés. Pourtant, en Irlande, cette culture à survécu; le christianisme l'a simplement modifiée. Lorsqu' Edmund Spenser, le poète élizabéthain, traversa l'Irlande, il fut bouleversé par la pauvreté les gens tombant morts de faim devant ses yeux, par exemple – mais il n'a pas compris les Irlandais. En fait, il les considérait à peine comme des êtres humains. Il était un homme de la Renaissance, eux étaient Celtes – les ancêtres en esprit de Joyce. Et ce poète, d'une sensibilité raffinée par ailleurs, préconisait la destruction complète – littéralement – des Irlandais qui, à ses yeux, ne pourraient jamais être «civilisés». D'autres peuples devaient également les trouver barbares… Vous pouvez imaginer ce que les voyageurs grecs et romains ont dû éprouver lorsque les Celtes leur faisaient les honneurs, y compris la visite de leurs têtes célèbres en conserve! Ils avaient coutume, vous savez, de conserver la tête de leurs grands hommes dans leurs sanctuaires.

Je me demandais si vos tableaux avaient un rapport quelconque avec ces coutumes.

Je ne suis pas précisément un adepte du culte irlandais de la tête. Mais ce que je fais n'y est pas complètement étranger en un sens. Comme les Celtes, j'ai tendance à considérer la tête comme une boîte magique qui retient l'esprit. Entrez dans la boîte, écartez le rideau boursouflé du visage et vous aurez le paysage complet de l'esprit. Le visage lui-même, cette écorce indéniable de la réalité, est aussi une expression de l'esprit dans une certaine mesure. C'est en fait ce qui me fascine parce que je suis obsédé par les apparences et ce qu'elles révèlent; la mobilité des expressions chez certains individus, par exemple, et la vitalité intérieure qui les transforme à tous moments. Si

bien que le visage est – pour moi, du moins – un paradoxe masquant l'esprit et le révélant à la fois.

Mais quelles sont les raisons précises qui vous ont amené à Yeats, Joyce et les autres? Était-ce l'admiration?

J'ai été attiré par l'œuvre, oui, certainement, et avant de commencer à les peindre je m'en suis imprégné aussi complètement que possible. Cependant, je les regarde moins comme des hommes célèbres ou brillants que comme des êtres vulnérables, des êtres particulièrement impressionnants, qui sont allés plus loin que d'autres et qui pour cette raison, sont plus isolés, plus émouvants. J'ai été attiré par-dessus tout par le chemin qu'ils ont parcouru durant leur vie et par l'ampleur universelle de leur vision.

Je crois que vous avez connu Yeats.

Oui, de la façon dont on dit d'un enfant qu'il «connaît» un maître ou un autre personnage important. Ma mère connaissait sa famille et je le voyais souvent – c'était un homme très remarquable. Yeats est un merveilleux exemple de la façon dont les apparences changent. Dans les images que j'ai faites de lui – je pense à elles comme à des traces, à des images plutôt qu'à des portraits – je permets à des aspects très différents de sa personnalité de se manifester.[1] Il faut dire que, maintenant que la photographie nous a montré les multiples facettes de l'apparence humaine, il serait futile et prétentieux d'essayer de capter les traits d'un homme célèbre en un seul portrait. En tout cas, dans ces séries d'images vacillantes que j'ai faites de Yeats, j'espère avoir retenu quelques-uns des multiples aspects du visage de cet extraordinaire irlandais et avoir ainsi exploré le paysage caché derrière ces «anciens yeux étincelants». Parfois, je me suis senti pris au jeu de l'évoquer, comme au cours d'une séance de spiritisme...

Avez-vous ressenti une impression semblable en travaillant aux portraits de Joyce?

Je me suis souvent taxé d'impertinence alors que j'interprétais l'apparence de ces hommes. J'avoue que Joyce m'inspira de la crainte, j'étais même littéralement effrayé. Son visage est le plus évocateur et le plus douloureux de tous ceux auxquels je me suis attaqué. J'étais extrêmement conscient de tout ce qu'il a dû souffrir – les humiliations, l'incompréhension, les souffrances physiques et la pauvreté. Et je pensais aussi constamment à l'extraordinaire aventure qui s'était déroulée dans sa tête. Parce qu'il a vraiment poussé les choses à l'extrême n'est-ce pas, naviguant dans des eaux où très peu de gens ont eu l'audace de s'aventurer. Je veux dire que ces hommes, Joyce et Yeats, étaient de véritables héros, des Prométhée de courage. Et toutes ces tensions sont devenues si fortes pendant que je travaillais au portrait de Joyce qu'à un certain moment j'ai eu l'impression que je ne pourrais pas continuer, je ne pouvais tout simplement pas retourner à l'atelier et me confronter à cette tête – un peu comme le Douanier Rousseau qui n'osait pas entrer dans son atelier après y avoir peint ce terrible lion!

Vous avez fait quelque cent vingt études d'après Joyce.[2]

Oui, si vous comptez, en même temps que les huiles, toutes les aquarelles et les fusains. En un sens, j'aurais pu continuer indéfiniment parce que je n'ai jamais eu l'impression d'avoir atteint quelque chose de définitif ou de concluant dans mes images. Je pense que l'œuvre même de Joyce était un peu semblable à ça, circulaire plutôt que linéaire, finissant comme elle avait commencé! Un cercle où l'on peut entrer à tous moments, à n'importe quel endroit. C'était l'œuvre d'un esprit celte, tout à fait remarquable, un esprit anti-Renaissance, dans un sens anti-logique peut-être comparable dans sa patiente minutie et sa con stante circularité aux méandres du célèbre manuscrit enluminé du Book of Kells. Puis, vous avez l'extraordinaire construction plastique de la tête même, avec le grand équilibre sculptural du front bombé et du menton saillant, avec le nez placé dans le vaste espace creux entre les deux. Une tête comme un croissant de lune.

Vous vous imprégnez de l'œuvre et de la vie des gens que vous peignez, mais vous accumulez également leur image photographique. Quel rôle donnez-vous à ces photos?

J'y trouve pour ainsi dire des preuves objectives, même quand ce sont de mauvaises photos, c'est-à-dire quand elles ne correspondent pas à l'apparence conventionnelle du sujet. Je cherche à faire des images aussi objectives que possible. Je sais, naturellement, que tout ce que l'on fait est, dans une certaine mesure, subjectif, le reflet de soi-même. Dans ce sens, la toile devient une sorte de miroir, et en peignant les autres, on se peint, du moins partiellement. En dépit de cela, je m'intéresse surtout à *l'autre*. Je pense qu'il serait prodigieusement fascinant de pénétrer dans la tête de quelqu'un d'autre, même dans celle d'un chat pendant quelques instants. Nous nous voyons tous très différemment, j'en suis certain. Si je pouvais par exemple entrer dans votre tête lorsque vous regardez Anne, je suis convaincu que je penserais «Non, non, ce n'est pas Anne. Anne n'est pas du tout comme ça.»

Comment utilisez-vous les photos lorsque vous travaillez?

Souvent je ne les regarde pas du tout, mais si je m'y réfère, j'en ai deux ou plus près de moi en même temps. Elles doivent me présenter des facettes très différentes des personnes en question et, en peignant, je n'essaie pas de les réconcilier. J'essaie de découvrir des aspects différents, des strates de la personne dans l'image que je suis en train de faire. Et les photos sont aussi des rappels utiles de la mobilité du visage, elles m'aident à éviter le piège de la ressemblance, ou du moins à demeurer conscient du danger. J'ai tendance à travailler en série, vous savez, et en travaillant sur trois images en même temps, cela aussi m'aide à briser l'idée simplement conventionnelle que l'on à d'une autre personne.

Vous auriez pu continuer indéfiniment à faire des images de Joyce. Qu'est-ce qui vous a poussé à entreprendre un nouveau sujet en fait?

J'aurais pu continuer avec Joyce seulement, c'est vrai. Mais j'ai aussi accueilli avec plaisir l'épreuve que présentait une personnalité nouvelle; j'aimais l'idée d'explorer un autre pays tout différent. Et puis le changement rend plus apte à reconnaître les formules stériles dans lesquelles on à tendance à s'enliser après un certain temps. Vous savez comment le nez de Yeats, large à

la base, s'amincit brusquement de façon si caractéristique? Eh bien, dès que vous êtes pris dans de telles formules, vous commencez à obtenir une image ressemblante de Yeats les yeux fermés – c'est un piège, une invitation à la facilité. Même chose avec Francis Bacon, si vous vous limitez à la largeur frappante des maxillaires. Or, l'habileté n'est pas ce que je recherche. On m'a reproché d'en avoir trop, trop de facilité technique. Mais un incident m'a permis de contredire cette impression: il y à deux ans environ, je me suis blessé à la main droite qu'une greffe de l'os à immobilisée dans le plâtre pendant plusieurs mois. Pour la première fois de ma vie, j'ai commencé à peindre de la main gauche et les images produites par celle-ci ne pouvaient être distinguées des autres: elles n'étaient ni meilleures ni pires. Et maintenant, bien que ma main droite soit en parfait état de nouveau, je continue parfois à peindre de la main gauche pour encourager l'inattendu ou l'accidentel qui permet à une image d'émerger.

Comment expliquez-vous le mot «accident» dans ce contexte?

L'accident est très important pour moi. Je crois que mon rôle d'artiste – pour autant qu'il existe – est essentiellement de reconnaître la signification des signes qui se forment. Ceux que je retiens et que je développe, ceux dont j'espère que l'image surgira. Pour moi, la peinture n'est pas un moyen de communication, même pas un moyen d'expres sion, mais plutôt un processus de découverte, ou de dépouillement. Je pense au peintre comme à une sorte d'archéologue, un archéologue de l'esprit qui remue patiemment la surface des choses jusqu'à ce qu'il fasse une découverte importante qui lui permette de poursuivre sa quête.

Comment ces signes importants se produisent-ils? Comment commencez-vous une nouvelle image?

Pour un tableau à l'huile, je fais d'abord une esquisse assez grossière au fusain. Ensuite, je prends le pinceau et je le trempe dans un peu de bleu d'un côté, disons, et un peu de rouge de l'autre et j'amorce des gestes libres autour de l'espace des orbites ou du menton, par exemple. Et parfois la suggestion d'une image – une sorte d'objet trouvé, si vous voulez – commence à émerger. Parfois non. Mais ces gestes sont presque toujours significatifs si l'on est attentif à leurs possibilités. Ils semblent obéir à une curieuse logique qui leur est propre. Dans mon cas, tout ce que je peux dire, c'est qu'il doit y avoir un élément accidentel ou une découverte ou une surprise quelque part afin que l'image qui apparaît soit moins faite par moi qu'elle ne m'est imposée, accident par accident, avec une vie autonome. Autrement je ne pense pas qu'elle présente une valeur quelconque.

Pouvez-vous être plus précis quant à la façon dont se déroule ce processus?

Voici, je crois, ce qui se passe. Les traces successives faites par une brosse trempée dans une couleur ou dans une autre, un peu au hasard, construisent une sorte de structure de gribouillage de couleurs dans et au-dehors des traits de l'image qui se forme graduellement. Et cette structure libre suggère d'habitude les zones où le blanc appliqué en couche épaisse pourrait former les plans extérieurs de l'image. Mais chaque plan et chaque

marque colorée, qu'elle soit nette ou que ses contours se fondent, doit avoir son autonomie – elle doit n'avoir aucun rôle descriptif. Et ces signes doivent coexister indépendamment à l'intérieur des différentes couches du paysage de l'image de la tête. Elles doivent pouvoir flotter – si on peut dire – à l'intérieur.

Mais étant donné l'importance que vous accordez au geste libre, à l'accidentel, est-ce que vous ne vous retrouvez pas parfois dans un inextricable désordre, obligé de tout gratter et de recommencer?

Bien sûr. Mais cela m'arrive moins souvent maintenant. La plus grande difficulté technique de ces peintures vient du fait que ce sont des têtes complètement isolées – sans aucun détail particulier, tel un col ou une cravate, ou un fond identifiable. Le plus difficile à mon avis est de faire ces têtes isolées de telle façon qu'elles ne soient pas de simples esquisses – ce qu'elles ne sont pas – ni des têtes de décapités. L'image doit naître d'une matrice plausible, étrangère à l'ordinaire, comme hors du temps. Vous avez sans doute remarqué qu'il n'y a aucun détail accessoire dans ces images – même pas la chevelure que je considère comme circonstancielle puisqu'elle peut être longue ou courte ou désigner un homme jeune ou âgé, autant de commentaires que je veux éviter.

Je voulais vous demander l'origine du fond blanc qui paraît être un élément caractéristique de vos toiles.

J'ai d'abord adopté le fond blanc en 1956, lorsque j'ai fait une série de bustes que j'appelais «présences». J'étais allé en Espagne cette année-là et j'ai été extrêmement frappé par le fait que l'ombre paraissait plus réelle que l'objet qui la projetait. Tout semblait noyé et dévoré par la luminosité si bien que j'étais arrivé à voir les choses comme existant dans une matrice de pure lumière blanche. Et plus tard, j'eus l'idée de faire surgir les images du néant, de la lumière, des profondeurs de la toile vierge, pour ainsi dire.

Vos impressions sont-elles modifiées en quoi que ce soit lorsque vous peignez des images de personnages vivants?

Il me semble que la différence vient du fait qu'avec les morts on a toute leur vie étalée devant soi: la jeunesse et l'âge mûr deviennent contemporains. Les vivants, au contraire, existant dans le temps, se transforment. Et puis, évidemment, avec les vivants il y à toujours l'ennuyeuse possibilité qu'ils changent encore et bouleversent les images que l'on a construites d'eux!

Est-ce que le fait d'avoir connu Beckett et Bacon, d'avoir pu observer leur apparence d'os et de chair, a fait une différence?

C'est un avantage, mais c'est aussi un facteur d'inhibition. Je veux dire que l'on peut éprouver l'impression que c'est une insolence de jouer avec leur apparence de cette façon – et aussi une «distorsion» de les placer en dehors du temps, dans la matrice dont je parlais. D'autant plus que les gens pensent – c'est une réaction que j'ai souvent rencontrée au cours des expositions – que d'une certaine façon on établit un «jugement» sur la personne que l'on peint. Mais je n'émets aucun jugement, vous savez. J'essaie simplement de dé-couvrir, de mettre à nu l'essence beckettienne de Beckett, l'essence baconienne de Bacon. Mais il est aussi vrai que lorsque vous

connaissez un peu les gens, les souvenirs que vous avez d'eux persistent. Ce curieux regard perçant qu'a Beckett me revient même lorsque je regarde une photo où il ne l'a pas!

Pensez-vous parfois à peindre ceux qui sont constamment proches de vous, les membres de votre famille ou de vieux amis?

Oui, bien sûr. J'ai peint un certain nombre de portraits de ma mère et de mon père. J'ai peint mes enfants et j'ai fait plus d'études d'Anne que d'aucun être. Toutes les études posent essentiellement le même problème. Ce qui me fascine, c'est *l'autre* et c'est ce que j'espère capter en peinture. Avec Anne surtout je suppose que c'est une sorte de fétichisme: j'essaie de saisir son être en la peignant. Je ne voudrais pas avoir l'air ésotérique, mais on peut dire que j'essaie d'accomplir un acte magique dans les limites de mon art et d'atteindre une image dotée d'une vie propre. Rien de plus.

Vous-avez fait allusion, dans nos conversations, à un certain mysticisme et au spiritisme. Est-ce que ces références impliquent des croyances précises de vortre part?

Je n'ai pas d'opinion religieuse très définie. Je suis, je l'espère, ce que l'on pourrait appeler un honnête agnostique qui essaie de garder une fenêtre ouverte aussi large que possible sur la réalité. J'ai été frappé par ce que le physicien Schrödinger m'a dit lorsque j'étais étudiant à Dublin, il y a environ quarante ans. La matière, m'a-t-il dit, ne peut pas être détruite – transformée jusqu'à devenir méconnaissable, peut-être, mais jamais détruite. Schrödinger croyait aussi que l'esprit ou la conscience étaient également indestructibles. Cette conviction m'impressionne toujours... Et lorsque l'on pense à l'univers avec ses innombra bles galaxies composées chacune d'une multitude d'étoiles, lorsque l'on pense à ses possibilités infinies et qu'on les compare à nos perceptions infimes, il paraît impossible de conserver des croyances dogmatiques. Je pense à nous comme habitant un coin minuscule de la réalité et ne percevant que ce qui se trouve dans notre champ de vision, un peu comme des langoustes dans un vivier qui balancent leurs antennes de droite et de gauche. Mais que peuvent-elles réellement savoir, plongées dans ces eaux, de la terre ou des villes ou encore de la nuit éternelle des étoiles?

Cette entrevue fut publiée pour la première fois par *Art International* (Lugano) en 1979.

Notes
[1] *À la recherche de WB Yeats – Cent portraits imaginaires*, exposés au Musée d'Art moderne de la Ville de Paris, octobre-novembre 1976.

[2] *Études vers une image de James Joyce*. Exposition itinérante à Gênes (S Marco dei Giustiniani), Zurich (Gimpel & Hanover), Londres (Gimpel Fils), Belfast (Arts Council Gallery), Dublin (Municipal Gallery of Modern Art), New York (Gimpel & Weitzenhoffer), Montréal (Waddington) et Toronto (Waddington) de novembre 1977 à décembre 1978.

Das Kopfbild

EIN INTERVIEW MIT LOUIS LE BROCQUY VON GEORGE MORGAN

Das nachfolgende Interview wurde über drei Einzeltreffen hinweg im 1995-96. Die Treffen fanden in Louis le Brocquys Haus in Südfrankreich statt. Der Text wurde gekürzt und zur Veröffentlichung überarbeitet, aber der Inhalt und Ton geben Louises Gedanken und Stimmungen bei diesen Gelegenheiten akkurat wieder.

————

George Morgan – Es scheint mir, daß die hervorstechende Eigenschaft Ihrer Kopfbilder deren gnadenlose Wiederholung ist. Warum diese besessene Wiederholung der Abbildung? Wie kam das zustande?

Louis le Brocquy – Nun, sehen Sie: um das menschliche Gleichnis, das eine Art zeitgenössischer Bedeutung hat, wiederzugeben, muß man erkennen, daß viele Aspekte entstanden sind, die über die letzten 100 Jahre unsere Wahrnehmung von Dingen revolutioniert haben. Aufgrund der Fotografie und des Kinos auf der einen Seite, und Psychologie auf der anderen, können wir das menschliche Wesen nicht mehr als statische Einheit betrachten, die nur biologischer Veränderung unterliegt. Wir können die Bilder von Dominique Ingres aus dem 19. Jahrhundert nicht länger als Wiedergabe der vielfältigen, kinetischen, sich immer wandelnden Natur menschlicher Realität ansehen. Die Ersetzung des definitiven Abbilds durch eine Serie ergebnisloser Bilder hat daher vielleicht etwas mit der zeitgenössischen Vision zu tun, die das Abbild als eine variable Konzeption wahrnimmt, anstatt einer definitiven Manifestation im Sinne der Renaissance. Heute tendieren wir dazu, mehr zu erfragen, auseinanderzunehmen und vielleicht zu analysieren. Wiederholung/Variation ist ein Aspekt dieses Vorgangs. Die Renaissance hatte keinen Bedarf an Wiederholung. Im Gegenteil: es scheint, daß sie dazu tendierte, einem gradlinigen Gedankengang zu folgen, der einen Anfang, eine Mitte und ein Ende unterstellt und dadurch Vollständigkeit, Ganzheit. Wiederholung, auf der anderen Seite, unterstellt nicht einen gradlinigen, sondern kreisförmigen Gedanken, eine karussellartige Interpretation der Realität, eine andere Form von Vollständigkeit, eine andere Ganzheit, die zu einem beliebigen Punkt betreten oder verlassen werden kann. Diese anti-Renaissance Tendenz ist, erstaunlicherweise, schon hier und da in unserer keltischen Tradition sichtbar, vom Book of Kells und Book of Lindisfarne bis zu *Finnegans Wake*.

Was war Ihr Interesse an Köpfen? Was waren die emotionalen oder faktischen Gründe, die ihre Entdeckung auslösten und die sie so bedeutend für Sie machten?

Der Ursprung einer langen Serie von Kopfbildern war das Pariser Musée de l'Homme. Es war dort, 1964, daß ich die polynesischen verzierten Köpfe entdeckte – Totenköpfe, über die aus Ton modelliert und ritualistisch bemalt wurden, um den Geist zu erhalten. Ich war von dieser Idee sehr fasziniert.

War Ihre spätere Entdeckung der keltischen Dimension des Kopfkultes in der Provence auch eine Erleuchtung?

Diese rudimentären Steinskulpturen, wie die Kelten selber im Jahre 123 vor Christus von Römern zerschlagen, zu entdecken, das war eine Erleuchtung. Aber wissen Sie, Erleuchtung ist hauptsächlich das Herausarbeiten einer Idee, die schon im Geiste wartete. In Irland kannte ich vereinzelte Beispiele des gleichen Kults, so wie der dreigesichtige Corlech Kopf. Nun wurde all dies ein Bestandteil des Konzepts menschlichen Bewußtseins. So sehr ich auch von den polynesischen Köpfen beeindruckt war, blieben sie doch außerordentlich fremdartig für mich. Ich konnte sie sozusagen eher anthropologisch als gefühlsmäßig verstehen. Das keltische Konzept gab meine eigenen Gefuhle wieder.

Ist der Kopfkuk etwas, das Sie in Ihre Lebensart eingefügt haben? Hat er Sie in Ihrer Existenz betroffen? Oder war er nur ein Werkeug und eine Technik, die Ihnen erlaubte, Ihre künstlerische Suche fortzusetzen?

Er hat mich sicherlich nicht in meiner Existenz betroffen. Diese makabre gallische Tätigkeit erschien mir genauso unangenehm wie den Griechen und Römern, denen die heiligen Beutestücke stolz gezeigt wurden. Nein, es war ein Weg, einen Eingang, eine Route in ein unsichtbare Region der Realität zu finden, ein unfaßbarer Ort, der äußerlichen Erscheinung des menschlichen Wesens unterliegt.

Ort oder Sicht?

Ort.

Und gleichzeitig gab es Ihnen eine Art von Sicht.

Und hoffentlich Einsicht.

Nach Ihrer Entdeckung dieser zwei verschiedener Kopfkulte 1964 malten Sie eine Reihe von Kopfbildern, viele trugen den Titel Ancestral Head. *Was hatten Sie zu dieser Zeit im Sinn ?*

Was ich mit diesen Bildern heraufzubeschwören versuchte, war, nehme ich an, das Konzept früherer menschlicher Leben. Ich machte einen Plan, in der Vorstellung optische Spuren von Wesen wie uns selbst wieder zu entdecken, Wesen, die uns geschichtlich und sogar vorgeschichtlich vorausgingen.

Sehen Sie diese malerische Aktivität als eine Art von Beschwörung, wie eine spiritualistische Seance?

Nein. Das würde die Wirklichkeit heraufbeschwören. Der Maler beschwört eine Realität des Geistes. Ich bin mir natürlich bewußt, daß der Geist nicht nur durch die materiellen Möglichkeiten des Malers – der Farbe selbst – unterstellt wird, sondern durch die Form des gemalten Objekts. Ich erinnere mich lebhaft an mein Gefühl, als ich, ca. vor 30 Jahren, den Totenkopf von René Descartes in einem Schaukasten in der anthropologischen Abteilung des Musée de l'Homme entdeckte – eine elfenbeinfarbene Kuppel, glatt wie ein Frauenbrust. Vielleicht nur ein bißchen Knochen, aber, durch Assoziation, ein Denkmal an den großen Moment menschlichen Bewußtseins.

Der Anthropologe, Joseph Campbell, beschreibt in The Hero with a Thousand Faces *die heroische Suche nach verschiedenen Masken, die vom Helden getragen wurden, während er seine Reise an den Rand des Bewußtseins fortsetzt. Es scheint eine Ähnlichkeit mit der Art, in der Ihre Malerei mit ihrer fortwädhrenden Suche und sich verändernden Gesichtern arbeitet, zu bestehen.*

Ich habe Joseph Campbell nicht gelesen, aber ich mag die Idee der unterschiedlichen Masken, die vom Helden getragen werden. WB Yeats hätte sie auch gefallen, als er über seine Maske, sein Alter Ego, nachdachte, die ihn befähigte, seine Identität und die weiten Grenzen seines Geistes zu erweitern. Es kommen Samuel Beckett's treffenden Worte angesichts der Navigation seiner Kunst und was er sein Versagen nannte, in den Sinn:

> For I myself putting to sea in the long hours
> without landfall. I do not see the return ...
> I do not hear the frail keel grating on the shore.

Die Künstler, die ich wiederholt malte, wie Yeats, Joyce und Beckett selbst, werden in dieser Art und Weise gesehen, wesentlich in der Isolation ihrer Kunst, außerhalb der Umstände.

Dann sind Sie hauptsächlich mit ihrem Sein, ihrer bewußten Existenz beschäftigt?

Ja, und verwundert über solche Momente der menschlichen Erfahrung.

Es ist interessant, daß Sie das Wort 'verwundert' benutzen. Es beschreibt sehr wie ich Ihre Malerei empfinde – eine Art unbeschreiblicher Überwältigung. Ist es das, was Sie suchen?

Verwunderung ist, wie ich mir vorstelle, das Tiefste in uns –

viel zu oft in der Kindheit zurückgelassen. Es unterstellt ein Unwissen, aber auch ein Bewußtsein über Bedeutung und über Geheimnis. Dadurch, daß bewußte Ideen nicht aufgedrängt werden, daß das Bild spricht, kann der Maler manchmal Verwunderung hervorrufen. Falls es ihm nicht gelingt, dann hat das Bild versagt.

Sie fragen, ob ich meine Malerei an die Grenze des Bewußtseins dränge. Ich würde das niemals behaupten, aber ich fühle, daß Bewußtsein sich selbst am äußeren Rande dessen befindet, was wir wissen. Es ist gleichzeitig das bekannteste und am weitesten entrückte aller Probleme – das, was die Wissenschaft am meisten verwirrt, da die Art des Bewußtseins das Letzte ist, was die Wissenschaft begreifen kann. Das Auge kann sich nicht selbst sehen. Die Wissenschaft kann nicht über das Benehmen von Bewußtsein sprechen – wie Freud oder Jung – aber seine Identität zu definieren, so wie man die Chemie des Wassers definiert, ist nicht möglich und so wie mir bekannt ist, kaum vorstellbar.

Entmutigt Sie das?

Nein, im Gegenteil. Mehr als alles andere provoziert es mich dazu, auf eine versteckte Realität hin zu malen, die ich nie erreichen kann.

Versuchen Sie, als Künstler, die Grenzen zu erweitern? Sehen Sie sich als einen Entdecker neuer Gebiete? Oder ist Ihre Arbeit bedeutungslos für die heutigen Kunstbewegungen in jeglicher Form?

In Dublin oder in London oder anderswo gehörte ich nie zu irgendeiner Gruppe oder Bewegung in der Kunst. Ich habe kein großes Interesse daran, ob meine Arbeit als Avant Garde oder anderweitig betrachtet wird. Zu verschiedenen Zeiten wurde sie von beiden Seiten attackiert oder ignoriert. In meinem Alter wäre ich enttäuscht – wenn nicht besorgt – hätten sich die visuellen Künste nicht weiterentwickelt. Das haben sie sicherlich und ich bin aufgeregt darüber, das kreative Experiment der letzten Jahre mitzuerleben. Aber wissen Sie, was ich mir für mich selbst wunsche, ist nicht weit zu gehen, sondern *tief*. Wenn meine Arbeit Originalität besitzt, wurde sie – wie die eines bekannten irischen Dichters – durch Ausgrabung gewonnen. Eine Art Archäologie, könnte man sagen.

Eine Archäologie des Geistes?

Ja, in dem Sinne, daß das Bild nicht eine sorgfältige Wiedergabe ist, sondern eine Entdeckung, der es bis zum gewissen Grade erlaubt ist, sich selbst zu bilden, ein Bild, das den Maler überraschen kann.

Überraschend wie dieses Bild sein mag, äußerliche Erscheinungen und Bestimmungen spielen eine fortwährende, wichtige Rolle in Ihrer Arbeit.

Erscheinung ist sehr wichtig für mich als Maler. Bei den Kopfbildern signalisiert sie Identität. Während ich unterliegende Realität erfassen möchte, beziehe ich mich ständig auf äußere Erscheinung – nicht in dem soliden Renaissance Sinne, sondern einfach, um das 'was ist es', sagen wir, eines Apfels, einer Stirn oder Unterlippe, zu identifizieren.

Mit Ihren Kopfbildern, fühlen Sie, daß Sie geistig versuchen, unter die Erscheinungen zu gelangen, über das, was Sie als 'den wallenden Vorhang des Gesichts' bezeichnet haben?

Nun, wenn Sie Fotografien einer Person auf der Staffelei verteilt sehen, um ein Bild herum wie es hervortritt, fühlen Sie sich unvermeidbar zu einem gewissen Ausmaß zu dem Bild hingezogen. Stéphane Mallarmé nannte solch einen Vorgang 'Eintauchen'. Aber Eintauchen kann Probleme hervorrufen. Einige Leute haben bemerkt, daß einige meiner Bildern, die ich von anderen malte, das Aussehen des Malers haben. Ich kann es selbst sehen. Es war sicherlich nicht meine Absicht, aber ich nehme an, daß man diese Ambivalenz akzeptieren muß, da das Bild im Kopf des Malers reflektiert wird. Selbst Picassos Ziegen sehen ein wenig wie Picasso aus!

Erklärt dieser Spiegeleffekt dann, warum Sie es mögen, den Kopf frontal zu malen? Ist es wichtig, daß man das Gesicht vollständig sieht?

Wenn ich Ihrer Frage vollständig ins Gesicht schaue, würde ich denken, daß ein Kopfbild einer Person – das etwas von seiner inneren Realität unterstellen soll – frontal, direkt versucht werden muß. Wenn der Kopf seitlich angesehen wird – im Profil – wird die Person objektiver gesehen, ohne das Gefühl eines Eintritts von einer Gesicht zu Gesicht Begegnung verursacht. Frontal kennen wir alle die Bedeutung der Augen als 'Fenster' zu einer unsichtbaren Realität. Ihre ausdrucksstarke Bedeutung ist durch Suggestion überwältigend, selbst wenn sie geschlossen sind. Es ist klar, daß ein Kopf, der frontal betrachtet wird, eindringlicher, durchsichtiger ist.

———

Sie haben in der Vergangenheit über Ihre Malerei als eine Art von Entdeckungsreise gesprochen. In welchem Stadium sehen Sie, daß diese Entdeckungsreise beendet ist, daß der Kopf fertiggestellt ist, daß es das war?

Sie haben gerade eine sehr, sehr alte Frage gestellt, die Malern ständig gestellt wird und die sie sich wiederholt selber stellen: wann ist das Bild fertig? Es kann keine bedeutsame Antwort geben. Ein Bild ist beendet, wenn es fertig ist, wenn es nicht weiter fortgesetzt werden kann. Etwas ist durchgekommen und nichts kann im Zusammenhang mit dieser Arbeit mehr hervortreten.

Und wenn das Bild schlecht beendet wurde?

Dann muß es zerstört werden; es *ist* zerstört werden. 1963 zerstörte ich mehr oder weniger die Arbeit des ganzen Jahres. Ich war zu der Zeit verzweifelt, aber ich bedaure nicht, daß ich es tät. Die Arbeit war vom Kurs abgekommen. Meine Freundin, die Malerin Joan Mitchell, hätte diese Bilder 'Henry' zugeschrieben. Henry ist für Joan der Affe, der in uns allen steckt und nachdrücklich abgelehnt werden muß.

Haben Sie jemals die Zerstörung einer Leinwand bedauert?

Natürlich. Sehen Sie, von Henry abgesehen, sind zwei bestimmte Personen daran beteiligt, ein Bild zu malen. Erst gibt es den Maler selbst, arbeitend, mit seiner Leinwand verbunden.

Dann gibt es den Betrachter, der objektiv nicht den arbeitenden Maler beurteilt, sondern das fertige Bild. Der letztere erkennt vielleicht die gemalte Struktur akkurater, aber kann die unterbewußte Richtung des Werks eventuell nicht würdigen. Hin und wieder zerstört er das falsche Werk.

Unterstellen Sie, daß der Maler nicht der beste Beurteiler seiner Arbeit ist?

Im allgemeinen hat ein Künstler ein tieferes Verständnis seiner eigenen Arbeit als irgendeine andere Person. Aber seine Verfehlung, wenn sie geschieht, hat ruinierende Folgen. In vergangenen Jahren besorgte René Gimpel, der Pariser Kunsthändler, der Haim Soutine unterstützte, diesem inter alia eine kostenlose Haushälterin. Sie hatte jedoch die Aufgabe, alle halbgroßen Porträts zu entfernen, 'bevor der Künstler sie in die Hände bekam' Sehen Sie, es war an diesem Punkt, daß Soutine das Werk als beendet ansah und es jedesmal zerstörte. Dank der unbekannten Haushälterin sind uns diese intensiven, eindringlichen Bilder mit ihren unvollendeten Händen heute erhalten.

Wie beurteilen Sie Ihre Arbeit im Zusammenhang mit der zeitgenössischen Szene?

Es wird anderen überlassen bleiben, das zu beantworten, aber natürlich habe ich meine eigenen Ideen darüber, was ich über die Jahre mit Malerei versuchte zu entdecken und wohin meine Arbeit heute zeigt.

Es könnte jedoch gesagt werden, daß über die Jahre Malerei bedeutungsloser geworden ist. Gab es nicht eine fortschrittliche Verschiebung in visuellen Künstformen? Es scheint mir, daß zeitgenössische Kunst auf konzeptuellen, umweltbewußten und fotografischen Techniken basiert und die Malerei größtenteils ersetzt hat.

Ja. Viele der wichtigen Anliegen unserer Zeit, sozial und ästhetisch, werden nun durch andere Mittel als Malerei ausgedrückt, durch konzeptuelle Arrangements, Umordnung des Umfelds, durch Verhaltenstechniken, durch fotografische Verfahren. Ich denke, daß diese Erweiterung der Mittel in visueller Kunst willkommen zu heißen ist, da sie zu weiteren Fragen und Einsichten auf einer weiten sozialen Basis führt.

Aber werden diese neuen Formen die Malerei ersetzen? Nach ca. 6 Jahrhunderten haben sich Sie Künstler in eine Sackgasse gemalt?

Nicht im Geringsten. Anerkannt oder nicht, die heutige Malerei bleibt wesentlich. Die Kunst der Malerei ist so begrenzt wie die menschliche Vorstellungskraft.

Sie haben den größten Teil Ihres Lebens der Malerei gewidmet. Denken Sie über die Malerei als eine wesentliche Qualität, die sich selbst merkwürdig erscheint?

In den Händen eines Künstlers, ob sein Werk abstrakt oder bildlich ist, kann Farbe zu Musik werden – ein lebendiges Ding in sich selbst. Aber Malen hat noch eine andere magische Ambivalenz, eine Wandlung in sich selbst, in der die Farbe, während sie ihre materielle Identität behält, das *Bild* wird,

während das Bild – sei es eine geradlinige Oberfläche oder ein Bund Spargel – in die Farbe verwandelt wird.

Es war Malraux, der sagte, 'das 21. Jahrhundert wird mystisch sein oder gar nicht sein'. Denken Sie, daß Kunst oder menschliches Bewußtsein sich im allgemeinen zu der Art von Entdeckungsreise, in die Sie vertieft sind, entwickeln wird, eine Entdeckung von Wunder, eine Entdeckung der innerlichen, spirituellen Art?

Beim studieren der Malerei habe ich mich natürlich gefragt, welche Art von Zeitalter mit diesem Jahrhundert begonnen hat. Ich habe sogar etwas darüber geschrieben, als ich ein Gasttutor am Royal College of Art in den frühen fünfziger Jahren war.[1] Es schien mir dann, daß, aufgrund ihrer Ursprünge, die westliche Kultur dazu tendierte, eine Reihe von verlängerten Epochen zu umspannen, lange Zeiträume der abwechselnd nach innen schauenden und nach außen schauenden Visionen. Übervereinfachung ist bekanntlich irreführend, aber es schien mir dann, daß unsere kulturellen Ursprünge in Ägypten, Mesopotamien und primitiven Griechenland eine nach innen schauende Realität, eine konzeptuelle Realität darstellte. Irgendwann um ca. das fünfte Jahrhundert vor Christus scheint diese Anschauung dramatisch von unserer ersten nach außen schauenden, wissenschaftlichen, sichtbaren Epoche verdrängt worden zu sein – dem Zeitalter der Griechen und Römer. Angeblich hat sich dies umgekehrt in den folgenden byzantinischen, romanischen, gotischen Stilen, wo wir wieder in einer Form oder anderen zu der geerbten Spiritualität der Ravenna Mosaike zurückkehrten. Sie werden damit übereinstimmen, daß wir dann die sichtbare und greifbare Welt durch den Weg der Renaissance wieder betraten, als ein blauer Himmel über uns aufstieg, sozusagen, der den byzantinischen goldenen Hintergrund der Unendlichkeit ersetzte. Nach Eintausend Jahren wurde die alte klassische Welt wiedergeboren, um weitere sechshundert Jahre zu überdauern.

Und jetzt?

Und jetzt? Nun, am Ende dieses Jahrhunderts haben wir nicht vielleicht wieder ein neues, nach innen schauendes, immaterielles Zeitalter betreten? Hat nicht Cézanne, der erklärte, daß 'Spiegelung Vision modifiziert', den konzeptuellen 'goldenen' Hintergrund, die *reduction à la surface picturale* wieder eingeführt? Hat nicht Cézannes anti-Renaissance 'verschachtelter' Platz Materie auf kristallinen Ebenen enthüllt, um weiter von Picasso und seinesgleichen analysiert zu werden?

Und was ist mit der Zukunft?

Wie André Malraux bemerkte, kann niemand sagen wie sich die Epoche, die wir begonnen haben, weiterentwickelt, aber in der Mitte der fünfziger schien es mir, daß sich der Wind gedreht hatte, daß jedes empfindliche Zeichen ständhaft in die andere Richtung zeigte, daß mit dem Beginn des zwanzigsten Jahrhunderts ein neues Zeitalter begonnen hatte.

Sie scheinen auf eine Art von wesentlichem Kern hinzubohren, den der Kritiker Michael Gibson quidditas oder 'Washeit' nannte. Wie entsteht diese Wesentlichkeit aus einem Kopf? Welche Einblicke gewinnen Sie daraus?

Es ist klar, daß man den Geist nicht malen kann. Man kann Bewußtsein nicht malen. Man beginnt mit dem Wissen, das wir alle besitzen, daß die bedeutsamste menschliche Realität unter materiellen Erscheinungen liegt. Somit, um dies zu erkennen, es als Maler zu greifen, versuche ich das Kopfbild tatsächlich von innen nach aus zu malen, ich arbeite in Schichten oder Ebenen und setze eine bestimmte flimmernde Durchsichtigkeit voraus. Das Endergebnis – wenn ich in irgendeiner Weise von dem entstehenden Bild begeistert bin – ist die Suggestion einer Turbulenz, die unter der Bildoberfläche, unter der äußeren Erscheinung des Bildes vor sich geht. Das ist alles, was ich sagen kann.

Sie haben seit dreißig Jahren mit Köpfen gearbeitet. Es gibt eine Kontinuität in der Art, in der Sie an Ihre Arbeit herangehen. Denken Sie, sie hat sich entwickelt?

Meine Angst wäre, daß sie als monoton wiederholend angesehen werden. Sehen Sie, meine Suche verlangt einen intensiven, engen Fokus, eine fast minimalistische Einstellung, die eine weite, bewegte Fläche oder eine freie Benutzung von Farbe ausschließt. Ich bin auf eine sehr enge Bohrstelle beschränkt, sozusagen.

Sehen Sie sich manchmal danach, in eine Art der malerischen Erweiterung auszubrechen?

Zeitweise breche ich wirklich in Naturbilder aus – Tauben, Blumen, Früchte, Analyse einer Landschaft in Aquarell, oder diese Gruppenbilder, die *Processions*. Existenz, wenn Sie wollen, auf einer anderen Ebene. Doch scheine ich zu dem, was zentral ist, zurückzukehren – diese unteilbare soziale Einheit, das einzelne menschliche Wesen in seiner 'Matrix' der Isolation.

Was verstehen Sie unter dem Wort 'Matrix'?

Ich erinnere mich daran, daß Sie sich einmal in diesem Zusammenhang auf die Gedanken von Lao Tsu bezogen haben, im Hinblick auf seine Vision einer Urmatrix, wo alle Realität ungeboren lag, eine schwangere, universelle Präsenz, die dazu bestimmt war, alle Materie und alles Leben zu produzieren. Für meine Bilder erhebe ich nicht so einen tiefen Anspruch! Aber in ihnen kann gesehen werden, wie das Bild aus einer vergleichbaren Matrix oder einem grenzenlosen Hintergrund aufsteigt, was der Kritiker Pierre Schneider *un fond perdu* nannte – eine verlorene Tiefe.

Sehen Sie dieses Phänomen als rein physisch an oder hat es, um ein verzwicktes Wort zu benutzen, spirituelle Manifestationen?

Ich denke, man muß sagen, daß es eine spirituelle Seite hat. Die Verzwicktheit des Wortes kommt, nehme ich an, daher, daß es oft als esoterisch interpretiert wird. Für einen Maler, denke ich, sollte es einfach diese Werte bedeuten, die über seine materiellen Fähigkeiten hinaus in der Welt des Geistes realisiert werden.

Ihre Köpfe – wenigstens so wie ich sie interpretiere – sind Paradoxe. Ein englischer Kritiker, Matthew Arnold, schrieb einmal, daß der keltische Geist fundamental paradox ist: Hervortreten/Vertiefung,

Erscheinung/was über Erscheinung hinaus geht. Wie sehen Sie selbst diese Paradoxe?

Ich denke, daß ich immer die Ambivalenz der Malerei im all gemeinen erkannt habe. Das heißt, die Ambivalenz der Realität dessen, was ein Bild ist oder auf was es hindeutet; seine Identität mit und seine Unterschiedlichkeit von der Realität des tatsächlichen Welt; seine Andersartigkeit. Und dann, im Hinblick auf diese zerlegenden Kopfbilder, die ich male, sehe ich eine merkwürdige Ambivalenz, in der bestimmte Faktoren der tatsächlichen Welt Raum, Zeit, Umstand – nicht benannt, gestelzt oder abwesend sind.

Sie benutzen ständig Worte wie 'tasten', 'suchen', 'Entdeckung' im Hinblick auf Ihre Malerei. Bedeutet das, daß Sie, wenn Sie malen, keine klare Vorstellung davon haben, wohin Sie gehen?

Wenn man malt, hat man nicht immer vollständig erkannt, was das Bild darstellt. Die Bedeutung schleicht sich allmählich ein. In einem frühen Werk, wie *A Picnic* 1941 zum Beispiel, hatte ich einfach vor, die Art der Malerei zu erforschen – die Welt Degas und die Bilder des japanischen Ukyo-e. Viele Jahre vergingen bevor ich die surreale Natur des Bildes, das ich malte, erkannte: drei Personen, die sich zu einem Picknick getroffen haben, trotzdem isoliert von einander um eine leere Tischdecke. Ohne mein Wissen zu der Zeit scheint das Bild zu unterstellen, daß der Einzelne im Grunde alleine ist – jeder von uns allein in seinem individuell eingemauerten Garten oder Bewußtsein. Sicherlich können wir über die Mauer den anderen betrachten, aber nicht einmal Liebende können in den Geist des anderen eindringen. Vielleicht ist die wundervollste Funktion der Künst, in all ihren verschiedenen Formen, daß jeder von uns, bis zu einem Grad, an einem einzelnem Bewußtsein teilhaben kann. Was mich allerdings interessiert, ist, daß diese Einsicht, gleichzeitig banal und profund, mir durch die Malerei, durch die Ausübung der Malerei, kam.

Drücken Sie immer noch diese Einsamkeit mit den Köpfen aus?

Sicherlich ist jeder von ihnen isoliert. Aber hier gibt es etwas von einem Paradox. In jedem Bild nimmt ein bestimmter Kopf seinen Platz auf der Leinwand ein, aber diese einsame Gegenwärtigkeit ist auch in jedem von uns, unser Potential, unsere Fähigkeit.

Wenn Sie sich selbst betrachten, ist die Malerei eine Art, Ihre eigene Einsamkeit auszutreiben, ein Mittel, eine Beziehung mit, vielleicht, der Einsamkeit eines anderen zu kreieren?

Ich denke nicht, daß es das sein kann. In meinem langen Leben war ich oft allein, aber ich habe nie bewußt darunter gelitten. Natürlich mag das Baby eine andere Geschichte haben, aber es hat mich sie nicht wissen lassen! Nein, ich kann nicht behaupten, die Malerei als Mittel zu benutzen, meine Einsamkeit zu diesen Zeiten auszufüllen.

Also denken Sie, daß Ihr Interesse nicht so sehr persönlich ist, sondern eher mit der menschlichen Wesensart zusammenhängt?

Ja. Ich stelle mir vor, daß Einsamkeit möglicherweise die tiefste Realität des Einzelnen ist, aber bedenken Sie, daß so ein

Wissen über die menschliche Art als Maler gewonnen wird, hauptsächlich abgeleitet von oder mit der merkwürdigen Logik der Malerei. Dadurch, daß ich hundert Bilder von Joyce in verschiedenen Materialien machte, konnte ich nicht nur seine Einzigartigkeit, sondern seine stolze Isolation, sein Alleinsein, verstehen. Ich fühle zu einem kleinen Grad, als hätte ich diese Isolation betreten. Nein, nicht betreten – sie berührt. Auf der anderen Seite – außerhalb der Welt der Malerei – erinnere ich mich daran, daß der große Physiker Erwin Schrödinger uns 1944 in Dublin versicherte, daß 'Bewußtsein ein Einzelstück ist, von dem die Mehrzahl unbekannt ist' und 'was eine Vielseitigkeit zu sein scheint, ist nur eine Reihe von verschiedenen Aspekten der gleichen Sache'.[2] Ich bleibe tief beeindruckt von diesem Gedanken.

Also beeinflußt Sie als Künstler diese Ansicht des Bewußtseins als einzelnes, untrennbares Ding?

Falls Bewußtsein wirklich ein Einzelding ist, das in jedem von uns immer wieder auftaucht, ist es offensichtlich aufregender in einigen entwickelt als in anderen. Vielleicht ist es das, warum ich mich dazu hingezogen fühle, große Künstler zu malen. Kunst hat ihren eigenen Gedankenweg und vielleicht kann ich das Bild eines Künstlers besser greifen als das anderer Denker.

Und ich nehme an, daß Ihre Vielfalt von Köpfen verschiedene Aspekte der gleichen Sache sind. Was mag das sein?

Ja, ich nehme an, ich sehe diese Köpfe total verschiedener Leute wahrscheinlich als grundsätzlich verwandt an – jeder ein Aspekt eines Ganzen. Aber würden Sie nicht sagen, daß jeder von uns ein Teil der gleichen Sache ist, ob sie diese Sache nun Menschlichkeit oder Bewußtsein nennen, oder das 'formlose, alles umfassende Etwas' des Lao Tsu oder eine der vielen religiösen Interpretationen dieser Sache.

Und Ihre Ansicht über Bewußtsein im Hinblick auf Sie selbst?

Nun, seit einer langen Zeit habe ich gefühlt, daß mein eigenes Bewußtsein nicht vollkommen ich ist, daß es irgendwie weiter und tiefer als das ist. Vor allem stamme ich von der Vorgeschichte ab, wie der Rest von uns. Meine Beine sind nicht ganz meine Beine. Sie sind, sozusagen, paläontologische Beine, die mir für ein Leben geliehen werden.

————

1975 begannen Sie, WB Yeats in einer Reihe von Bildern zu malen. Wie kamen Sie auf Yeats? Was war der Auslöser?

Was mich dazu bewegte, diese vielen Bilder von Yeats zu malen, war die Galerie Börjeson in Malmö, die beabsichtigte, ein Portfolio von Drucken in Würdigung der Nobelpreisgewinner zu erstellen. Vertretende Künstler wurden dementsprechend ausgewählt, um einen Druck zu produzieren, der ihren nationalen Preisgewinner Tribut zahlte. Karel Appel vertrat die Niederlande, Miró, daran erinnere ich mich, Spanien und so weiter. Ich vertrat dann Irland. Aus den vielen irischen Nobelpreisgewinnern zu diesem Zeitpunkt – Beckett hatte seinen noch nicht bekommen – wählte ich Yeats als mein Objekt, da ich ihn für den bedeutesten hielt und weil ich ihn kannte, als ich ein Junge war. Ich machte ein Zahl von

Studien für mein endgültiges Aquatinto und war von ihrer Unterschiedlichkeit überrascht. Es war dann, daß ich erkannte, daß ein Portrait nicht länger die stabile, säulenartige Einheit der Renaissance Vision war – daß das Portrait unserer Zeit keine visuelle Finalität haben kann. Mit Absicht fuhr ich mit diesen Bildern fort, machte über hundert Studien von Yeats in Kohle, Aquarell und Öl. Sie wurden im Musée de l'Art Moderne de la Ville de Paris 1976 ausgestellt, und ich erinnere mich daran, daß der Kritiker von Le Monde zur Ausstellung kam und sagte, 'Wie können Sie sagen, all diese sind Yeats? Alle erscheinen sehr unterschiedlich, eins vom anderen, und manche ähneln ihm kaum.'

Und wie haben Sie geantwortet?

Ich antwortete, daß ich mir selbst diese Frage gestellt hatte, da ich Theodore Roosevelt in einer Studie und Marlon Brando in einer anderen erkannte. Alles, was ich zu ihm sagen konnte, war, daß ich ohne Abweichung auf Yeats abgezielt hatte, daß die einzig beständige Sache in all dem das Ziel war. Auf der anderen Seite schrieb Anne Yeats in *Quotidien de Paris*, daß diese Bilder lebhaft an ihren Vater erinnerten, so wie sie sich an ihn erinnerte. Ich möchte denken, daß Anne vielleicht eine tiefere Yeatsheit, über fotografische Bilder hinaus, sah, mit der sie vertraut war.

Als sie Yeats malten, waren Sie überhaupt von der dem Dichter eigenen Theorie der Maske als ein Ausdruck des Anti-selbst, des Anderen, beeinflußt?

Unvermeidbar. Yeatses Konzept der Maske, wie es in A Vision und wiederholt in den Gedichten vorkommt, hatte viel mit seinem Bild zu tun. Yeatses Maske, sein Alter-Ego, war sicherlich in meinem eigenen Kopf, während ich diese ambivalenten Studien von ihm machte.

Da wir von Masken sprechen, Sie haben eine bronzene Todesmaske von James Joyce in Ihrem Studio. Hat Joyce eine besondere Bedeutung für Sie? Ich fühle, er war ein sehr ertragreicher Einfluß.

Ich habe keinen spezialisierten Einblick in Joyce, genau so wenig wie ich ihn in Yeats habe, aber seine Werke, sein Leben, sein Sein, wurden immer wichtiger für mich. Vielleicht mehr wegen des Aspekts an ihm, der eindeutig keltisch ist, nicht in einer nationalistischen Interpretation, sondern in einem tiefen Sinne, der eher einen kreisförmigen als einen gradlinigen Gedankengang unterstellt.

Das Bild von Samuel Beckett scheint auch viel für Sie in Ihrer Arbeit bedeutet zu haben.

Ja, vielleicht mehr sogar als die Bilder von Yeats oder Joyce, zu denen ich wieder und wieder zurückkehre. Vielleicht wurden der Mut und die Hartnäckigkeit, die Ausdauer und Ironie und die Menschlichkeit in seiner Arbeit akuter an mich herangetragen, da ich ihn so kannte, wie ich ihn kannte.

Sie haben auch Shakespeare gemalt. Es gibt kein verläßliches Abbild von Shakespeare. Hat Sie das überhaupt behindert?

Bei meiner ersten Ausstellung in der Galerie Jeanne Bucher

1979 schlug mir Jean-François Jaeger Shakespeare vor. Erst lehnte ich ab, und dann, als ich darüber nachdachte, begann ich eine Reihe von Ölbildern und Aquarelle aus reiner Neugierde, was dabei herauskommen könnte. War das dreist? Ich weiß nicht. Ich erinnere mich, daß John Russel in der *New York Times* das Wort 'Überheblichkeit' in einer ansonsten günstigen Kritik meiner Arbeit verwendete. Fur mich waren diese *Studies Towards an Image of William Shakespeare* hauptsächlich ein Spiel der Vorstellungskraft. Tatsächlich konnte wenig von den zwei einzig authentischen Bildern von Shakespeare abgeleitet werden. Das erste ist eine sehr schlechte Radierung von ihm, von einem zeitgenössischen Maler, dessen Namen ich vergesse. Das andere ist ein Holzschnitt, nach seinem Tode angefertigt, der erst bemalt war, dann übermalt, und im Laufe der Jahre immer und immer wieder übermalt wurde. Keines hat die geringste Ähnlichkeit mit dem anderen, noch beinhaltet oder deutet es auf die Ausstrahlung dieses größten der englischen Schriftsteller hin, die der Welt gehören.

Sie malen sehr wenige Frauenköpfe, außer einer Zahl von Studien Ihrer Frau, Anne. Warum ist das so?

Ich finde, daß ich Schwierigkeiten damit habe, einen Frauenkopf zu malen. Eine Frau unterliegt vielleicht eher Verfremdung. Es ist wahr, ich habe Anne oft gemalt, aber mein geistiges Bild ihrer Schönheit stört die formale Entdeckung in der Malerei.

Ziehen Sie es vor, die gefühlsbetonteren oder sinnlicheren Verbindungen mit dem weiblichen Gesicht zu vermeiden?

Ich würde sagen, daß meine eigenen Gefühle und sinnlichen Gefühle für ein Frauenbild ziemlich so bleiben, wie sie waren als ich die früheren 'Präsenzen' – hauptsächlich Frauenkörper – malte, in denen der sinnliche Aspekt offensichtlich genug ist. Es erscheint sicherlich so für Herben Read. Ich erinnere mich an seinen *Letter to a Young Painter*, in dem er fühlte, daß 'die Erotik so intensiv ist', aber daß 'die volle Kraft der erotischen Bildern nur bei ruhiger Überlegung enthüllt wird'. Die Köpfe sind aber eine andere Geschichte. Ob sie männlich oder weiblich sind, ihre erotischen Verbindungen sind vielleicht weniger direkt, da sie von dem Zusammenhang zu ihren Körpern isoliert sind.

Ist dann Kunst nur 'formale Entdeckung'? Welchen Platz schreiben Sie Ihrer Ansicht nach den traditionellen Ideen von 'Schönheit' zu, dieser 'ewigen Freude'?

Formale Entdeckung ist sicherlich der Hauptpunkt der Malerei. Sie kommt von einem Sinn der Bedeutung. Bedeutung – wie Verwunderung – ist nicht leicht zu formulieren. Aber ohne den Vorstoß von Bedeutung bleiben bildliche Formen flach oder dekorativ. Schönheit in der Malerei ist ähnlich verbunden, würde ich sagen. Ohne Bedeutung riskiert es Schönheit, eine bedeutungslose nette Sache zu werden. Schönheit ist auch Bedeutung.

In vieler Ihrer frühen 'Präsenzen' und in einigen Ihrer neuesten Köpfe gibt es, was wie eine Darstellung von Energiezentren aussieht, etwas was Chakren ähnelt. Ist das Ihre Absicht?

Ich denke, daß sie ein wenig so angesehen werden können. Sie

können leicht als Chakren interpretiert werden, da sie nicht Ausdrücke materieller Existenzen sind. Für mich repräsentieren sie Gefühle – halb körperlich, halb fühlend.

Ihre Malerei wurde als eine Form von Entdeckung oder Wiederfinden bezeichnet... das Wiederfinden von etwas verlorenem. Sie scheinen eine Faszination für verlorene Dinge, oder wenigstens unvorhandene Dinge, zu haben, ungefähr wie Heaneys Besessenheit mit den Bog Menschen, dem Tollundmann. In dem Gedicht 'Strange Fruit', bezieht er sich auf einen Mädchenkopf. Dies sind die Anfangs- und Schlußzeilen:

> *Here is the girl's head like an exhumed gourd.*
> *Oval-faced, prune-skinned, prune-stones for teeth.*
> *They unswaddled the wet fern of her hair...*
> *...nameless, terrible,*
> *Beheaded girl, outstaring axe*
> *And beatification, outstaring*
> *What had begun to look like reverence.*

Es gibt in dieser Ansicht eines Kopfes ein Element des Terrors, der 'schrecklichen Schönheit'. Dies existiert auch sehr in Ihrer eigenen Arbeit, so wie ich es sehe. Möchten Sie darauf eingehen?

Vor vielen Jahren, in der Mitte der siebziger Jahre, denke ich, nahm ich an einer Ausstellung in Belfast teil. Als ich mit dem Zug zurückkam, ging ich durch die Waggons, um mir ein Glas Bier zu besorgen und wen anders sollte ich da zufällig treffen als Seamus Heaney. Zu dieser Zeit kannte ich ihn kaum, aber wir verbrachten den Rest der Reise gemeinsam. Komischerweise hatten wir beide gerade PV Globs *Bog People* gelesen. Jeder von uns wurde vom Tollundmann, dem Windeby Mädchen, und anderen, die in einer Eisenzeit geopfert wurden, die sie perfekt bis auf eine Bewegung eines Lids erhalten hatte, verfolgt. Ja, ich fürchte, der 'schreckliche' Aspekt könnte in meiner Arbeit wiedergegeben werden.

Also sehen Sie eine Verbindung zwischen diesem Kult der Bog Menschen und Ihrer eigenen Aufdeckung oder der Wiedentdeckung der Köpfe?

Einer der Gründe, warum ich an diesen Bog Menschen so interessiert war, war, daß sie wie die polynesischen Köpfe die menschliche Präsenz einverleibt und erhalten hatten. Ihre Gesichter, entstellt durch das Gewichts des Bogs, schienen ein weiteres, unerforschtes Gefühl, ein ruhiges, zeitloses Gefühl, zu unterstellen, das sie von den schrecklichen Umständen ihres Todes befreite.

Sie sprechen irgendwo von Ihrer Arbeit als keine Art des Selbstausdruckes. Und, tatsächlich ist Ihre Arbeit vielfach sehr unpersönlich. Die Gesichter enthalten durchwegs einen Mangel an Gefühl. Die Augen, wenn vorhanden, sind oft streng und starrend.

Ich bin mir bewußt, daß einige dieser Kopfbilder in ihrer Isolation unpersönlich erscheinen können. Sie können sogar beklagenswert sein. Aber wissen Sie, als ich Federico Garcia Lorca malte, befürchtete ich sein Schicksal, genau wie er selbst. Mein Ziel war, das Bild aus dem Inhalt von Humor und normalem sozialen Miteinander zu heben, es außerhalb von Zeit und Umstand zu stellen.

In einem Sinne sind dies Mitteilungen der Unsterblichkeit.

Sie können als Momente der *Idee* von Unsterblichkeit beschrieben werden. Die Idee ist in einer metaphysischen Geisteshaltung beinhaltet. Es ist vollkommen sinnvoll zu sagen, daß, da unsere Realität Raum in der Zeit einnimmt, wir es so hinnehmen können, daß was geschah nicht real ist; es *war* real. Doch sollen wir glauben, daß alles was jetzt in diesem Moment real ist, unreell werden wird? Das ist eine metaphysische Frage. Wenn ich versuche, ein Bild einer Person zu malen – entweder tot oder lebendig – bleibt sie Teil eines Kontiuums, und dieses Kontiuum ist Teil eines Ganzen, so wie ich es sehe. Es formt eine An von Realität, von der ich nicht glauben kann, daß sie jemals gänzlich ausgelöscht wird. In jedem Falle hat der Bereich, in dem ich versuche zu malen, mit Bedingungen zu tun, die über die Überlegung des Auslöschens hinausgeht. Es ist ein Bereich, in dem der Schwamm der Zeit nicht länger wirksam ist.

Vor kurzem haben Sie mit einer neuen Reihe von Gemälden experimentiert, die Sie Human Images *genannt haben und die mehr oder weniger freizügig verschiedene Öffnungen im menschlichen Körper darstellen – den Mund, das Ohr, den Bauchnabel usw. Was hat Sie dazu bewegt, dieses neue Thema zu beginnen?*

Ich erinnere mich daran, daß der polnische Maler Jankel Adler mir sagte: 'Inspiration, wenn sie kommt, kommt zur Staffel, nicht zur Bedkante.' So war es für ihn und so ist es tatsächlich auch für mich. Seltsamerweise jedoch kam mir diese Idee nachts, buchstäblich aus der Dunkelheit. Was ich sah, was mir bewußt wurde, war eine Bildoberfläche, gelöchert oder eingeschlitzt, eine Öffnung von dem, was körperlich und äußerlich ist, in die nicht wahrzunehmende, innere menschliche Realität.

Diese neue Reihe hat eine klare Verbindung zu Ihren früheren Stücken. Und doch grenzt die Ausführung in einigen der weniger freizügigen 'menschlichen' Öffnungen an das Abstrakte, wobei sie eine Art minimalistischer Bedeutung umarmt. Sehen Sie diese Stücke als einen neuen Schritt oder als ein weiteres Experiment Ihrer lebenslangen Navigatio in den Geist?

Alle bedeutenden Bilder, stelle ich mir vor, kommen aus vergangener Erfahrung, selbst diejenigen mit zukünftiger Bedeutung für uns. Ja, ich erkenne das Wiederauftreten dieser 'Präsenzen' aus den Fünfzigern, *und* die offenen Münder der *Ancestral Head* Reihe. In der Tat könnte in diesen früheren Werken der offene Mund als eine Öffnung in einer Oberfläche gesehen werden. Sie haben auch recht, vorzuschlagen, daß in diesen neueren Arbeiten solch ein Mund, isoliert auf der Leinwand und frei vom Zusammenhang mit dem Gesicht, abstrakt erscheinen muß, ein abstraktes Loch in einer Oberfläche eines minimalistischen Gemäldes. Aber das ist nicht meine Absicht.

Sie haben diese Bilder Human Images *genannt, und doch haben viele nur die geringste Verbindung zu der menschlichen Form an sich. Die Spärlichkeit ihrer Ausführung selbst suggeriert, daß Sie sich von der menschlichen zu der mehr fundamental metaphysichen Dimension bewegen. Ich weiß, wie stark Sie immer Ihre Teilnahme am 'Menschlichen' ausgedrückt haben, wenigstens im direkteren*

Sinne. Habe ich das dann falsch verstanden?

Seit fast vierzig Jahren habe ich auf in der einen oder anderen Weise versucht, eine Art von Zeichen hervorzurufen, um die unsichtbare Realität, die wir Bewußtsein nennen, zu erleuchten. Menschliche Gestalt hat klare Bedeutung dafür, ist aber nicht zentral. Und so wie man mehr auf dieses nicht wahrnehmbare Zentrum, sowohl bekannt wie auch mysteriös, zugeht, vielleicht neigt man sich dann unvermeitbar zum Metaphysischen, wie Sie vorschlagen. Aber meine Suche bleibt dieselbe.

Diese Bilder kümmern sich stark um die malerische Qualität des Pigments selbst, mit dem Geschehen auf der Leinwand. Es wurde von ihnen gesagt, daß die Oberfläche nun die Präsenz geworden ist. Ist das relevant für die Weise, in der Sie hier gearbeitet haben?

Ja, das ist es. Seit langer Zeit habe ich auf genau das hingearbeitet. 1961 hat mich Robert Melville zitiert, daß ich 'bestrebt sei, eine substanzielle Identität von Oberfläche und Bildnis zu produzieren'. Vielleicht geschieht dies endlich.

Diese Stücke sind als ambivalente Geschehnisse relevant. Sie kreieren dieses Gefühl von Staunen und Aufregung, das ich vorher erwähnte, den Terror von etwas, das darüberhinaus geht, und doch sind sie Momente des Anfangs, fast die erste Welle oder der erste Fluß in der kosmischen Suppe, sozusagen, so wie das vorgeschichtliche Chaos den ersten Mund, das erste Wort formt.

Es ist beachtlich, daß Sie sich hier auf die 'kosmische Suppe' und solche vorgeschichtlichen Dinge beziehen. Um die Oberfläche dieser Bilder zu aktivieren, mit Energie zu versehen, habe ich aufeinanderfolgende, farbige Schichten einer stark verdünnten Farbe auf die vorbereitete Leinwand aufgetragen. Es geschah dann, daß die hervorgetretene Beschaffenheit eine Oberfläche von Körnern oder Partikeln – vorgeschichtliche Partikel, wenn Sie möchten – produzierte, die so angesehen werden können, daß sie sich in ein dürftiges, menschliches Bildnis verfestigten, welches hervortreten und sich öffnen sollte.

In diesen Bildern scheint es ein Element der Gewalt zu geben. Viele von ihnen suggerieren einen Schnitt oder Einstich in der Leinwand.

Ich nehme an, daß es Gewalt in jedem von uns gibt, und wir alle tagtäglich in unserem Leben Wut über Gewalt empfinden. Sie können mein Bild eines offenen Mundes, isoliert in der Mitte der Leinwand, sehr wohl als einen Schrei oder als einen Ausdruck der Wut interpretieren. Sehen Sie sich um. Es *ist* all das! Aber es kann auch als einen Weg ins Innere gesehen werden.

Diese Bilder rufen auch eine eindringliche Tiefe hervor, was Heaney eine 'Tür in die Dunkelheit' nannte. Schon die Köpfe schienen zwischen der Welt der Erscheinungen und der Realität hinter der Leinwand hin und her zu schweben. Hier haben Sie die Leinwand direkt zum Raum dahinter geöffnet, einen Raum des Mysteriums und Staunens, der uns hineinwinkt, jedoch schon heraussickert. Ich bin versucht, Sie eher naiv zu fragen: 'Was ist auf der anderen Seite?'

Ja, für mich sind der offene Mund, der Schlitz eines geschlossenen Mundes, die tiefe Delle des Nabels, das Auge, das Ohr in erster Linie ausgewählte Öffnungen in der Undurchsichtigkeit des Körpers – Eingänge in die Dunkelheit oder in das, was nicht sichtbar ist, die Realität des inneren Seins, die 'andere Seite', wie Sie es nennen. Sie fragen mich, was auf der anderen Seite liegt. Erinnern Sie sich an eine berühmte Fotografie meines alten Freundes Henri Cartier-Bresson? Darin sieht man einen Mann, der durch ein Loch in der Segeltuchbarriere einer anscheinend provinziellen Stierkampfarena schaut. Hier befinde ich mich in der gleichen Position wie der Fotograf (der zufällig auch ein Maler ist). Nicht wie der Mann, der durch das Loch schaut, der bewußt ein Lebensdrama auf der anderen Seite miterlebt, sieht Cartier-Bresson nur das Loch im Segeltuch, hinter dem, wie er glaubt, eine dramatische Erfahrung im Bewußtsein des hindurchschauenden Mannes existiert. Ich nehme an, es war dieser aufregende Glaube, der den Fotografen dazu veranlasste, das Foto zu schießen, motiviert durch die Bedeutung eines Lochs in der Segeltuchbarriere in Relation zu der bewußten Erfahrung, die auf der anderen Seite versteckt war. Ich neige dazu, die 'Löcher' in meinen Leinwänden in einer ähnlichen Weise zu betrachten.

Louis, wir sind am Ende angelangt. Haben Sie ein letztes Wort?

Das ist etwas, über das ich nachdenken muß. Nichts im einzelnen...

Wie würden Sie gerne in Erinnerung bleiben?

Ich habe mir einmal selbst gesagt – vor langer Zeit, als ich begann zu malen, als ich versuchte, die Fähigkeit zu malen zu entwickeln – daß ich sehr glücklich wäre, wenn ich den Status eines sehr guten Malers, eines *petit maître*, erreichen könnte oder als solcher angesehen würde. Nun, hin und wieder über die Jahre wurde ich beim Malen und durchs Malen dazu bewegt, qu glauben, daß mir etwas mehr gewährt wurde, mir möglich gemacht wurde, ein wenig in die Bedeutung des Lebens zu greifen.

[1] 'Thoughts on our Time and Jean Lurçat', Louis le Brocquy, *Ark 17* (Royal College of Art, London, 1956)
[2] *What is Life?*, eine Reihe von Vorlesungen über Genetik von Prof Erwin Schrödinger am Trinity College, Dublin

George Morgan ist Dozent für englische Literatur an der Universität von Nizza, Frankreich. Er ist Spezialist für keltische Literatur und hat zahlreiche Beiträge über irische und walisische Dichtkunst veröffentlicht. Er übersetzt Gedichte und verfasst auch eigene.

Interview mit Louis le Brocquy

MICHAEL PEPPIATT, 1979

Das untenstehende Interview besteht aus einer Destillation der Notizen und Erinnerungen an eine sich über viele Stunden erstreckende Konversation, die zu verschiedenen Zeiten in dem Atelier, in dem le Brocquy und Anne Madden arbeiten, stattfand. Einmal starrten sechs neue, aber noch nicht ganz fertige Köpfe von Beckett in einem Halbkreis von ihren Staffeleien auf weitere sechs Köpfe von Bacon herunter. Während der Gespräche verblaßte ihre Aura von Grimmigkeit und terribilitá, und etwas Verletzlicheres, Menschlicheres kam zum Vorschein. Etwas switer entfernt, an der Wand präsidierte die Todesmaske von James Joyce mit ihrem unter dem schwachen Lächeln vollkommen nach innen gerichteten Ausdruck über alles. Unter dieser Musterung, und während des sich verändernden, sondierenden Gesprächs entwickelte sich das unbehagliche Gefühl, daß alles nur Aussehen, nur Oberfläche ist – daß die gemalten Köpfe und die lebendigen, redenden Köpfe nur zwei Schichten einer Illusion, sind, die entfernt werden müssen.

––––––

Michael Peppiatt – In der Vergangenheit haben Sie im wahrsten Sinne des Wortes Hunderte von Köpfen von Yeats, Joyce und Lorca gemalt. Jetzt fangen Sie mit denen von Beckett und Bacon an. Woher kommt diese Faszination mit Köpfen und allein mit Köpfen?

Louis le Brocquy – Ja, wissen Sie, das kam, nachdem ich ein sehr schlechtes Jahr durchgemacht hatte, gewissermaßen ein blindes Jahr, in dem mir keine Bilder kamen und ich überhaupt nicht weiterkam. Das war 1963, und ich hatte davor für die letzten sechs oder sieben Jahre an einer Reihe von Figuren oder etwas, das ich als Präsenzen ansehe, auf weißem Grund gearbeitet. Plötzlich schien mir nichts auch nur irgendwie Wertvolles einzufallen, und am Ende dieses Jahres zerstörte ich dreiundvierzig schlechte Bilder. Zu diesem Zeitpunkt ging es mir selbstverständlich ziemlich schlecht und meine Frau schlug vor, daß wir nach Paris fahren sollten, aßer so, als ob wir irgendwo hinfahren würden, wo wir uns nicht auskannten. so daß es noch Dinge für uns zum Erforschen gäße. Und tatsächlich, ich machte eine für mich entscheidende Entdeckung dadurch, daß ich in Berührung kam mit diesen melanesisch-polynesischen Bildnissen, wie sie im Musée de l'Homme ausgestellt sind. Das sind Schädel, wissen Sie, die teilweise in Ton nachgeformt sind und dann in der typischen dekorativen Art und Weise bemalt sind – oft noch mit Cowrie-Muscheln als Augen. Sie beeindruckten mich zutiefst und kurz danach fing ich an, Köpfe zu malen, Sie könnten sagen, körperlose Köpfe

oder eher vollkommen alleinstehende Köpfe. Dann, wieder etwas später, fand ich noch einen Kopfkult – in der Nähe von Aix-en-Provence, in Entremont und Roquepertuse – dieses Mal keltischen oder auch als keltischligurisch bezeichneten Ursprungs. Und dies war für mich wie eine Offenbarung, die mir bestätigte, daß das Bird eines Köpfes wie eine Art von Zauberkiste ist, die den Geist gefangen hält.

Ich stelle mir vor, daß wir jetzt über Kopfskulpturen reden.

Aber ja. Sie können die Überreste davon in den Museen in Aix und Marsailles sehen. Wissen Sie, nur wenig ist dort von der keltischen Kultur erhalten geblieben. Die Römer löschten sie systematisch aus, das wichtigste Oppidum sowie auch die heiligen Orte Entremont und Roquepertuse. Natürlich hatten auch die Kelten selber einige recht unangenehme Angewohnheiten wie z.B. das Aßtrennen der Köpfe getöteter Feinde, die sie dann an ihrem Gürtel trugen.

Wie auch die Skythen…

Ja. Wissen Sie, es fiel mir dann ein, daß die Kelten in gewisser Weise von den Skythen abstammen müssen. Ihre Kunst ist auf jeden Fall miteinander verwandt. Wie ich schon sagte, wurde die keltische Kultur von den Römern zerstört. Die Druiden wurden in die Wälder getrieben und zur Strecke gebracht. Diese Kultur – diese keltische Art und Weise, die Dinge zu betrachten, überlebte jedoch in Irland. Das Christentum modifizierte es nur. Als Edmund Spenser, der elisabethanische Dichter, dort stationiert wurde, war er von der Armut sehr berührt – Menschen brachen vor seinen Augen vor Hunger zusammen und so weiter – aber er konnte sie nicht verstehen. In der Tat, er sah sie kaum als menschliche Wesen an. Er war ein Angehöriger der Renaissance und sie waren Kelten, die Vorfahren des Geistes Joyces. Und dieser einfühisame Dichter empfahl, daß die Kelten – ganz wörtlich – ausgelöscht werden sollten, da sie niemals, so wie er es nannte, 'zivilisiert' werden würden. Natürlich erschien das Benehmen der Kelten anderen sicherlich als barbarisch, genau wie ihre gallischen Cousins den Römern erschienen waren. Sehen Sie, die Gallier präparierten die Köpfe wichtiger Personen und bewahrten sie in ihren Heiligtümern auf. Sie können sich sicher vorstellen, wie sich griechische und römische Reisende gefühit haben müssen, wenn die keltischen Ligurier ihnen die Ehre erwiesen und sie auch einen ausgiebigen Blick auf ihre teuren eingemachten Köpfe werfen ließen!

Ich frage mich, ob Sie Ihre Bilder in irgendeiner Weise als damit verwandt ansehen.

Ich denke nicht unbedingt, daß ich bei einem irischen Kopfkult mitmache, allerdings gewinne ich schon in gewissem Sinne davon. Wie die Kelten neige ich dazu, den Kopf als diese Zauberkiste, die den Geist enthält, anzusehen. Wenn man diese Zauberkiste betritt, wenn man hinter den wehenden Vorhang des Gesichtes tritt, dann liegt vor einem die gesamte Landschaft des Geistes. Und das Gesicht selbst, diese unbestreitbare äußere Schale der Realität, ist auch bis zu einem gewissen Grade ein Ausdruck des Geistes. Das ist das, was mich so fasziniert, weil mich Aussehen und was dadurch enthüllt wird, fasziniert. Die Art und Weise, wie ein Gesichtsausdruck sich bei manchen Menschen von einem Moment zum anderen ändern kann, weil die Lebenskraft in ihnen aufwallt und sie die ganze Zeit immer wieder verändert. So daß der Kopf, wenigstens für mich, ein Paradox ist, welches zur gleichen Zeit den Geist versteckt oder maskiert und ihn freilegt oder ausdrückt.

Aßer was bringt Sie im Besonderen zu Yeats und Joyce und den anderen? War es die Bewunderung ihres Werkes?

Ihre Werke ziehen mich ganz sicherlich an, und in jedem Fall, bevor ich anfange zu malen, versuche ich mich so tief wie ich kann darin zu verankern Auf der anderen Seite sehe ich sie nicht unbedingt nur als brilliante oder berühmte Männer, sondern auch als verletzliche, besonders ergreifende Menschen, die weiter als der Rest von uns gegangen sind, und aus diesem Grund auch isolierter und bewegender waren. Vor allem wurde ich von ihrer Reise, die sie durchs Leben machten und wie sie die weite Welt als ihre Vision nahmen, angezogen.

Soweit ich weiß, kannten Sie Yeats?

Nur in der Weise, wie ein Kind einen Lehrer oder sonst eine gehobene Person 'kennt'. Meine Mutter kannte seine Familie, so daß ich mit ihm und seiner sehr beeindruckenden Verhaltensweise recht vertraut war! Yeats ist ein wundervolles Beispiel wie sich ein Aussehen verändern kann, und in diesen Blidern – sehen Sie, ich sehe sie mehr als Spuren, Bilder denn als Portraits – gab ich den sehr unterschiedlichen Aspekten seines Aussehens freien Lauf. Ich würde sagen, daß uns die Fotografie heute gezeigt hat, wie vielschichtig menschliches Aussehen ist, so daß es müßig und großspurig wäre, einen großen Mann in nur einem 'Portrait' festhalten zu wollen. Wie dem auch sei, in diesen Reihen von huschenden Blidern die ich von Yeats hatte,[1] hoffte ich, etwas von der Vielseitigkeit dieses außergewöhnlichen Iren einzufangen, und so, vielleicht auch die Landschaft hinter 'diesen uralten glitzernden Augen' zu berühren. Manchmal spielte ich sogar ein Spiel, in dem ich ihn erscheinen ließ, so wie man einen Geist bei einer spirituellen Seance herzitiert!

Hatten Sie jemals ein ähnliches Gefühl, als Sie an Joyce arbeiteten?

Ich fühlte oft, daß es von meiner Seite aus impertinent wäre, mit den Erscheinungen dieser Männer herumzuspielen. Joyce, das muß ich gestehen, flößte mir gewaltige Ehrfurcht ein und ich hatte wörtlich Angst! Er ist der aufrüttelnste und

schmerzvollste Kopf, den ich jemals in Angriff genommen habe. Mir war extrem bewußt, was er alles erlitten haben muß – die Erniedrigungen und die Vernachlässigung, das körperliche Leiden und die Armut. Und natürlich dachte ich auch konstant an das außergewöhnliche, in seinem Kopf stattfindende Abenteuer. Denn er fuhr wirklich weit raus, nicht wahr, er segelte in Reiche, die nur wenige Menschen zu betreten wagen. Ich meine, ich denke, daß diese Männer Joyce und Yeats wirkliche Helden waren, Helden mit Mut, prometheisch. Und diese Spannungen bekamen so akut während ich an Joyce arbeitete, daß ich einmal sogar dachte, daß ich nicht weiter machen könnte, daß ich einfach nicht zurück gehen könnte, um wieder diesem Kopf gegenüberzustehen – so ungefähr wie Douanier Rousseau, der es nicht wagte, in sein Atelier zurückzukehren, um den angsterzeugenden Löwen, den er gemalt hatte, ins Auge zu sehen!

Sie fertigten ungefähr 120 Studien von Joyce an.[2]

Ja, wenn Sie neben den Ölbildern alle Aquarelle und Kohlezeichnungen mitrechnen. Und, in gewisser Weise hätte ich noch bis ins Unendliche damit weitermachen können, weil ich nie fühlte, daß sie etwas Endgültiges oder Schlüssiges hatten. Ich denke, das Joyces eigenes Werk auch so war, eher zyklisch als linear, es fing so an, wie es begann, ein Kreis, der überall und zu jeder Zeit betreten werden konnte. Es war das Produkt eines bemerkenswerten Geistes, im gewissen Sinne eines Geistes der Gegenrenaissance, der mit seiner minuziösen Geduld, mit seiner konstanten Zirkularität vielleicht vergleichbar ist mit den ineinander verflochtenen Bordüren im Book of Kells. Und dann haßen Sie die außergewöhnliche Plastizität des Kopfes selbst mit den großen, ausgewogenen figuralen Bewegungen der Stirn und des sich nach vorne reckenden Kinns, und der Nase, die ihren Platz in der ausholenden Vertiefung zwischen Stirn und Kinn findet. Ein Kopf wie ein sichelförmiger Mond!

Sie vertiefen sich in die Werke und das Leben der Menschen, die Sie malen. Sammeln Sie auch Fotografien von ihnen? Und wie wichtig sind diese Fotografien?

Sie dienen gewissermaßen als objektive Beweisstücke, selbst wenn sie als 'schlechte' Fotos angesehen werden, da sie nicht mit dem konventionellen Ansehen desjenigen, wer immer er auch war, übereinstimmen. Ich bin daran interessiert, Bilder zu kreieren, die so objektiv wie nur eben möglich sind. Mir ist seibstverständlich klar, daß egal, was man tut, es immer zu einem gewissen Grad subjektiv ist, da es notwendigerweise einen Teil des eigenen Geistes reflektiert. In diesem Sinn bekommt die Leinwand eine Art Spiegel, und durch das Malen Anderer, malt man auch wenigstens teilweise sich selbst. Trotzdem interessiert vor allem der Andere, das andere Wesen. Ich denke oft, wie ganz und gar faszinierend es sein würde, wenn man sich für ein paar Minuten in den Kopf eines anderen Wesens versetzen könnte, selbst den Kopf einer Katze. Ich meine, ich bin mir sicher, daß wir uns alle recht unterschiedlich sehen. Falls ich in der Lage wäre, mich zum Beispiel in Ihren Kopf zu versetzen, während sie gerade Anne anschauen, dann bin ich mir ganz sicher, daß ich denken würde: 'Nein, nein, das ist nicht Anne, so sieht Anne doch überhaupt nicht aus!'

Wie benutzen Sie eigentlich die Fotos beim Malen?

Oft richte ich mich überhaupt nicht nach ihnen, aber wenn ich es tue, dann habe zwei oder mehr zur gleichen Zeit neben mir. Diese Fotos neigen dazu, einen sehr unterschiedlichen Eindruck von der fraglichen Person zu geben, und ich versuche, eine Beziehung dazu aufzubauen. In dieser Weise hoffe ich, daß ich gewissermaßen die verschiedenen Seiten und Schichten einer Person in dem Bild, dem ich Form zu geben versuche, aufdecken kann. Und dann sind die Fotos auch nützlich als Erinnerung daran, wie komplett sich ein Gesicht verändern kann, und sie helfen mir dabei, die Falle der Realistik zu vermeiden, oder wenigstens mir ihrer bewußt zu sein. Ich neige dazu, an Bilderreihen auf einmal zu arbeiten – wissen Sie, mit drei Bildern in Arbeit zur gleichen Zeit – und das hilft mir auch dabei, mit der nur persönlichen oder konventionellen visuellen Vorstellung, die man von dieser Person mit sich herumträgt, zu brechen.

Sie hätten noch unendlich mit dem Malen von Bildern von Joyce weitermachen können. Was regte sich dazu an, sich mit einem anderen Subjekt zu beschäftigen?

Da haben Sie ganz recht, ich hätte noch bis ins Unendliche mit Joyce weitermachen können. Aber ich begrüße auch die Herausforderung, die eine neue Persönlichkeit darstellt. Ich denke gern, daß ich dann vielleicht mit einem Bein in einem anderen, ganz neuen Land stehe, und die Veränderung macht einem die sterilen Formeln, in die man nach einer Weile so gern verfällt, bewußter. Sie wissen schon, so wie die Nase von Yeats am Nasenbein breit ist und dann in bemerkenswerter Weise immer schmaler wird. Nun, sobald sich ein solche Vorstellung festgesetzt hat, dann fängt man an, eine erkennbare Vorstellung von Yeats immer bereit zu haßen – und das wandelt sich dann in eine Falle um, eine Einladung nur zur reinen Geschicklichkeit. Das Gleiche passiert mit Francis Bacon, wenn man sich nur auf ungewöhnliche Breite seiner Kieferlinie versteift. Geschicklichkeit ist, wie Sie sich sicher vorstellen können, nicht das, worauf ich aus bin. Mir ist der Vorwurf gemacht worden, daß ich zuviel davon habe, zuviel rein technisches Können. Dies wurde nun durch ein merkwürdiges Unglück widerlegt. Vor ungefähr zwei Jahren verletzte ich mich an der rechten Hand, nach einer Knochenverpflanzung mußte die Hand für mehrere Monate in einen Gipsverband bleiben. Zum ersten Mal in meinem Leben fing ich an, mit meiner linken Hand zu malen. Die Bilder, die unter ihr Form annahmen, waren nicht von den anderen zu unterscheiden weder besser noch schlechter. Und nun, obwohl meine rechte Hand jetzt wieder wie vorher funktioniert, male ich manchmal immer noch mit der linken Hand, um das Unerwartete oder Zufällige zu ermutigen, durch das ein Bild zum Vorschein kommen kann.

Wie würden Sie 'Zufall' in diesem Zusammenhang verstehen?

Zufälle sind sehr wichtig für mich. Ich glaube, daß meine Rolle als Künstler, soweit diese überhaupt existiert, in dem Erkennen von wichtigen Zeichen liegt. Und diese sind es dann, ich behalte und erweitere, und von denen aus, so hoffe ich, ein Bild Gestalt gewinnt. Malen ist für mich nicht ein Mittel der Kommunikation oder sogar des Selbstausdrucks, sondern ein

Prozeß des Erforschens oder Aufdeckens. Ich sehe den Maler als eine Art Archäologe, ein Archäologe des Geistes, der geduldig die Oberfläche von Dingen aufführt, bis er eine Entdeckung macht, durch die er in die Lage versetzt wird, seine Suche noch weiter zu bringen.

Wie finden diese wichtigen Zeichen statt? Wie fangen eigentlich ein neues Bild an?

Für ein Ölbild mache ich normalerweise zuerst eine grobe Kohleskizze. Dann nehme ich den Pinsel, und, sagen wir mal, nehme ein wenig blau auf die eine Seite und ein wenig Indianerrot auf die andere Seite und dann mache ich diese freien Handbewegungen, um den Bereich der Augenbrauen oder des Kinns oder sonstwo herum. Und manchmal beginnt dann die Vorstellung eines Bildes, wenn Sie wollen, eine Art objet trouvè, zum Vorschein zu kommen. Manchmal aber auch nicht. Aber diese Bewegungen werden immer irgendwie wichtig, wenn man den Möglichkeiten, die durch sie hervorgerufen werden, Beachtung schenkt. Sie scheinen ihre eigene sonderbare Logik zu haben. In meinem Fall, alles was ich sagen kann, ist daß es immer ein Element des Zufalls oder der Erforschung oder der Überraschung geben muß, so daß das zum Vorschein kommende Bild nicht unbedingt von mir gemacht wird, sondern sich mir eher aufdrängt, von Zufall zu Zufall, mit seinem eigenen autonomen Leben. Wäre es anders, dann denke ich, hätte es gar keinen Wert.

Können Sie genauer beschreiben, wie dieser Prozeß normalerweise evolviert?

Nun, was passiert, denke ich, ist folgendes: Durch aufeinanderfolgende Zeichen, die mit einem Pinsel der mehr oder weniger zufällig erst in dieses, dann in jenes Pigment getaucht wurde, gemacht wurden, wird eine Art von gekritzelter Farbstruktur aufgebaut, aus und in den Gesichtszügen des sich graduell formenden Bildes. In dieser freien Struktur gibt es dann normalerweise Bereiche, die sich nur dazu anbieten, daß Farbpigment mit schweren Pinselstrichen weiter aufgetragen wird, um dann die äußeren Ebenen des Bildes zu bilden. Aber jede Ebene und jedes farbige Zeichen, egal ob scharf umrissen oder ineinander verschmelzend, muß seine Autonomie, gewissermaßen seine Unabhängigkeit von einer nur beschreibenden Funktion haben. Und diese Zeichen müssen unabhängig voneinander innerhalb der verschiedenen Tiefen der Landschaft des Kopfbildes nebeneinander existieren. Es muß ihnen erlaubt sein, gewissermaßen darin zu schwimmen.

Aber mit diesem Schwerpunkt auf freier Bewegung und Zufall, haben Sie sich nicht schon einmal in einer absoluten Sackgasse befunden, so daß Sie alles wieder abkratzen und wieder von vorne anfangen mußten?

Selbstverständlich. Aber das passiert jetzt immer weniger als vorher. Viele der rein technischen Schwierigkeiten in diesen Bildern rühren von der Tatsache her, das sie Köpfe in vollkommener Isolation sind – ohne irgendwelche bestimmten Umstände, wie zum Beispiel ein Kragen und ein Schlips, oder ein erkennbarer Hintergrund. Meiner Meinung nach ist es jetzt das Schwierigste, diesen isolierten Kopf so zu malen, daß er auf der einen Seite nicht wie eine bloße Skizze, die er nicht ist,

aussieht und auf der anderen Seite auch nicht wie eine Art von Enthauptung. Das Bild muß aus einer glaubhaften Matrix hervorkommen, jenseits von gewohnheitsmäßigen Umständen oder Umgebungen, als ob es von außerhalb der Zeit käme. Wie Sie vielleicht bemerkt haben, gibt es in meinen Bildern keine Indizien – selbst kaum Haar, was ich auch schon als Indizie ansehe, da es lang oder kurz sein kann, oder einen jungen oder alten Mann andeuten kann, was alles Kommentare sind, die ich zu vermeiden suche.

Ich wollte sie über den Ursprung des weißen Hintergrundes fragen. Er scheint fast ein traditionelles Merkmal Ihrer Malerei zu sein.

Nun ja, ich benutzte einen weißen Hintergrund zum ersten Mal 1956, als ich an einer Reihe von Torsos, oder was ich als 'Präsenzen' bezeichne, arbeitete. Ich war dieses Jahr In Spanien gewesen und war außerordentlich beeindruckt von der Art und Weise, wie Schatten dort realer als die eigentliche schattenwerfende Substanz aussahen. Sämtliche Substanzen schienen von dieser Brillianz durchdrungen zu sein und von ihr aufgegessen zu werden, so daß ich dazu kam, alles Existierende In einer Matrix von purem weißen Licht anzusehen. Dann, später, hatte ich die Idee, Bilder gewissermaßen aus dem Nichts, aus Licht, aus den Tiefen barer Leinwand hervorzuzaubern

Verändern sich Ihre Reaktionen überhaupt, wenn Sie Bilder von lebenden Personen malen?

Ich denke, daß der große Unterschied hier darin liegt, daß bei Toten ihr ganzes Leben wie eine Ebene vor einem ausgebreitet ist: die Jugend und das Alter werden beide gegenwärtig. Die Lebenden, auf der anderen Seite, befinden sich noch in der Zeit, bewegen sich und verändern sich. Und natürlich dann bei Lebenden gibt es immer die potentielle Peinlichkeit, daß sie noch einmal auftauchen und alle Bilder, die man aus ihnen entwickelt hat, wieder durcheinander werfen.

Machte die Tatsache, daß Sie Beckett und Bacon kannten, daß Sie ihr Aussehen in Fleisch und Blut beobachten konnten, einen Unterschied?

Es ist schon ein Vorteil, aber es auch etwas, was einen hindert. Ich meine, man fühlt vielleicht, daß man unverschämt ist, wenn man mit ihrem Aussehen in dieser Art herumspielt – und es ist auch eine Verzerrung, sie außerhalb der Zeit darzustellen, gewissermaßen innerhalb der Matrix, ich schon erwähnt habe. Ganz besonders, da Menschen glauben – eine Reaktion, der ich oft in meinen Ausstellungen begegnet bin – daß ich in irgendeiner Art eine 'Aussage' über die gemalte Person mache. Wissen Sie, ich mache überhaupt keine

Aussage, ich versuche einfach, Aspekte des Beckettseins von Beckett, des Baconseins von Bacon zu erforschen, aufzudecken. Es ist allerdings auch wahr, daß sobald man diese Menschen ein wenig in Person kennt, daß diese Erinnerungen einen begleiten. Dieser merkwürdig durchdringende Blick, den Beckett so an sich hatte, an den erinnere ich mich immer wieder, selbst bei Fotos, auf denen er diesen Blick gar nicht hat.

Denken Sie jemals daran, Menschen zu malen, die Ihnen nahestehen, Familienmitglieder oder alte Freunde?

Oh, aber ja! Zu einem Zeitpunkt malte ich eine Anzahl von Portraits meiner Mutter und meines Vaters. Ich habe meine Kinder gemalt, und ich habe mehr Studien von Anne als von irgendeinem anderen menschlichen Wesen gemacht. Aber im wesentlichen stellen alle Studien von Menschen die gleichen Probleme dar. Besonders mit Anne, nehme ich an, ist es eine Art des Fetischismus: ich versuche, ihr Wesen in Farbe zu realisieren. Ich möchte mich nicht esoterisch anhören, aber man könnte sagen, daß ich versuche, einen magischen Vorgang innerhalb der Beschränkungen meiner Kunst auszuüben und somit, hoffentlich, mit einem Bild herauszukommen, das sein eigenes Leben hat. Nichts weiter.

Sie haben sich in der Vergangenheit auf bestimmte mystische Haltungen und auch auf Spritualität bezogen. Unterstellt das bestimmte Glaubensrichtungen Ihrerseits?

Ich habe keine definierten religiösen Ansichten. Ich bin, könnte man sagen, ein guter Agnostiker, der versucht, sein Fenster zur Realität so offen wie möglich zu halten. Ich war enorm beeindruckt von etwas, was Schrödinger, der Physiker, zu mir sagte als ich vor fast vierzig Jahren Student in Dublin war. Er sagte, daß Materie nicht zerstört werden könne – über jede Wiedererkennung hinaus modifiziert vielleicht, wie zum Beispiel in Energie umgewandelt – aber niemals zerstört. Schrödinger glaubte auch, daß der Geist, oder das Bewußtsein, auch unzerstörbar war. Ich muß sagen, daß ich weiterhin von diesem Gedanken beeindruckt bleibe. Und dann, wenn Sie über das Universum mit seinen zahllosen Galaxien, jede mit zahllosen Sternen, nachdenken, wenn Sie über die unbegrenzten Möglichkeiten nachdenken und sie mit unserer eingeschränkten Wahmehmung vergleichen, scheint es unmöglich, irgendeinen dogmatischen Glauben zu vertreten. So wie ich uns sehe, leben wir nur in einer kleinen Ecke der Realität und nehmen wahr, was wir können, eher wie Hummer in einem Becken, wissen Sie, mit ihren empfindlichen Fühiern, die in die eine oder die andere Richtung schwingen. Aber was kann man wirklich da unten im Wasser, über das Land oder die Städte oder die immerwährende Nacht der Sterne sagen?

Interview aus *Art International* (Lugano), 1979

Anmerkung

1 Austellung mit dem Titel 'A la recherche de WB Yeats – Cent portraits imaginaires' im Musée d'Art Modeme de la Ville de Paris von Oktober-November 1976.

2 'Studies towards an image of James Joyce' Diese Reiseausstellung (November 1977-Dezember 1978) wurde in Genua (s. Marco dei Giustiniani), Zürich (Gimpel & Hanover), London (Gimpel Fils), Belfast (Arts Council Gallery), Dublin (Hugh Lane Municipal Gallery), New York (Gimpel &Weitzenhoffer), Montreal (Waddington) und in Toronto (Waddington) gezeigt.

Louis le Brocquy

Louis le Brocquy was born in Dublin on 10 November 1916. In 1938, he abandoned his laboratory work there to become a painter. Self-taught, he studied in the museums of London, Paris, Venice, and Geneva, then exhibiting the Prado collection.

Coming to London in 1947, he began his long association with Gimpel Fils and to exhibit internationally, winning a major prize at the Venice Biennale in 1956. Two years later he married the painter Anne Madden and has since worked in France and in Ireland.

In 1962, le Brocquy was awarded an honorary Litt.D. by the University of Dublin, and in 1988, an honorary Ll.D. by the National University of Ireland. He was made Chevalier de la Légion d'Honneur in 1975, and in 1996, Officier des Arts et des Lettres.

Louis le Brocquy est né à Dublin le 10 novembre 1916. En 1938, il y abandonne son travaille de laboratoire, pour devenir peintre. Autodidacte, il étudie dans les musées de Londres, Paris, Venise, et Genève, exposant alors la collection du Prado.

Arrivé à Londres en 1947, il commence sa longue association avec Gimpel Fils, et expose à travers le monde, gagnant un prix important à la Biennale de Venise en 1956. Deux ans plus tard, il épouse le peintre Anne Madden et travaille, depuis, en France et en Irlande.

En 1962, le Brocquy fut diplômé honoris causa Litt.D. par l'Université de Dublin, et en 1988, honoris causa Ll.D. par l'Université Nationale d'Irlande. En 1975 il fut fait Chevalier de la Légion d'Honneur, et en 1996, Officier des Arts et des Lettres.

Louis le Brocquy wurde am 10. November 1916 in Dublin geboren. 1938 verließ er seine Arbeit in einem Labor dort, um Maler zu werden. Er studierte autodidaktisch in den Museen von London, Paris, Venedig, und Genf, die damals die Prado Kollektion ausstellten.

Im Jahre 1947 kam er nach London und begann seine langjährige Zusammenarbeit mit Gimpel Fils und fing an, international auszustellen. Auf der Biennale 1956 in Venedig gewann er einen der Hauptpreise. Zwei Jahre später heiratete er die Malerin Anne Madden und arbeitet seitdem in Frankreich und Irland.

Im Jahre 1962 wurde le Brocquy von der Dubliner Universität der Titel Ehrendoktor der Literatur und im Jahre 1988 von der Stattlichen Universität Irland der Titel Ehrendoktor der Rechtswissenschaft verliehen. 1975 wurde er zum Chevalier de la Légion d'Honneur ernannt, und im Jahre 1996, der Titel Officier des Arts et des Lettres.

MUSEUM EXHIBITIONS
EXPOSITIONS DE MUSÉES
WICHTIGSTE AUSSTELLUNGEN

1997 Musée d'Art Moderne et
 Contemporain, Nice

1996 Irish Museum of Modern Art,
 Dublin

1991 Museum of Modern Art,
 Kamakura; Itami City Museum
 of Art, Osaka; City Museum of
 Contemporary Art, Hiroshima

1989 Picasso Museum, Antibes

1988 Museum of Contemporary Art,
 Brisbane; Westpac Gallery,
 National Gallery of Victoria,
 Melbourne; Festival Centre,
 Adelaide

1987 Ulster Museum, Belfast

1982 Palais des Beaux-Arts, Charleroi

1981 New York State Museum

1978 Hugh Lane Municipal Gallery of
 Modern Art, Dublin

1976 Musée d'Art Moderne de la Ville
 de Paris

1973 Fondation Maeght, France

1967 Ulster Museum, Belfast

1966 Hugh Lane Municipal Gallery of
 Modern Art, Dublin

PUBLIC COLLECTIONS INCLUDE
COLLECTIONS PUBLIQUES
ÖFFENTLICHE KOLLEKIONEN
UNTER ANDEREM

Albright Knox Art Gallery, Buffalo
An Chomhairle Ealaíon /
 The Arts Council, Dublin
The Arts Council of Great Britain
Carnegie Institute, Pittsburg
Chicago Arts Club
City Art Gallery, Leeds
City Art Gallery, Rugby
City Art Gallery, Waterford
City Museum of Contemporary Art,
 Hiroshima
Columbus Museum of Art, Ohio
Contemporary Art Society, London
Council House, Wisconsin
Crawford Municipal Art Gallery, Cork
Detroit Institute of Art
Etat Français, Paris
Fondation Maeght, St Paul
Fondation Vincent Van Gogh, Arles
Fort Worth Center, Texas
Foundation of Brazil Museum, Bahia
Graves Art Gallery, Sheffield
Gulbenkian Museum, Lisbon
Guggenheim Museum, New York
Hirshhorn Museum and
 Sculpture Garden, Washington DC
Ho-Am Museum of Art, Seoul
Hugh Lane Municipal Gallery
 of Modern Art, Dublin
Itami City Museum of Art, Osaka
Kunsthaus, Zurich
Moravian Gallery, Brno
Municipal Gallery, Darlington
Municipal Gallery, Swindon
Musée d'Art Moderne
 de la Ville de Paris
Musée Cantini, Marseille
Musée de Nantes
Musée Picasso, Antibes
Museo de Arte Moderna, Sao Paulo
Museum of Modern Art, Kamakura
National Gallery, New Delhi
Nelson Art Gallery, New Zealand
New York State Museum
San Diego Museum of Art
Tate Gallery, London
Trinity College Collection, Dublin
Uffizi Gallery, Florence
Ulster Museum, Belfast
University of Calafornia, Berkeley
University of Warwick
Vatican Museums, Rome
Victoria and Albert Museum, London
Waterford Municipal Art Collection

SELECTED BIBLIOGRAPHY
LECTURES CHOISIES
AUSGEWÄHLTE BIBLIOGRAPHIE

Alistair Smith, *Louis le Brocquy –
 Paintings 1939-1996* (Irish Museum
 of Modern Art, Dublin, 1996)
George Morgan, *Louis le Brocquy –
 Procession* (Gandon Editions, 1994)
Anne Madden, *Seeing His Way –
 Louis le Brocquy, a Painter*
 (Gill & Macmillan, Dublin, 1994)
George Morgan, *Louis le Brocquy –
 The Irish Landscape*
 (Gandon Editions, 1992)
Sister Wendy Beckett, *Art and the
 Sacred* (Random, London, 1992)
Dorothy Walker, 'Images, Single and
 Multiple', *Irish Arts Review 1991-92*
Anne Crookshank, intro Seamus
 Heaney, *Louis le Brocquy*
 (Hibernian Fine Art / Kerlin
 Gallery, Dublin, 1991)
Dorothy Walker, Seamus Heaney, John
 Russell, Tadayaso Sakai,
 *Louis le Brocquy – Images, Single and
 Multiple 1957-1990*
 (Yomiuri Shimbun / Japan
 Association of Art Museums, 1991)
Tadayasu Sakai, *Portraits of Unique
 Painters* (Keibun-Sha, Tokyo, 1991)
Michael Peppiatt, 'Entretien avec le
 Brocquy', *Pleine Marge* (June, 1990)
Michael Gibson, Bernard Noël, John
 Montague, Richard Kearney,
 Louis le Brocquy – Images 1975-88
 (Musée Picasso, Antibes, 1989)
Maiten Bouisset, 'Portrait de Louis le
 Brocquy', *Beaux Arts* (Paris, 1989)
Richard Kearney, 'Le Brocquy and Post-
 Modernism', *Irish Review* (1988)
Claude Esteban, *Traces, figures, traversées*
 (Editions Galilée, Paris, 1985)
Dorothy Walker, 'Louis le Brocquy –
 The New Work', *Irish Arts Review*,
 vol.2, no.1, Spring 1985
Bernard Noël, *Louis le Brocquy –
 l'Atelier Mental* (Galerie Jeanne
 Bucher, 1982)
M Benezet, S Faucherau, J Ristat,
 'Conversation avec Louis le
 Brocquy', *Digraphe / Temps Actuels*
 (Paris, 1982)
Dorothy Walker, intro John Russell,
 Louis le Brocquy (Ward River Press,
 Dublin, 1981; Hodder & Stoughton,
 London, 1982)

FILM

Michael Garvey, *Louis le Brocquy – An
 Other Way of Knowing* (RTE, 1986)

TUNISIAN *Crochet*
Basic & Textured Stitches

Volume 1

Petra Tornack-Zimmermann

Dear Crocheters

Since I was introduced to the Tunisian crochet technique, I became fascinated with the many possibilities to create stitch patterns other than the Tunisian Simple Stitch. In this book you will learn all Tunisian basic stitches and also how to combine those to crochet unique fabrics with textured surfaces.

Have a wonderful crochet time!

Petra Tornack-Zimmermann

Contents .

Materials

- All you need to get started is a Tunisian crochet hook, also called an afghan hook, and yarn in the correct weight for your hook. The average Tunisian crochet hook is 12" to 14" (30 to 35.5 cm) long, and smooth so the stitches glide easily. This size hook is used for narrow items such as scarves or potholders.

- If you want to crochet larger pieces, such as sweaters or afghans, you will need a hook with a nylon cord attached. The cords range in length from 16" to 60" (40 to 150 cm).

- Tunisian Crochet will create a dense fabric. If you want a lighter or more airy fabric, choose a hook that is larger than what is recommended for your yarn.

Abbreviations

ext	= extended
st, sts	= stitch, stitches
F	= Forward Row
R	= Return Row
TDCS	= Tunisian Double Crochet Stitch
TESS	= Tunisian Extended Simple Stitch
TFS	= Tunisian Full Stitch
TKS	= Tunisian Knit Stitch
TPS	= Tunisian Purl Stitch
TRS	= Tunisian Reverse Stitch
TSS	= Tunisian Simple Stitch
TSLS	= Tunisian Slanted Stitch
TSS2tog	= Tunisian Simple Stitch 2 together
TSS3tog	= Tunisian Simple Stitch 3 together
[...]	= Pattern repeat between brackets

Reading Crochet Charts

- The numbers of the Forward Rows are at the right side of the chart, Return Rows at the left.
- Read and crochet the stitches of the Forward Rows from right to left, as indicated by the gray arrow.
- The pattern repeat is framed in black.
- Stitches used for each pattern are listed at the bottom.
- Also note the color of Forward and Return Rows in patterns with two colors.
- Edge stitches are not shown in the chart, but are always crocheted as explained in the pattern.

3

Tunisian Crochet Technique .

Every Tunisian row consists of two steps, a Forward Row and a Return Row. In the Forward Row you pull up loops and leave them on the hook. In the Return Row the loops will be worked and slipped off of the hook until one last loop remains. The first Forward and Return Row will create the Foundation Row. All patterns in this book begin with this Foundation Row.

pull
up loop

Foundation Row

All Tunisian crochet pieces start with a foundation chain. To crochet the first Forward Row chain a multiple number of the stitch count, skip the last chain, insert the hook in the second chain, bring the yarn over the hook and pull up a loop. Repeat picking up stitches each chain across until the end of the row.

1 chain

Return Row

Crochet one extra chain (return chain) in the last stitch on hook.

return row

To work the stitches off of the hook, form a Yarn Over and draw through next two stitches on hook. Repeat with every stitch until one stitch remains.

finished foundation row

The Foundation Row is done. All Return Rows of the following patterns will be worked in the same manner as this first Return Row.
The remaining stitch on hook is the right edge stitch.

Stitch Bars .

1. front bar
2. back bar
3. upper bar
4. lower bar
5. back horizontal bar

- The next Forward Rows of the following patterns will be crocheted in the way as the Fondation Row. Now there are a variety of ways to insert the hook into the bars in order to pull up a loop.

- To create different textured patterns, it is important to know the look of the stitches or bars as shown in picture E.

- Every stitch has two "legs" or vertical bars created in the Forward Row (with blue yarn), one in front and one in back. And there are three horizontal bars (with white yarn) made in the Return Row, two in front and one in back.

- To start the next Forward Row, always skip the front bar of the right edge stitch and begin with the second front bar (= first stitch) to pull up loops.

1. Front Bar
The front bar is the vertical left "leg" of the stitch. It is used for the most Tunisian patterns and creates the Tunisian Simple Stitch (TSS). Normally, you insert the hook from right to left.

2. Back Bar
The back bar is the vertical right "leg" of the stitch. The hook inserted from the back creates the Tunisian Reverse Stitch (TRS).

3. Upper Bar
For increases and some patterns Tunisian Simple Stitches are crocheted inserting the hook into the upper bar.

4. Lower Bar
The lower bar is not used in this book.

5. Back Horizontal Bar
To see the back horizontal bar, also called the back bump, tilt the work to the front.

6. Other possibilities for inserting the hook
To create different textured patterns from TSS there are other places to insert the hook.

Furthermore the hook can be inserted directly in a stitch, meaning between both "legs" from front to the back and below the Return Row. This creates the Tunisian Knit Stitch (TKS).

For Tunisian Full Stitch (TFS) you insert the hook in the void between two stitches from front to the back and below the return row.

For some stitches to enhance the stability of the fabric (Tunisian Double Crochet Stitch) it is better if the hook is inserted in two different bars at the same time, for example in the front bar and adjoining upper bar.

Cast on the right number of stitches

Foundation Row Cast On

even number of stitches
1 edge st + 8 pattern sts + 1 chain st
cast on 10 chain stitches

- For the Foundation Chain crochet a multiple number of stitches as given in the pattern repeat and add two chain stitches for both edges.

- If a pattern requires an even number of stitches, also cast on an even number of chains. Skip the last chain stitch and pull up a loop in each remaining chain stitch.

- If you want to crochet for example a strip with 10 stitches as shown in the schematic picture at the left, begin with 10 chain stitches, skip the last stitch and pull up 9 loops.

- The right and left loop on the hook are the edge stitches. The stitches between are crocheted in the pattern repeat.

- To test a pattern, it is usuallly enough to crochet a swatch with 16 stitches.

Edge Stitch .

F insert hook under front and back bar

- For a nice, even **left edge** always insert the hook in both the front and back bar of the last stitch to pull up a loop.

- The remaining stitch on the right side after the Return Row automatically creates a neat **right edge**.

Increases and Decreases .

Increase Stitches at the Right Edge
To increase one stitch at the right edge, crochet one chain and pull up the loop through the first vertical bar, the one you usually skip.

Increase Stitches at the Left Edge
To increase one stitch at the left edge, crochet an extra stitch in the last upper bar, before the edge stitch.

Decrease Stitches at the Right Edge
To decrease in the Return Row, pull the loop through the last stitch without Yarn Over.

Decrease Stitches at the Left Edge
To decrease one stitch at the left edge, insert the hook in both front bars of the two last stitches at the same time to pull up a loop.

Bind Off Row .

finished bind off row

- For a smooth upper edge end your work with a Bind Off Row.

- Insert the hook in the same bar (or bars) as required for your pattern, then pull up a loop through all stitches on the needle to crochet a slip stitch. Repeat with each stitch across until the end of the row.

- If in the pattern the hook is inserted in two front bars, also insert in this manner for the Bind Off Row, to continue the same texture. Instead of a Yarn Over work a chain stitch.

7

Tunisian Simple Stitch . . .

The easiest and most common Tunisian stitch is the Tunisian Simple Stitch (TSS). To crochet a TSS insert the hook from right to left in the front bar, Yarn Over and pull up a loop. Repeat with each stitch across.
Chain any number of stitches.

1. F: Chain the desired number of sts and crochet the Foundation Row.
1. R: Work sts off of the hook as shown in the technique chapter.
2. F: Crochet a row of **TSS** in front bars, work the last st as edge st in front and back bar.
2. R: Work sts off of the hook.
Repeat row 2.

| I | TSS |
| ~ | Return Row |

Tunisian Tweed

If you change the color before each Return Row while working TSS, the front side shows a nice tweedy effect and the back is striped.
Begin the Return Row with one chain stitch in the new color.
Chain any number of stitches.

1. F: With **color 1** chain the desired number of sts and crochet the Foundation Row.
1. R: With **color 2** work sts off of the hook.
2. F: With **color 2** crochet a row of **TSS** in front bars, end with 1 edge st.
2. R: With **color 1** work sts off of the hook.
3. F: With **color 1** crochet **TSS**, end with 1 edge st.
3. R: With **color 2** work sts off of the hook.
Repeat row 2 and 3.

| I | TSS |
| ~ | Return Row |

Tunisian Purl Stitch

Tunisian Purl Stitches (TPS) are crocheted with the working yarn in front. Insert the hook from right to left in the front bar and pull up a loop, see the right picture above. Repeat with each stitch across.
Chain any number of stitches.

1. F: Chain the desired number of sts and crochet the Foundation Row.
1. R: Work sts off of the hook.
2. F: Crochet a row of **TPS** in front bars, work the last stitch as edge stitch in front and back bar.
2. R: Work sts off of the hook.
Repeat row 2.

I	TSS
−	TPS
~	Return Row

Tunisian Purl Stripes

While working TPS, if you change the color at the left edge, the front shows a mottled pattern and the back is striped. Work the return chain at the end of the Forward Row with the new color.
Chain any number of stitches.

1. F: With **color 1** chain the desired number of sts and crochet the Foundation Row.
1. R: With **color 2** work sts off of the hook.
2. F: With **color 2** crochet a row of **TPS** in front bars, end with 1 edge st.
2. R: With **color 1** work sts off of the hook.
3. F: With **color 1** crochet **TPS**, end with 1 edge st.
3. R: With *color 2* work sts off of the hook. Repeat row 2 and 3.

I	TSS
−	TPS
~	Return Row

Pinstripes.

front | back

This striped pattern combines TSS and TPS only in the front bars. The back shows a waffled texture. Chain an even number of stitches.

1. F: Chain an even number of sts and crochet the Foundation Row.
1. R: Work sts off of the hook.
2. F: Crochet a row of alternately [1 TSS and 1 TPS] and 1 edge st.
2. R: Work sts off of the hook.
Repeat row 2.

		TSS
	—	TPS
	~	Return Row

. .

Continued from Colored Pinstripes B
1. R: With **color 1** work sts off of the hook, the last st with **color 2**.
2. F: With **color 2** crochet a row of [1 TSS and 1 TPS], end with 1 edge st.
2. R: With **color 2** work sts off of the hook, the last st with **color 1**.
3. F: With **color 1** crochet like row 2.
3. R: With **color 1** work sts off of the hook, the last st with **color 2**. Repeat row 2 and 3.

Colored Pinstripes

A) Pinstripe Pattern crocheted with color changes after the Forward Row. Work the return chain at the beginning of the Return Row with the new color.
B) If the color change is after the Return Row, crochet the last stitch of the Return Row already with the new color. Chain an even number of stitches.

A
1. F: With **color 1** chain an even number of sts and crochet the Foundation Row.
1. R: With **color 2** work sts off of the hook.
2. F: With **color 2** crochet a row of [1 TSS and 1 TPS] and 1 edge st.
2. R: With **color 1** work sts off of the hook.
3. F: With **color 1** crochet like row 2.
3. R: With **color 2** work sts off of the hook. Repeat row 2 and 3.

B
1. F: With **color 1** chain an **even** number of sts and crochet the Foundation Row.

		TSS
	—	TPS
	~	Return Row

10

Seed Stitch

The Seed Stitch combines TSS and TPS, worked only in front bars. The stitches are offset from the previous row.
Chain an even number of stitches.

1. F: Chain an even number of sts and crochet the Foundation Row.
1. R: Work sts off of the hook.
2. F: Crochet alternately **[1 TSS and 1 TPS]**, end with 1 edge st.
2. R: Work sts off of the hook.
3. F: Crochet a row of **[1 TPS and 1 TSS]**, end with 1 edge st. The TPS are offset to the previous row.
3. R: Work sts off of the hook.
Repeat row 2 and 3.

	TSS
−	TPS
~	Return Row

. .

Continued from Colored Seed Stitch B
2. F: With **color 2** crochet alternately **[1 TSS and 1 TPS]**, end with 1 edge st.
2. R: With **color 2** work sts off of the hook, the last st with **color 1**.
3. F: With **color 1** crochet alternately **[1 TPS and 1 TSS]**, end with 1 edge st. The TPS are offset to the previous row.
3. R: With **color 1** work sts off of the hook, the last st with **color 2**. Repeat row 2 and 3.

Colored Seed Stitch

A) Seed Stitch with color changes at the left edge.
B) Seed Stitch with color changes at the right edge.
Chain an even number of stitches.

A
1. F: With **color 1** chain an even number of sts and crochet the Foundation Row.
1. R: With **color 2** work sts off.
2. F: With **color 2** crochet alternately **[1 TSS and 1 TPS]** and 1 edge st.
2. R: With **color 1** work sts off.
3. F: With **color 1** crochet alternately **[1 TPS and 1 TSS]**, end with 1 edge st. The TPS are offset to previous row.
3. R: With **color 2** work sts off of the hook. Repeat row 2 and 3.

B
1. F: With **color 1** chain an even number of sts and crochet the Foundation Row.
1. R: With **color 1** work sts off of the hook, the last st with **color 2**.

	TSS
−	TPS
~	Return Row

Grid Stitch

To create an airy grid texture, crochet using the TSS into the back bump of the Return Row (see chapter Stitch Bars, picture E, No. 5). Insert the hook from the front to pull up a loop. Chain any number of stitches.

1. F: Chain any number of sts and crochet the Foundation Row.
1. R: Work sts off of the hook.
2. F: Crochet a row of **TSS in back bumps**, end with an edge st.
2. R: Work sts off of the hook.
Repeat row 2.

I	TSS
Ī	TSS, back bump
~	Return Row

Tunisian Reverse Stitch . .

For the Tunisian Reverse Stitch (TRS) insert the hook into the vertical back bar (see picture E, No. 2) from the wrong side of the fabric and pull up a loop. The last Return Row will tilt forward and form little knots in front. Chain any number of stitches.

1. F: Chain any number of sts and crochet the Foundation Row.
1. R: Work sts off of the hook.
2. F: Crochet a row of **TRS** (in the back bar), end with an edge st.
2. R: Work sts off of the hook.
Repeat row 2.

I	TSS
b	TRS, back bar
~	Return Row

Striped Reverse Stitch . . .

The Tunisian Reverse Stitch (TRS) worked with color changes at the right edge creates a striped pattern with visible purl ridges at the wrong side of the fabric. Chain any number of stitches.

1. F: With **color 1** chain any number of sts and crochet the Foundation Row.
1. R: With **color 1** work sts off of the hook, the last st with **color 2**.
2. F: With **color 2** crochet a row **TRS** and an edge st.
2. R: With **color 2** work sts off of the hook, the last st with **color 1**.
3. F: With **color 1** crochet like row 2.
3. R: With **color 1** work sts off of the hook, the last st with **color 2**.
Repeat row 2 and 3.

~	~	~	~	~	~	>3
b	b	b	b	b	b	3<
~	~	~	~	~	~	>2
b	b	b	b	b	b	2<
~	~	~	~	~	~	>1
I	I	I	I	I	I	1<

I	TSS
b	TRS, back bar
~	Return Row

Mirror Stitch

The Mirror Stitch is the opposite of the TSS. The wrong side looks like TSS. It is crocheted with TPS in the back bars. First bring the yarn in front as for TPS, insert the hook in the back bar as for TRS and pull up a loop.

1. F: Chain any number of sts and crochet the Foundation Row.
1. R: Work sts off of the hook.
2. F: Crochet a row of **TPS in the back bar**, end with an edge st.
2. R: Work sts off of the hook.
Repeat row 2.

>3	~	~	~	~	~	~
Г	Г	Г	Г	Г	Г	3<
>2	~	~	~	~	~	~
Г	Г	Г	Г	Г	Г	2<
>1	~	~	~	~	~	~
I	I	I	I	I	I	1<

I	TSS
Г	TPS, back bar
~	Return Row

Smooth Stitch

To create the Smooth Stitch insert the hook from the front around the back bar or "right leg", as shown in the right pic, and crochet TSS.

The edge of the crocheted piece tends to slant to the right. For this reason skip the first bar every 3rd or 4th row and increase one stitch at the end of the same row. To make the increase, crochet a stitch in the back bar and in the front bar of this last stitch.

Chain any number of stitches.

I TSS

J TSS, from front around back bar

~ Return Row

1. F: Chain any number of sts and crochet the Foundation Row.
1. R: Work sts off of the hook.
2. F: Crochet a row of **TSS in the back bar**, end with an edge st.
2. R: Work sts off of the hook.
Repeat row 2.

Tunisian Knit Stitch

The Tunisian Knit Stitch (TKS) looks like knitting, but the fabric is more dense. Work the stitches loosely or use a bigger hook than recommended for the yarn. Insert the hook from front to back between the two vertical bars (or between the "legs" of one stitch) and under the Return Row to pull up a loop, see right picture. Chain any number of stitches.

1. F: Chain any number of sts and crochet the Foundation Row.
1. R: Work sts off of the hook.
2. F: Crochet a row of **TKS**, end with an edge st.
2. R: Work sts off of the hook.
Repeat row 2.

I TSS

↓ TKS

~ Return Row

Full Stitch.

To crochet the Tunisian Full Stitch (TFS) insert the hook in the space between two stitches. The stitches are offset to the previous row. To create a rectangular piece, skip the first space every other row and increase one st at the end of the row. Chain any number of stitches.

1. F: Chain any number of sts and crochet the Foundation Row.
1. R: Work sts off of the hook.
2. F: Crochet a row of **TFS**, begin in the first space and skip the last space, end with an edge st.
2. R: Work sts off of the hook.
3. F: Crochet a row of **TFS**, begin in the second space and work the last space, end with an edge st.
3. R: Work sts off of the hook.
Repeat row 2 and 3.

I	TSS
f	TFS
~	Return Row

Basket Stitch

To crochet the Basket Stitch, work TSS in the upper bar. Insert the hook from the front (see right pic). To create a rectangular piece, skip the first upper bar every other row and increase one stitch at the end of the row. Chain any number of stitches.

1. F: Chain any number of sts and crochet the Foundation Row.
1. R: Work sts off of the hook.
2. F: Crochet a row of **TSS in the upper bar**, begin at the first st and skip the last st of the row, end with an edge st.
2. R: Work sts off of the hook.
3. F: Crochet a row of **TSS in the upper bar**, begin at the second st and work the last st of the row, end with an edge st.
3. R: Work sts off of the hook.
Repeat row 2 and 3.

I	TSS
Î	TSS, upper bar
~	Return Row

Purls Grid.

This airy pattern is worked with purl stitches in the upper bar. With yarn in front insert the hook from the back into the upper bar and crochet a TPS. Before each Forward Row make one extra chain and pull it tight. Chain any number of stitches.

1. F: Chain any number of sts and crochet the Foundation Row.
1. R: Work sts off of the hook.
2. F: Crochet a row of **TPS in the upper bar**, end with an edge st.
2. R: Work sts off of the hook, add 1 chain and pull it tight to continue.
Repeat row 2.

I	TSS
🛆	TPS, upper bar
~	Return Row

Extended Simple Stitch . .

chain

To crochet the Tunisian Extended Simple Stitch (TESS) insert the hook in the front bar, crochet a TSS and add a chain to each stitch. To adjust the height of the rows, add a chain to the left and right edge stitch too. Chain any number of stitches.

1. F: Chain any number of sts and crochet the Foundation Row.
1. R: Work sts off of the hook.
2. F: Begin with 1 chain and crochet a row of **TESS**, end with an ext edge st.
2. R: Work sts off of the hook.
Repeat row 2.

I	TSS
⸖	TESS
~	Return Row

Crossed Stitches

For this Crossed Stitches Pattern two TSS are crossed pairwise. Skip the first stitch, insert the hook in second front bar, pull up a loop, then insert the hook in the skipped front bar and pull up a loop. Repeat with each pair of sts.

Chain an even number of stitches.

1. F: Chain an even number of sts and crochet the Foundation Row.
1. R: Work sts off of the hook.
2. F: Crochet a row of **[2 crossed sts]** and an edge st.
2. R: Work sts off of the hook.
Repeat row 2.

I	TSS
xx	2 Crossed Sts
~	Return Row

Alternating Crossed

This Pattern is crocheted as the Crossed Stitches Pattern, but the pairs of stitches are offset to the previous row.
Chain an even number of stitches.

1. F: Chain an even number of sts and crochet the Foundation Row.
1. R: Work sts off of the hook.
2. F: Crochet a row of **[2 crossed sts]** and an edge st.
2. R: Work sts off of the hook.
3. F: Begin with 1 TSS, then crochet a row of **[2 crossed sts]**, end with 1 TSS and an edge st. The pairs of crossed sts are offseet to the previous row.
3. R: Work sts off of the hook.
Repeat row 2 and 3.

I	TSS
xx	2 Crossed Sts
~	Return Row

Extended Crossed

Each of the crossed stitches is extended with one chain stitch. Skip the first front bar, insert the hook in second front bar, pull up a loop, chain one, insert the hook in skipped front bar, pull up a loop and chain one. Repeat with each pair of sts. To adjust the height of the rows, add a chain to the left and right edge stitch too.
Chain an even number of stitches.

1. F: Chain an even number of sts and crochet the Foundation Row.
1. R: Work sts off of the hook.
2. F: Begin with 1 chain and crochet a row of **[2 crossed ext sts]**, end with an ext edge st.
2. R: Work sts off of the hook.
Repeat row 2.

	TSS
88	2 Extended Crossed Sts
~	Return Row

Thick and Thin

For the Thick and Thin Pattern crochet Tunisian Extended Knit Stitches (TEKS). Insert the hook as for Tunisian Knit Stitch between front and back bar (between both "legs"), pull up a loop and chain one. Repeat with each stitch across.
To adjust the height of the rows, add one chain to the left and right edge stitch too.
Chain the desired number of stitches.

1. F: Chain any number of sts and crochet the Foundation Row.
1. R: Work sts off of the hook.
2. F: Begin with 1 chain and crochet a row of **TEKS**, end with an ext edge st.
2. R: Work sts off of the hook.
Repeat row 2.

	TSS
?	TEKS
~	Return Row

Tunisian Double Crochet

To crochet Tunisian Double Crochet Stitches (TDCS), make a Yarn Over, insert the hook in the front bar, pull up a loop, Yarn Over and pull through two loops on hook. Repeat with each stitch across. A more durable fabric is created, when inserting the hook in the front bar and next upper bar at the same time. To adjust the height of the rows, add one chain to the left and right edge stitch too. Chain the desired number of stitches.

1. F: Chain any number of sts and crochet the Foundation Row.
1. R: Work sts off of the hook.
2. F: Begin with 1 chain and crochet a row of **TDCS**, end with an ext edge st.
2. R: Work sts off of the hook.
Repeat row 2.

Tunisian Slanted Stitch. . .

The Tunisian Slanted Stitch (TSLS) is worked as the TSS in the front bar, but the hook will be inserted from left to right with the tip upwards. The thread will slant to the right. It is easier to pull the front bar with the hook to the right side while inserting. Chain the desired number of stitches.

1. F: Chain any number of sts and crochet the Foundation Row.
1. R: Work sts off of the hook.
2. F: Crochet a row of **TSLS**, end with an edge st.
2. R: Work sts off of the hook.
Repeat row 2.

Diagonal Effect

This diagonally striped pattern combines TSS and TPS, all stitches in the front bar.
Chain a multiple of four and two edge stitches.

1. F: Chain a multiple of 4 and 2 sts, for example 18 or 22 sts in total, and crochet the Foundation Row.
1. R: Work sts off of the hook.
2. F: Crochet a row of **[2 TSS and 2 TPS]**, end with an edge st.
2. R: Crochet this and all other Return Rows as usual.
3. F: Begin with 1 TSS and 2 TPS, continue with **[2 TSS and 2 TPS]**, end with 1 TSS and an edge st. The sts are shifted one to the right.
4. F: Begin with 2 TPS, continue with **[2 TSS and 2 TPS]**, end with 2 TSS and an edge st.
5. F: Begin with 1 TPS, continue with **[2 TSS and 2 TPS]**, end with 2 TSS, 1 TPS and an edge st.
Repeat row 2 to 5.

	TSS		—	TPS
	~	Return Row		

Wide Ribs

The Wide Ribs looks like knitted cuffs, but the resulting fabric is not that stretchy. It is worked with Tunisian Knit Stitch (TKS) and Tunisian Purl Stitch (TPS).
Chain a multiple of four and two edge stitches.

1. F: Chain a multiple of 4 and 2 sts and crochet the Foundation Row with for example 18 or 22 sts in total.
1. R: Work sts off of the hook.
2. F: Crochet a row of **[2 TKS and 2 TPS]**, end with an edge st.
2. R: Work sts off of the hook.
Repeat row 2.

	TSS
—	TPS
↓	TKS
~	Return Row

20

Slip Stitches

This Pattern uses Slipped Stitches and Tunisan Simple Stitches. To slip a stitch put the front bar on the hook without working the stitch. The dusky pink stitches in the right picture are are slipped, the purple stitches are crocheted TSS. Chain an even number of stitches.

1. F: Chain an even number of sts and crochet the Foundation Row.
1. R: Work sts off of the hook.
2. F: Crochet alternately **[1 TSS and slip 1 st]**, end with an edge st.
2. R: Work sts off of the hook.
3. F: Crochet alternately **[slip 1 st and 1 TSS]**, end with an edge st. The slipped sts are offset to the previous row. Always crochet the long front bars and slip the short front bars on the hook.
3. R: Work sts off of the hook. Repeat row 2 and 3.

	TSS
v	slip front bar
~	Return Row

Colored Slip Stitch

front back

An interesting checkered effect is created, when the Slipped Stitch Pattern is made in two colors. The wrong side is striped. Use the same color for one Forward and Return Row. Chain an even number of stitches.

1. F: With **color 1** chain an even number of sts and crochet the Foundation Row.
1. R: With **color 1** work sts off of the hook.
2. F: With **color 2** crochet alternately **[1 TSS and slip 1 st]**, end with an edge st.
2. R: Work with **color 2**, the last st with **color 1**.
3. F: With **color 1** crochet alternately **[slip 1 st and 1 TSS]**, end with an edge st.
The slipped sts are offset to the previous row. Always crochet the front bars with the same color like the working thread and slip the front bars with other color on the hook.
3. R: With **color 1** work sts off of the hook, the last st with **color 2**.
Repeat row 2 and 3.

	TSS
v	slip front bar
~	Return Row

21

Twisted Stitch

The grainy texture is created with the Tunisian Twisted Stitch (TTWS). To pull up a loop insert the hook in the front bar from upper left to lower right, see picture above. Chain any number of stitches.

1. F: Chain a desired number of sts and crochet the Foundation Row.
1. R: Work sts off of the hook.
2. F: Crochet a row of **TTWS**, end with an edge st.
2. R: Work sts off of the hook.
Repeat row 2.

I	TSS
Y	Twisted Stitch
~	Return Row

Fine Ribs

Fine Ribs are crocheted with the Tunisian Knit Stitch (TKS) and Tunisian Reverse Stitch (TRS). Chain an even number of stitches.

1. F: Chain an even number of sts and crochet the Foundation Row.
1. R: Work sts off of the hook.
2. F: Crochet alternately **[1 TKS and 1 TRS]**, end with an edge st.
2. R: Work sts off of the hook.
Repeat row 2.

I	TSS
↓	TKS
b	TRS
~	Return Row

Squares

For these small Squares use Tunisan Knit Stitch (TKS) and Tunisan Reverse Stitch (TRS). Chain a multiple of four and two edge stitches.

1. F: Crochet a Foundation Row with a multiple of 4 and 2 sts, for example 18 or 22 sts in total.
1. R: Work this and all Return Rows as usual.
2. F: Crochet a row of **[2 TKS and 2 TRS]**, end with an edge st.
3. F: Repeat row 2.
4. F: Crochet a row of **[2 TRS and 2 TKS]**, end with an edge st. The pairs of sts are offset to the previous row.
5. F: Repeat row 4. Repeat row 2 to 5.

	TSS
↓	TKS
b	TRS
~	Return Row

Yarn Over Pattern

pull Yarn Over over two TSS

To create this texture form a Yarn Over (YO), crochet two TSS and pull the YO over these two stitches. Use the tip of the hook to pull both stitches through the YO. Chain an even number of stitches.

1. F: Chain an even number of sts and crochet the Foundation Row.
1. R: Work this and all Return Rows as usual.
2. F: Crochet a row of **[1 YO, 2 TSS and pull YO over 2 sts]**, end with an edge st.
3. F: Begin with 1 TSS, continue with **[1 YO, 2 TSS and pull YO over 2 sts]**, end with 1 TSS and an edge st. The YO-sts are offset to the previous row. Repeat row 2 and 3.

I	TSS
↑ I°	Yarn Over over 2 TSS
~	Return Row

Sloped Spikes

TSS2tog

TFS

Satin Surface

This pattern uses the same stitches (TSS2tog and TFS) as the Sloped Spikes, but the stitches are offset to the previous row.
Chain an even number of stitches.

For the Sloped Spikes insert the hook in two front bars at the same time and pull up a loop, to crochet two stitches together (TSS2tog). Substitute the missing stitch with a Tunisian Full Stitch (TFS) in next space between two stitches. From row 3 on, to crochet two stitches together, always insert the hook first into TSS2tog-stitch, then in the TFS of the previous row. Chain an even number of stitches.

1. F: Chain an even number of sts and crochet the Foundation Row.
1. R: Work sts off of the hook.
2. F: Crochet alternately **[1 TSS2tog and 1 TFS]**, end with an edge st.
2. R: Work sts off of the hook.
Repeat row 2.

1. F: Chain an even number of sts and crochet the Foundation Row.
1. R: Work this and all Return Rows as usual.
2. F: Crochet a row **[1 TSS2tog and 1 TFS]**, end with an edge st. In even rows, to crochet 2 sts together, always insert the hook first in the TSS2tog-stitch, then in the TFS of the previous row.
3. F: Crochet a row **[1 TFS and 1 TSS2tog]**, end with an edge st. The sts are offset to the previous row.
In uneven rows, to crochet 2 sts together, insert the hook first in the TFS, then in TSS2tog-stitch the of the previous row.
Repeat row 2 and 3.

I	TSS
^	TSS2tog
f	TFS
~	Return Row

I	TSS
^	TSS2tog
f	TFS
~	Return Row

Chunky Knits

TPS TSS2tog

The knit-look texture is created with crocheting two stitches together (TSS2tog), see right arrow. Substitute the missing stitch with a purl stitch (TPS) in the next upper bar, see left arrow. From each second stitch we use two bars (front and upper).
Chain an even number of stitches.

1. F: Crochet a Foundation Row with an even number of stitches.
1. R: Work this and all Return Rows as usual.
2. F: Crochet in the first 2 sts **[1 TSS2tog and 1 TPS in upper bar]**, continue the pattern repeat at st No. 3 and 4, No. 5 and 6 and so on, end with an edge st.
Repeat row 2.

I	TSS
^	TSS2tog
⌂	TPS, upper bar
~	Return Row

Yarn Over Lace

Yarn Over

TSS2tog

Worked with a bigger hook, this Yarn Over Pattern will result in a lace fabric. Stitches used are TSS2tog and a Yarn Over, see thread on hook. From row 3 on, to crochet two stitches together, always insert the hook first in the front bar of the TSS2tog-stitch, then in the YO-stitch of the previous row.
Chain an even number of stitches.

1. F: Crochet a Foundation Row with an even No. of sts.
1. R: Work all sts off of the hook.
2. F: Crochet alternately **[1 TSS2tog and 1 YO]**, end with an edge st.
2. R: Work all sts off of the hook, treat Yarn Overs like normal sts. Repeat row 2.

I	TSS
^	TSS2tog
O	Yarn Over
~	Return Row

Diagonal Texture

37

Yarn Over

TSS2tog

1. F: Chain an even number of sts and crochet the Foundation Row.
1. R: Work all sts off of the hook.
2. F: Crochet alternately **[1 YO and 1 TSS2tog]**, end with an edge st.
2. R: Work all sts off of the hook, treat Yarn Overs like normal sts.
3. F: Skip first YO and crochet alternately **[1 YO and 1 TSS2tog]**, end with 1 YO and 1 edge st. From now on to crochet a TSS2tog, insert the hook first into the YO-stitch of the previous row, then in the front bar at the same time.
4. F: Begin with 1 TSS, pull right edge-st over this TSS (decrease made), continue with **[1 YO and TSS2tog]**, end with 1 TSS and 1 edge st.
Repeat row 3 and 4.

Stitches used for the Diagonal Texture are TSS2tog (see arrow) and followed by a Yarn Over (YO), see thread on hook. To crochet two stitches together always insert the hook first into the smaller YO-stitch of the previous row, then in the front bar at the same time and pull up a loop.

If you only repeat row 2, it results in a diagonal shaped piece as used for the shawl at the end of the book.

To create a rectangle piece, it is necessary in even rows to decrease one stitch at the right edge.
The right edge stitches are added in the crochet chart, only in row 4 work the decrease stitch, as indicated with a gray triangle symbol.
Chain an even number of stitches.

I	TSS
∧	TSS2tog
O	Yarn Over
▲	Decrease (work 1 TSS and pull through first loop on hook)
~	Return Row

Jeans

I	TSS
∧	TSS2tog
⌂	TPS, upper bar
~	Return Row

26

Jeans

TPS

TSS2tog

Like the Chunky Knits the Jeans Pattern is crocheted with two stitches together (TSS2tog) and Tunisian Purl Stitch (TPS), but the hook insertion is switched. To work TSS2tog, always insert the hook first in the shorter front bar, then in the longer front bar of previous row, see arrows. Work the purl stitch into the following upper bar. We use three bars from two stitches!
Chain an even number of stitches.

<<< Crochet chart see left page.
1. F: Chain an even number of sts and crochet the Foundation Row.
1. R: Work this and all following Return Rows as usual.
2. F: Crochet alternately **[1 TSS2tog and 1 TPS in upper bar]**, end with an edge st.
3. F: Begin the row with 1 TPS in upper bar, continue with **[1 TSS2tog and 1 TPS in upper bar]**, end with 1 TPS in upper bar, 1 TSS and an edge st. To crochet TSS2tog always insert the hook first the in shorter front bar, then in the longer front bar of the previous row.
Repeat row 2 and 3.

Baby Rib

The Baby Rib pattern combines the Tunisian Simple Stitch (TSS) and Tunisian Slanted Stitch (TSLS), all worked in front bars. To crochet the TSLS insert the hook from left to right, see picture.
Chain an even number of stitches.

1. F: Chain an even number of sts and crochet the Foundation Row.
1. R: Work sts off of the hook.
1. F: Crochet alternately **[1 TSS and 1 TSLS]**, end with an edge st.
1. R: Work all sts off of the hook.
Repeat row 2.

│	TSS
╱	TSLS
~	Return Row

Waffle Pattern

The Waffle Pattern is worked like the Baby Rib, but stitches are alternated. Crochet Tunisian Simple Stitch (TSS) and Tunisian Slanted Stitch (TSLS). Chain an even number of stitches.

1. F: Chain an even number of sts and crochet the Foundation Row.
1. R: Work this and all following Return Rows as usual.
2. F: Crochet alternately **[1 TSS and 1 TSLS]**, end with an edge st.
3. F: Crochet alternately **[1 TSLS and 1 TSS]**, end with an edge st. The sts are offset to the previous row.
Repeat row 2 and 3.

Simple and Purl Ridges . .

For Simple and Purl Ridges crochet Tunisian Simple Stitch (TSS) and Tunisian Purl Stitch (TPS), all in the front bars. The stitches are offset to the previus row.
Chain a multiple of eight and two edge stitches.

1. F: Crochet a Foundation Row with a multiple of 8 and 2 sts, for example 18 or 26 sts in total.
1. R: Work this and all Return Rows as usual.
2. FR: Crochet alternately **[4 TSS and 4 TPS]**, end with an edge st.
3. FR: Crochet alternately **[4 TPS and 4 TSS]**, end with an edge st. The TPS are offset to the previous row.
Repeat row 2 and 3.

| | TSS
| / | TSLS
| ~ | Return Row

| | TSS | — | TPS | ~ | Return Row

Peaks

For the Peaks crochet two stitches together (TSS2tog) in front bars. Substitute the missing stitch with a TSS into the upper bar. The Peak stitch uses three bars from two stitches. Chain an even number of stitches.

1. F: Chain an even number of sts and crochet the Foundation Row.
1. R: Work sts off of the hook.
2. F: Crochet alternately **[1 TSS2tog and 1 TSS in upper bar]**, end with an edge st.
2. R: Work sts off of the hook.
From now on to crochet TSS2tog, insert the hook first in the TSS2tog-stitch, then in the TSS of previous row. Repeat row 2.

	TSS
	TSS, upper bar
	TSS2tog
	Return Row

Staggered Peaks

This pattern is crocheted like the Peaks, but the insertion points of the hook are switched. From row 3 on to crochet two stitches together (TSS2tog), insert hook first into the front bar of the TSS, then into the front bar of the TSS2tog-stitch of the previous row. Substitute the missing stitch with a TSS into the upper bar. We use three bars from two stitches. Chain an even number of stitches.

1. F: Chain an even number of sts and crochet the Foundation Row.
1. R: Work this and all Return Rows as usual.
2. F: Crochet alternately **[1 TSS2tog and 1 TSS in upper bar]**, end with an edge st.
3. F: Begin with 1 TSS into front bar of TSS2tog-stitch of previous row and crochet alternately **[1 TSS2tog and 1 TSS in upper bar]**, end with 1 TSS and an edge st.
From now on to crochet a TSS2tog, insert hook first in TSS, then in TSS2tog-st of previous row. Repeat row 2 and 3.

	TSS
	TSS, upper bar
	TSS2tog
	Return Row

29

Yarn Over Columns

To make the Yarn Over Columns form a Yarn Over (YO), crochet three TSS and pull the YO over these three stitches just made. Use the tip of the hook to pull all three stitches through the YO. Chain a multiple of three and two edge stitches.

1. F: Crochet a Foundation Row with a multiple of 3 and 2 sts, for example 17 or 20 sts in total.
1. R: Work sts off of the hook.
2. F: Crochet a row of **[1 YO, 3 TSS and pull YO over 3 sts]**, end with an edge st.
2. R: Work sts off of the hook.
Repeat row 2.

I TSS

Yarn Over over 3 TSS

~ Return Row

Extended Seed Stitch. . . .

The Extended Seed Stitch is worked with Tunisian Extended Purl Stitches (TEPS) in front bars and Tunisian Extended Reverse Stitches (TERS) in back bars. Also add a chain to each edge stitch. Chain an even number of stitches.

1. F: Chain an even number of sts and crochet the Foundation Row.
1. R: Work this and all Return Rows as usual.
2. F: Chain 1 and crochet alternately **[1 TERS and 1 TEPS]**, end with an ext edge st.
3. F: Chain 1 and crochet a row of **[1 TEPS and 1 TERS]**, end with an ext edge st. The sts are offset to the previous row. Repeat row 2 and 3.

I TSS

ᄝ TERS

ᄋ TEPS

~ Return Row

Cross Ribs

Crochet two Crossed Stitches and Tunisian Purl Stitches (TPS). To cross two stitches, skip the first front bar, insert the hook in second front bar, pull up a loop, then insert the hook in the skipped front bar and pull up a second loop.

Chain a multiple of four and two edge stitches.

1. F: Crochet a Foundation Row with a multiple of 4 and 2 sts, for example 22 or 26 sts in total.
1. R: Work this and all Return Rows as usual.
2. F: Crochet a row of **[1 TPS, 2 Crossed Sts and 1 TPS]**, end with an edge st.
Repeat row 2.

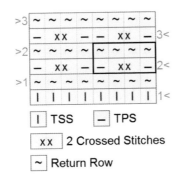

I	TSS	—	TPS
xx	2 Crossed Stitches		
~	Return Row		

Beehive

To make the Beehive stitch insert the hook in two front bars, crochet a Tunisian Extended Simple Stitch (TESS), again insert hook in the same two front bars and make a second TESS,
(= 2 TESS in 2 sts tog).
Also crochet one chain on both edge sts. Chain an even number of stitches.

1. F: Chain an even number of sts and crochet the Foundation Row.
1. R: Work all Return Rows as usual.
2. F: Chain 1 and crochet a row of **[2 TESS in 2 sts tog]**, end with an ext edge st.
3. F: Chain 1, begin with 1 TESS and crochet a row of **[2 TESS in 2 sts tog]**, end with 1 TESS and an ext edge st.
The sts are offset to the previous row.
Repeat row 2 to 3.

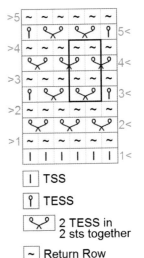

I	TSS
?	TESS
⚭	2 TESS in 2 sts together
~	Return Row

31

Cross Seed Stitch

This pattern is worked with two Crossed Stitches and Tunisian Purl Stitches (TPS). To cross two stitches, skip the first front bar, insert the hook in the second front bar, pull up a loop, then insert the hook in the skipped front bar and pull up a loop. Chain a multiple of four and two edge stitches.

1. F: Crochet a Foundation Row with a multiple of 4 and 2 sts, for example 18 or 22 sts in total.
1. R: Work all Return Rows as usual.
2. F: Crochet alternately **[2 TPS and 2 Crossed Sts]**, end with an edge st.
3. F: Crochet alternately **[2 Crossed Sts and 2 TPS]**, end with an edge st. The TPS are offset to the previous row. Repeat row 2 and 3.

Extended Ribs.

The Extended Ribs are worked with Extended Purl Stitches (TEPS) in front bars and Tunisian Extended Reverse Stitches (TERS) in back bars. Also elongate the edge stitches with one chain. Chain an even number of stitches.

1. F: Chain an even number of sts and crochet the Foundation Row.
1. R: Work sts off of the hook.
2. F: Chain 1 and crochet a row of **[1 TERS and 1 TEPS]**, end with an ext edge st.
2. R: Work sts off of the hook.
Repeat row 2.

Cross Rows

The Cross Rows are made of TSS and rows in Crossed Stitches. To cross two stitches skip the first stitch, insert the hook in the second front bar, pull up a loop, then insert hook in skipped front bar and pull up a loop.

Chain an even number of stitches.

1. F: Chain an even number of sts and crochet the Foundation Row.
1. R: Work sts off of the hook.
2. F: Crochet a row of **[2 Crossed sts]**, end with an edge st.
2. R: Work sts off of the hook.
3. F: Crochet a row of **TSS**, end with an edge st.
3. R: Work sts off of the hook.
Repeat row 2 and 3.

I	TSS
xx	2 Crossed Sts
~	Return Row

Infinity Scarf

The stitch pattern of the scarf is introduced at page 26 (stitch pattern 37). The edges become a diagonal shape, when only row 2 is crocheted.
The picture shows the long version of the scarf, which can be wound two times around the neck.

The short cowl version is quickly crocheted and fits snug around the neck.
Use self striped yarn to create a diagonally colored effect.

Materials

- short cowl: 1 skein of self coloring microfiber yarn "Tahiti Batik" by Gründl (color 06) with a yardage of 260 m per 100 g (or 284 yds per 1.75 ounce)
- long scarf: 2 skeins, 200 g
- long Tunisian crochet hook 4 mm (or G-6)
- 5 decorative buttons
- scissors and darning needle

Measurements
(short cowl)

Stitch Pattern

	TSS
∧	TSS2tog
O	Yarn Over
~	Return Row

How to Crochet

Foundation: Loosely chain 50 sts. Skip the last st and pull up a loop in each chain accross. Work a usual Return Row as shown in the technique chapter.

2. Row: Repeat Row 2 of the stitch instructions. From now on to crochet TSS2tog, insert the hook first in the front bar of YO-st of previous row, then in TSS2tog-st at the same time, see picture 37. This results in a diamond-shaped form.

For a short scarf repeat row 2 until a total length of 58 cm (23") or for a long scarf of 120 cm (48").

Last 3 Rows: For the buttoned edge crochet 3 rows TPS in front bars.

Bind Off Row: Insert the hook in front bar, crochet a TPS and pull it directly through last loop on hook, slipstitch made. Repeat with each st across until all sts are bound off. Cut yarn and weave in ends.

Finishing: Lay down the shawl to form a ring, overlap the short edges around 3 cm (2") as shown in measurements picture. Sew the buttons in place and through both layers of fabric.

35

Other Titles .

Coming soon:

TUNISIAN Crochet
Colors & Stripes
Vol. 2

TUNISIAN Crochet
Colorful Pattern Mix
Vol. 3

Copyright. .

ISBN-13: 978-1539153900

Printed in Great Britain
by Amazon